# MOSAICS

## KAFFE FASSETT
## CANDACE BAHOUTH

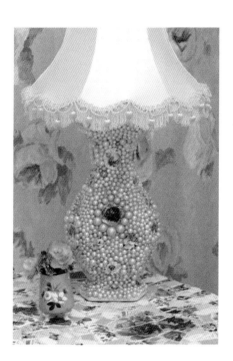

This book is dedicated to the visionaries who carried out their dreams with passion.

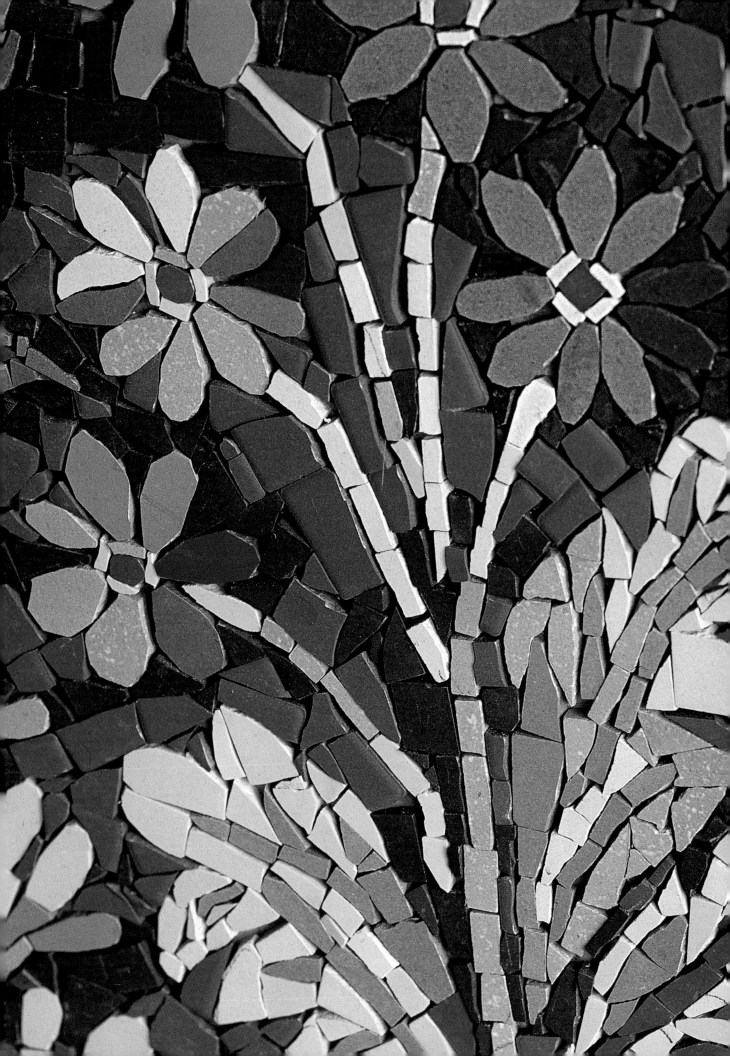

# MOSAICS

## INSPIRATION AND ORIGINAL PROJECTS FOR INTERIORS AND EXTERIORS

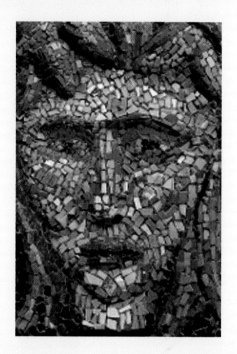

# KAFFE FASSETT
# CANDACE BAHOUTH

Special photography by Debbie Patterson

The Taunton Press

To the visionaries who carried out their dreams with passion.

First published in hardcover in 1999

First published in paperback in 2001

1  3  5  7  9  10  8  6  4  2

Editor: Sally Harding
Art director: Polly Dawes
Photographer: Debbie Patterson
Picture researcher: Nadine Bazar
Copy editor: Allie Glenny

## Taunton
**BOOKS & VIDEOS**

*for fellow enthusiasts*

First published in the United Kingdom in 1999 by
Ebury Press Limited
Random House, 20 Vauxhall Bridge Road, London SW1V 2SA

The Taunton Press, Inc.
63 South Main St.
PO Box 5506
Newtown, CT 06470-5506
www.taunton.com

Distributed by Publishers Group West

ISBN 1-56158-568-8

Printed and bound in Singapore

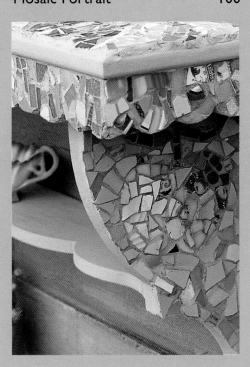

# contents

# Kaffe Fassett on Mosaics . . .

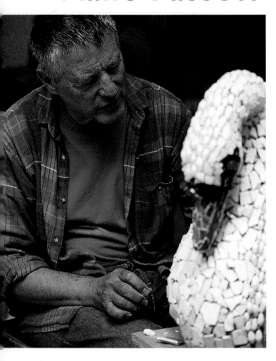

Mosaics first excited my vision a long time ago. All through my early years in California I was aware of mosaic on eccentric structures like Watts Towers in Los Angeles and small examples in San Francisco's China town. But what impressed me the most in those days were the personal mosaics of an artist friend of my family who covered walls, tables and window sills with keys, bottles, tinselly glass, beads and other unrespected materials.

Zev Harris built his whimsical palace of a house on a sand dune in California in the 1940's and named it Crazy Crescent. It contained walls that used coloured wine bottles instead of bricks, and a floor of up-ended blocks of wood in a variety of shapes. Every window sill and counter had mosaics which all complemented his many paintings and drawings. When my parents built a large modern restaurant on Big Sur's wild California coast, Zev made zany mosaic table tops to brighten up the wood and concrete structure.

When I came to England in 1964 I worked first as a painter, concentrating on still lifes. As my pieces became more decorative, depicting patterned china on patterned fabrics, my interest in any colourful pattern-work — such as embroidery, patchwork or mosaic — was fully awakened. Then I got well and truly stuck into textile making, first knitting, then needlepoint. More recently I went on to include patchwork in my textile repetoire.

Early on, I had met Candace Bahouth, an American shaking up the British scene with witty, beautifully observed woven portraits. Eventually I visited her studio, an old West Country chapel near Wells, and was delighted to find a kindred personal approach to decorated surfaces. The entire space was dancing with high colour at every angle. It was filled with needlepoint-covered furniture and draped with exotic fabrics and coloured yarns. Best of all were the bathroom, cabinets and shelves studded with mosaic fragments in jewel colours. I was so inspired by the delicious lift mosaic gave to household objects that I rushed home

ABOVE LEFT **Kaffe Fassett at work on his shell-covered** *White Swan Urn* **in his studio in London.** RIGHT **The mosaic-filled exhibition stand at the 1998 Chelsea Flower Show that Kaffe designed in collaboration with the Hilliers garden centre.**

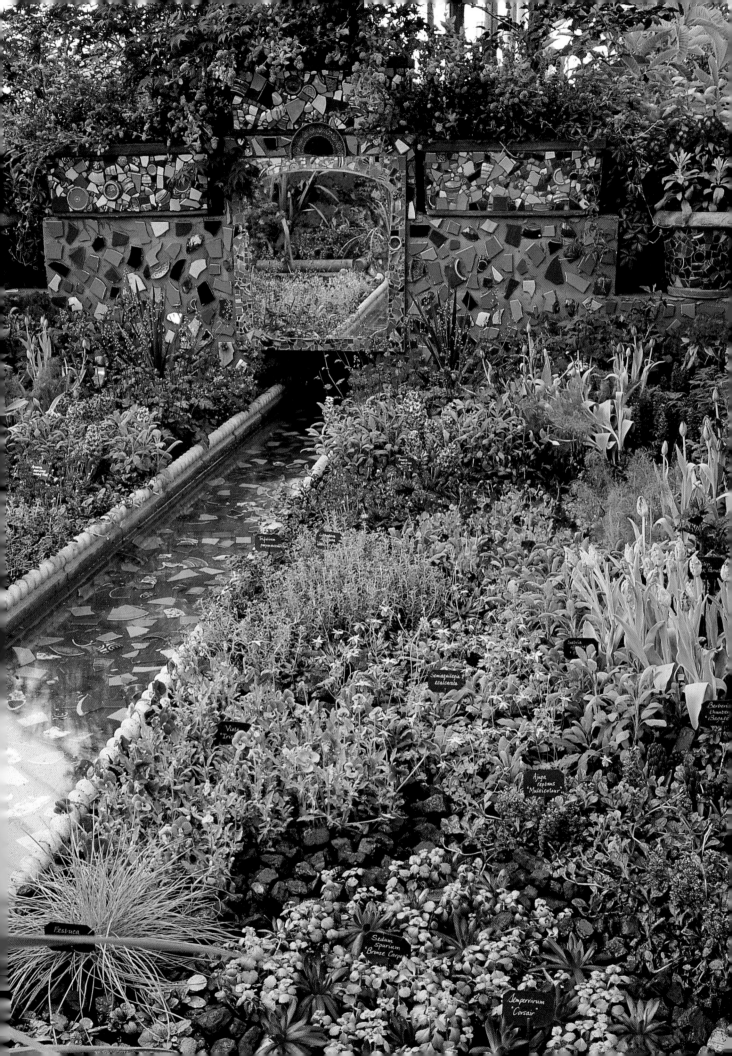

and started covering pots, lamp bases, metal plates and mirror frames.

As Candace branched out into garden urns, benches and best of all a shell grotto, I was impressed by her painstakingly careful placement and punchy sense of colour. Having been inspired by her to mosaic much of my house and garden, I jumped at the chance when she suggested our doing a book together on mosaics. We both have an amused fascination with the naïf, extreme decoration of every-day abodes, vehicles, and spaces. We have shared trips together, seeking out decorative art in other parts of the world, and light up at any special bit of design in unexpected places. Flights of fantasy and imagination, no matter how kitsch or bad taste, delight us!

The book project started just as we were both completing our largest mosaic commissions to date. Candace was coming to the end of months of work on her splendid grotto and I was installing my designs for the 1998 Chelsea Flower Show in London after a one-and-a-half-year preparation.

When asked to design the exhibition stand for Hilliers garden centres by Andy McIndoe, my first thought was bronze leafy plants! I've always admired how the British use bronze to add an elegant antique note to their garden schemes. To my eye, bronze looks best with deep rich tones, so a dark garden formed in my imagination. Mosaic to frame it would

**RIGHT** Hilliers' stand at the Chelsea Flower Show collonaded with Kaffe's richly mosaicked pillars and planters. **FAR RIGHT** Kaffe's pearly shell mosaics in the other section of the garden.

have to be equally dark and jewel-like to underline this dark mood; the usual seaside bright pastel would not do for this mysterious theme.

With deepness of tone in mind, I scoured my local car-boot sales and charity shops. Suddenly, the most hideous 1950's ochres, moss greens and brown tableware with naff motifs sprang to my attention and begged to be part of the massive columns and flower troughs I was planning. Cobalt blues, maroons, turquoise and black really brought the mood to a rich crescendo. Working in primitive spirals chalked on to columns made from two lengths of clay drainage pipes, I mosaicked contrasting groups of colours in spirals up the tube. I added ochre, followed by cobalt blue, followed by deep reds, being careful not to get too much bright red or any light yellows.

On the other two sets of columns I applied layers of contrasting triangles and a large primitive lattice with bright colours in each diamond shape. I kept these patterns on a large scale so I could do them in dynamic big pieces like saucer bottoms and sides of teacups, et cetera. Round terracotta flowerpots topped off the

columns and were planted to branch wonderfully over the sides.

Long troughs at the bottom of the garden were kept mostly blues and greens, and a mirror of blue and turquoises was placed to reflect back light. A waterway down the centre was strewn with broken shards in a rich palette, and the crowning glory was two cement garden swans covered in black mosaic. On both sides of the waterway, Andy McIndoe added a glorious symphony of dark plants which I separated with a lattice of black coal.

Candace inspired me again with her baroque use of shells. I decided to do

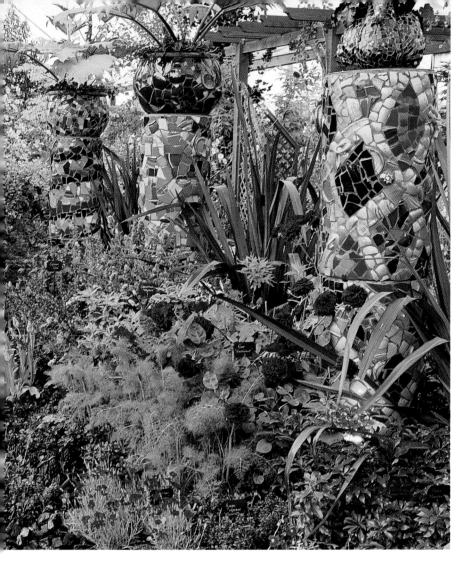

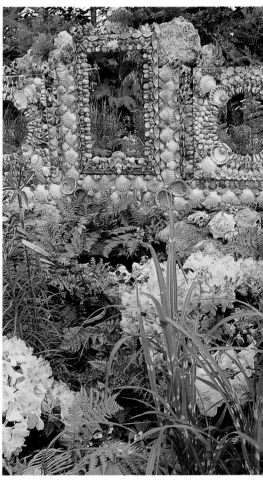

a second scene for Hilliers that would appeal to people who might find my dark garden a bit hard to take. We divided the available space into two sections so that the flip side of the dark collonaded garden was as pale and pearly as wedding cake. I covered three mirrors frames in rows of shells and extended those with primitive, but light-coloured rocks. Pools of water at their base were surrounded with pale green grasses and ferns, and peach and off-white rhododendrums.

The irrepressible urge in some people to decorate their surroundings is a never-ending fascination to me. Like them I am incapable of living in a plain unadorned space for more than a day or two. A postcard, a leaf, a bit of fabric, feathers, soon arrange themselves on my walls and surfaces quickly to be followed by flea market finds and friends' photos or drawings. Over time the desire for more permanent decoration leads me to paint flowers on cupboards and mosaic shards on window sills or front door steps. This obsession likes company, and I'm drawn to anyone who shows the same tendencies. Fascination with other 'humble decorators' (for these people often create with the least expensive means) partly stems from the fact that the rest of the world is so bereft of creative spirit. Quiet, detail-less little white rooms strike fear into my heart. There is no evidence of human potential there.

Mosaic is a medium that can utilize so much that is undervalued or thrown away in our society. The wonderful patterns created by repetition of rubbish-tip items remind us of elegant ethnic decoration. A simple spoon, key or cup handle repeated acquires a magic hypnotic musical rhythm. Once people start to play in this simple way, they spot opportunities everywhere. I hope this book can help to free the inner artist in you so you can find joy in expression.

# Candace Bahouth on Mosaics . . .

There has been a gradual and natural evolution in my work, from woven tapestry to needlepoint to mosaic. What these media have in common is the enchanting process of building up small areas of colour, whether with a thread,

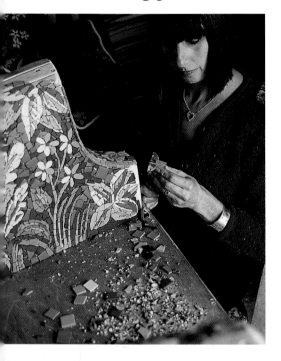

a stitch or a fragment. Woven tapestry first captured me with its potent colour produced by beating down a weft thread with a bobbin; the resulting quality of saturated hue is like nothing else. A natural extension was needlepoint, with its small dabs of coloured stitches multiplying into a whole composition. This in turn is not unlike mosaic, in which fragments assembled and arranged give birth to a picture or pattern. All a sequence of small happenings, a series of repeated elements, which when joined together express a personal vision.

The original exponents of the mosaic art – mainly Greeks, Romans and Africans – used black, white and coloured marble, stone tiles, coloured glass or smalti as their building blocks. It was generally fashionable to compose images of mythological subjects appropriate for the times, and geometric patterns and motifs. The delicate subtlety of early mosaicists communicates a personal view of daily life, encapsulating their hopes and dreams.

For me, mosaic is a declaration of faith. A belief that with a touch of imagination, a hint of humour and the ritual of 'doing', you can express your own fantasy. It is also quite a funky medium. There's madness in the process! The idea of gathering various bits, breaking them up and putting them back together again could be considered bizarre – even irrational! Yet there lies my fascination with the medium, the redemption of ordinary scrap, transformed into something extraordinary.

Using up life's left-overs is very dear to me, and justifies my feverish collecting. I find that the shattered remains of once useful items acquire an importance simply because they have been used or admired, but eventually rejected. Street fairs, car-

boot sales, and charity shops generated china that I could afford and, if accidentally broken, still save. True to my magpie nature, I have never been able to throw anything away and am constantly seeking ways to recycle my debris.

It must run in the family since my son Joseph is another accumulator. He also has a keen eye for the smallest detail and used to bring me delightful pieces of china from our garden or

ABOVE LEFT  Candace Bahouth fitting tiny shards into her throne-like *Tapestry Chair*. RIGHT  A shrine in Candace's magnificent grotto mosaic.

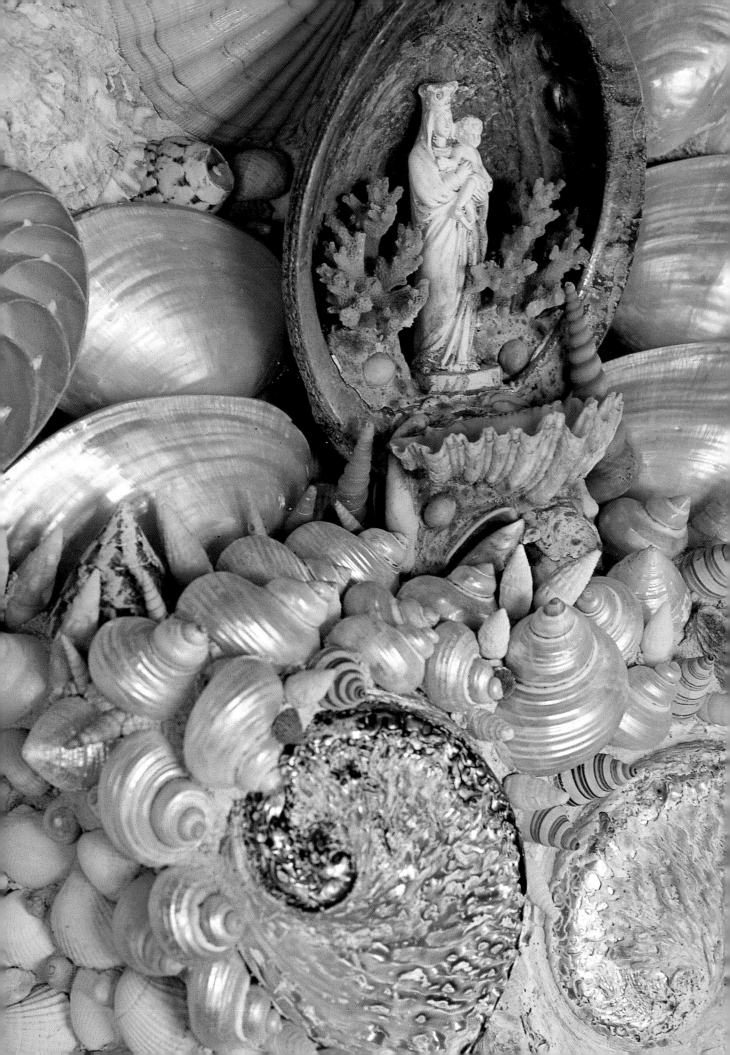

OPPOSITE PAGE A vaulted hexagonal grotto provided a perfect setting for Candace's theatrical creation. LEFT AND ABOVE Details of the gold-star studded blue sky and shimmering shell mosaic in the grotto.

the village stream. We would gaze in wonder at the varied patterns, these traces of the past. As I recall, our first mosaic was a windowsill covered in blue and white broken china. Things have moved on, but that first piece still brings great joy, as it's a sweet reminder of how it all started.

Richard Dennis, the ceramic dealer, gave me my first mosaic commission. At the time he was the owner of Moorcroft Pottery in Stoke-on-Trent. During an excavation for a new car park, a buried dump of old Moorcroft shards was discovered. Richard asked me to create a six-by-four-foot mural of the factory that illustrated the bottle-shaped chimneys, using the

exquisitely glazed shards from the tip. Because of his interest in disectology, he asked me to group the various patterns to allow interested collectors to decipher the numerous designs. The names – flambé red, Clarmont mushrooms, Eventide, sunray yellow, pomegranates, moonlit blue, et cetera – were as evocative as the tile patterns themselves.

Recently, a long cherished dream – to use my personal vision to create a whole environment – has been realized. It began one chilly, drizzly night, when a vaulted grotto room was revealed to me. It was hexagonal in shape, approximately five metres across, with water issuing from the

centre of an ammonite floor. Imagine my pleasure at being given free rein to compose an exotic, theatrical mosaic within this garden grotto.

The vaulted ceiling required special thought because of its cathedral quality and vast expanse. I felt that a gold firmament in a medieval blue sky giving way to constellations accented with raditating ribs of fractured gold would be heavenly and romantically poetic.

A great deal of time was spent researching and sourcing the materials, especially the gold. Various specialists produce gold tiles, yet the Italian gold-leaf glass squares proved to be the only plausible solution since they can withstand the abrasive grout.

I drew a small rough sketch, but nothing more, as I tend to rely on my experience, trained eye, some experimenting and holding the concept in my head.

My husband Andrew built a scaffolded platform and a high table for me to work from, rigged up lights, and covered the openings with polythene. We brought in ladders, bags of cement and sand, PVA, a heater and my ever-present radio.

Starting at the central boss – the 24-inch tunnel of light that connects the grotto with the tower above – I began to mirror its interior, then worked outwards. Physically the job was hard: up and down ladders, mixing mortar in buckets, grouting,

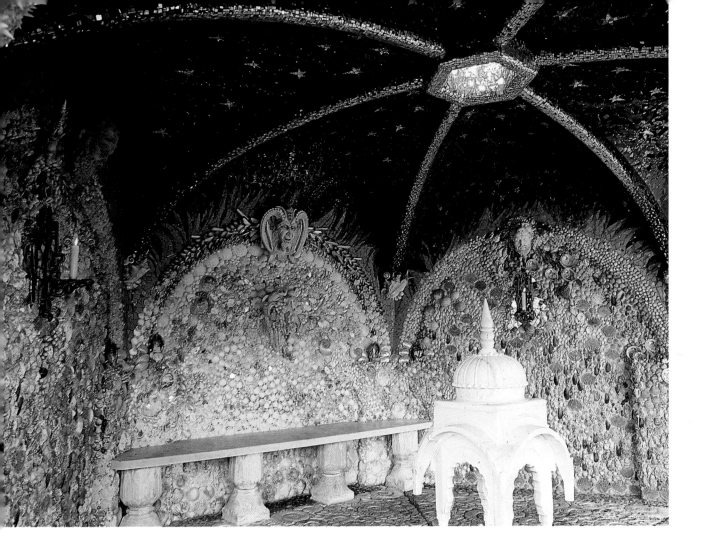

cleaning, head leaning back for hours on end, all in the damp and cold. But it was equally cheering watching the intense blue sky with gold stars exploding outwards from the centre.

When the sky was completed, we dragged out tea chests full of shells, which had been collected by the owners, to cover the walls. It seemed that there were masses, mainly oyster and scallops, but also unusual tropical beauties — snakeshead cowries, babylons, screw shells, pearly goldmouths, chambered nautilus and Asses ear.

As I began, it became obvious that to produce a feeling of encrustation I would require more specific shells, which I bought from Marine Arts in Penzance. Wanting the shells to have a directional flow, I fixed them from the top moving downwards. (In retrospect, it would have been best to start from the bottom, taking into consideration the weight of shells and mortar.) I also began on a side panel in order to gain more confidence before reaching the prominent centre.

Johan Engels, an opera set designer, who conceived the whole folly from the outset, was a tremendous support and a guiding mentor. His finely tuned creative eye and confidence in me were so valuable throughout the seven months it took to complete this glorious celebration.

'A match made in heaven' was declared when my good friend Kaffe Fassett agreed to collaborate on this book. We bring our own individual styles, yet complement each other perfectly. Kaffe mainly uses larger elements and a different colour palette; working very fast, he produces dramatic, theatrical effects.

Hopefully you will be motivated by the diversity in this book, comforted by our relaxed approach to technique, seduced by our enthusiasm, tempted by the countless possibilities of the medium, and encouraged and stimulated to find your own voice with which to Collect, Compose and Create.

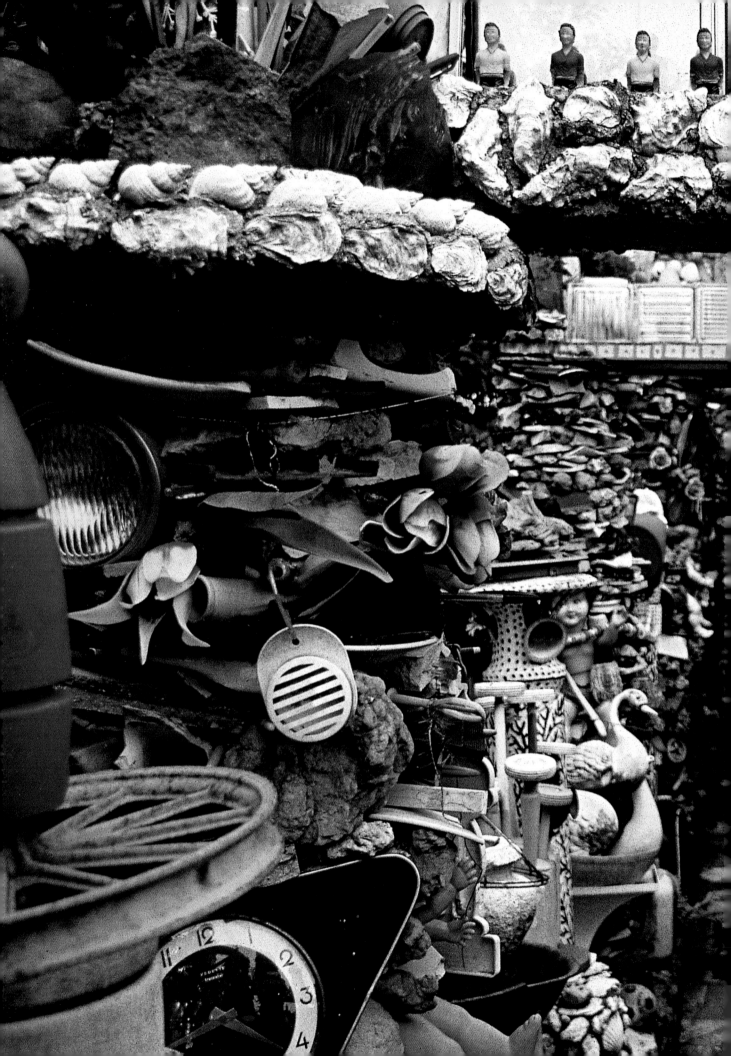

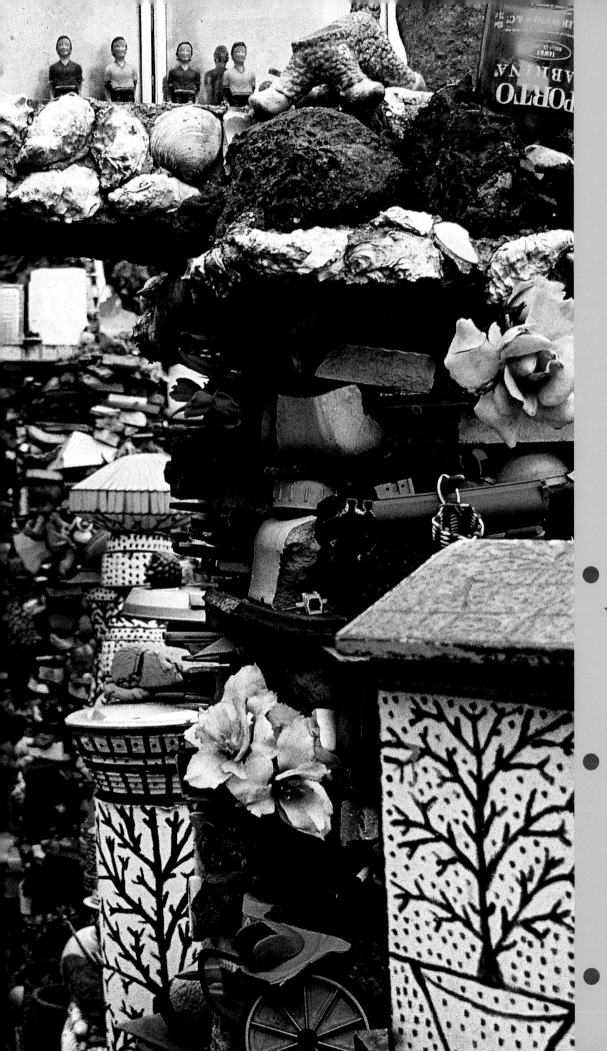

inspirations

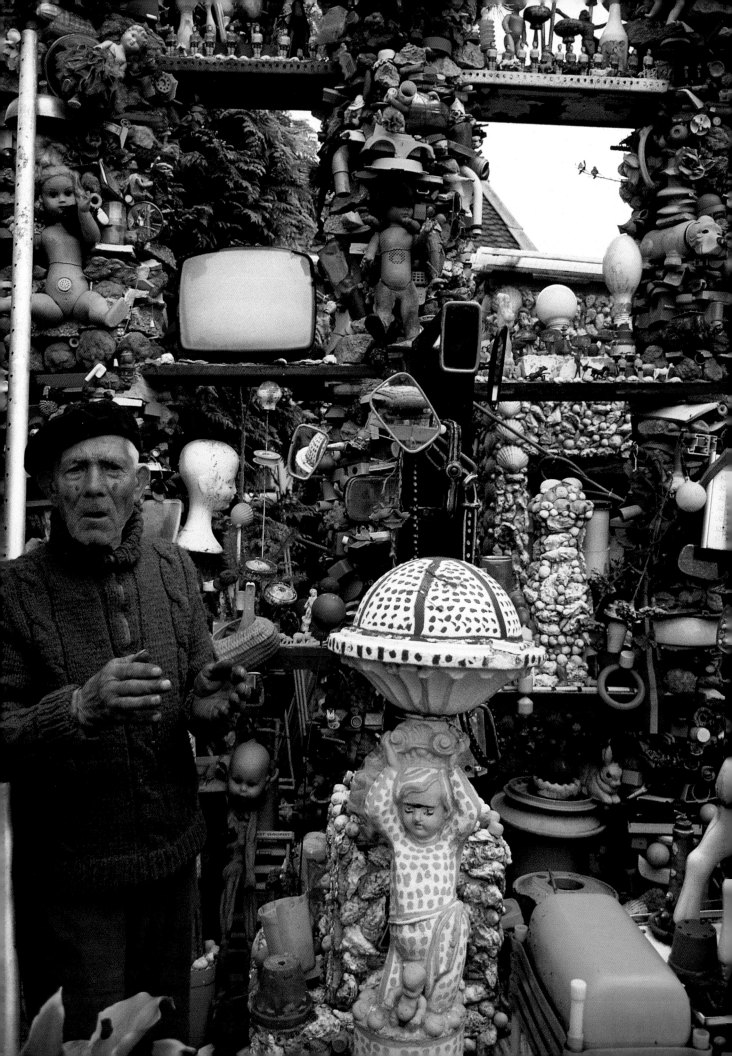

Drawing from the work of a wide range of artists, Kaffe and Candace present here the creations that have inspired them.

**Candace Bahouth:** I'm thrilled that we have included Bodham Litniandski's Jardin de Coquillage in our selection of mosaic inspirations. You know that 'junk' gardens are a passion of mine. They hold a joyous meaning: those moments when someone makes their own world, their own personal order out of what others have disregarded or cast aside. I agree with Thomas Edison who said, 'to invent, you need a good imagination and a pile of junk!' And there is such diverse junk here – layers of bicycle wheels, plastic dolls and flowers, chains, radios, TVs, shells, stones, car lights, mirrors, lampshades, clocks, the shattered and discarded remnants and clutter of modern life. If these were his trophies, what on earth did he reject!?

**Kaffe Fassett:** I'm not as big a fan of this garden as you are. Looking down the crowded walkway I get the same feeling of claustrophobia I feel viewing New York from a tall building. But it is horrendously fascinating in its dense texture of dolls, machine parts, wonderful painted objects, and the primitive patterns daubed on as if some more detail was sorely needed. And I do think it is commendable for its bold use of three-dimensional objects to create the edifices.

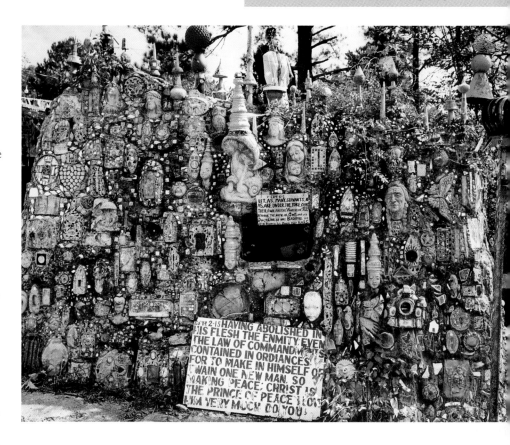

**CB:** Yes, and it may appear higgledy-piggledy at first glance, a completely random selection of jumbled objects, but it is these encrusted pillars that give it structure and create order in the chaos. To me the whole collection resembles a wonderful old hand-tinted engraving. What do you think of Paradise Gardens? My brother, who lives in Atlanta, Georgia, introduced them to me. They are the Reverend Howard Finster's personal vision of the garden of Eden.

**KF:** The wall in the picture we have chosen of the gardens is pure theatre to my eye! A sprawling puppet show of faces and heads studded with mosaic jewels. It is also very much a religious temple with a wondrous variety of turrets. You have the feeling

LEFT AND PAGES 15 AND 16 Jardin de Coquillage, the garden of Bodnam Litniandski in Vitry-Noureuil, France. ABOVE Paradise Gardens created by Howard Finster in Alabama.

the whole wall could lift its skirts and dance off into the mist with the tinkling of bells. I've always loved using the human face to decorate rooms, et cetera, and all these heads must be amazing to stumble across as you enter the garden.

**CB:** They are, and the juxtaposition of the sacred and profane is striking as well. Finster's message is very direct, patriotic, southern, moral and, as you mentioned, spiritual. He is spreading the gospel with verses such as 'walk down the golden streets is really the

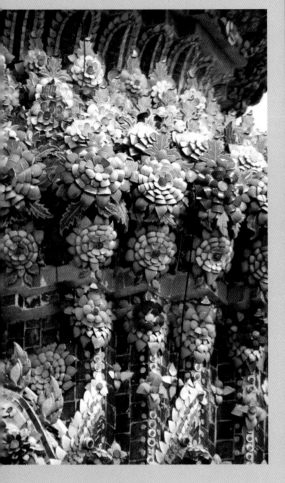

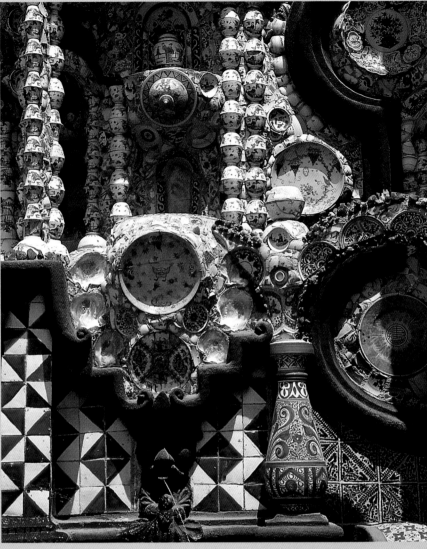

choice to make' and 'cover the world with the word of God'. The words are enhanced by the seemingly junky creations strewn throughout his plot of land. This hodgepodge, eclectic environment is full of edifices 'decorated' with clutter – bottles, tools, machine parts, glass, toys, cars, buttons, lumber, wire, spark plugs, marbles, hubcaps, iron pipes, TVs and so on. He must have been compelled to generate and forge his view every moment of his life. Finster and Litniandski are similar in what they are

trying to convey – that one man's rubbish is another man's treasure!
KF: Moving on to mosaic inspiration made from ceramic pieces, I find the Bangkok Palace Temple three-dimensional mosaic flowers are really lush. How wonderfully frilly this porcelain appears! The explosion of crockery on the Mexican risco fountain shown here also retains a light touch. This is the best example I've found of the use of whole plates, lids of jars, and wine cups. What amazes and thrills me about it is the

ABOVE LEFT Mosaicked flowers on a temple in the Royal Palace, Bangkok. ABOVE AND RIGHT A risco fountain in Mexico City, begun circa 1740 and made up of Mexican pottery and Chinese porcelain, including Ming.

obsessive laciness of all those plates and cups within such a masculine baroque frame. The delicate oriental patterns on so many different-sized plates and saucers is underlined by the bold blue and white geometric tiles at the base. What extravagance!

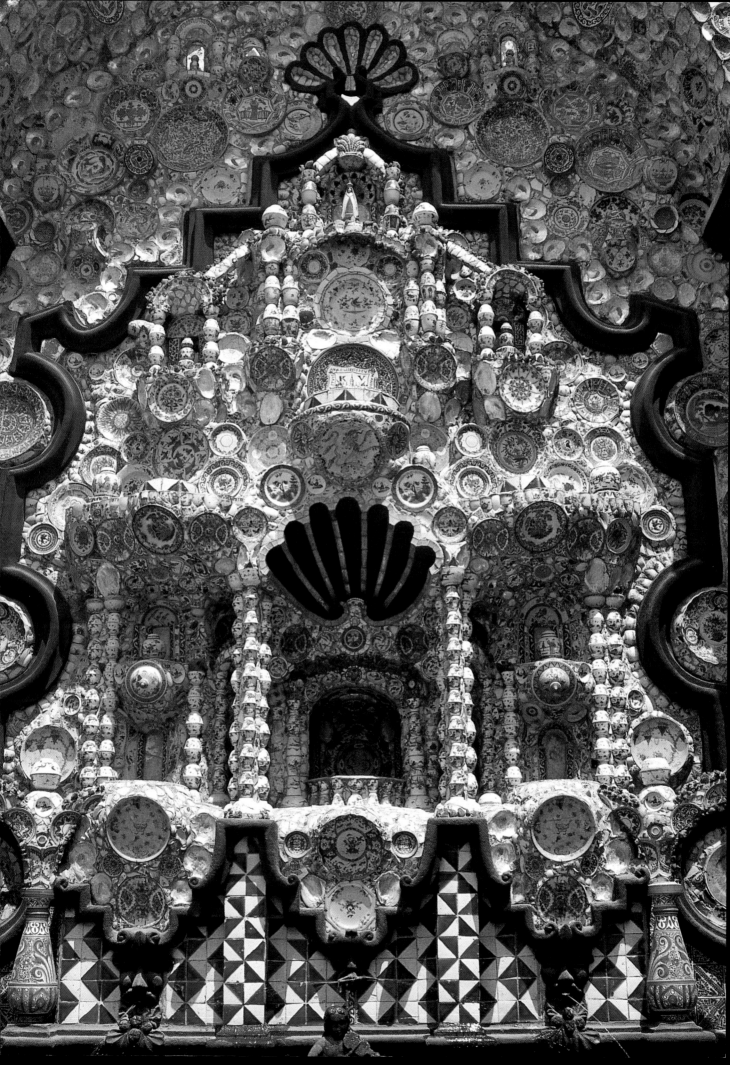

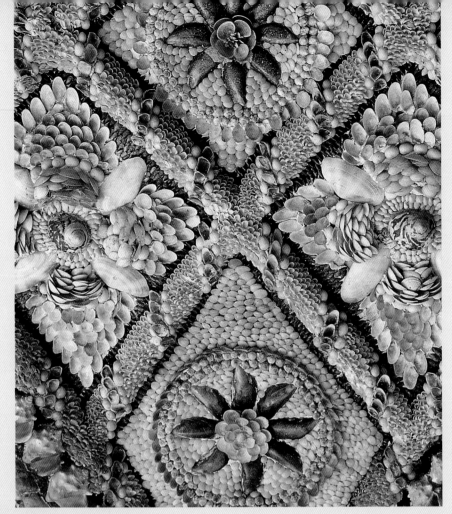

I can only suppose that the stunning dishes were a dime a dozen then or that the fountain was built by a pottery importer. They are used as extravagantly as shells you'd pick up on a beach. But the most exciting thing to me is the way not a square inch is left without a detail, yet how wonderfully balanced the mirror image effect is. It is like the brilliant seamless circus act of someone juggling while perched on a parasol carried by a bicycle rider.

**CB:** Your Mexican fountain, Kaffe, is so encrusted and very pretty. I think the juxtaposition with the geometrics at the bottom works well and throws the whole frothy concoction into

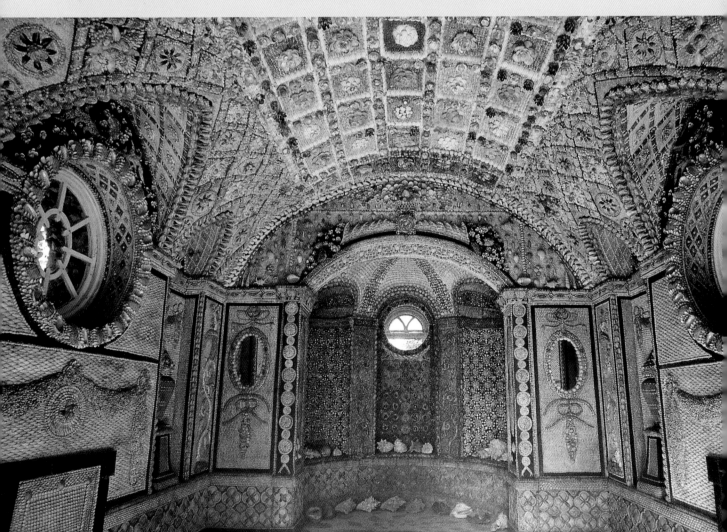

another realm. I can see why you're in rapture about it; it's chunky and the egg-cup shapes, whole plates and lids amplify the depth.

Did you know Kaffe, that the shell room we both like was begun in 1739 by the Duchess of Richmond and her daughters, who spent seven years weaving these intricate lacy shellwork patterns? It is our most ordered and harmonious inspiration and a systematic and clever use of hundreds of thousands of nature's water-babies. The prominent colour is a delicate shell pink, but one can also see orange scallops and dusty blue mussels. The glow of the shells is strengthened by the glitter of mirrored glass. It's a classic example of astonishing restraint and skill – having an almost mathematical precision.

**KF:** I think one of the secrets of this confection is the very delightful complex shapes that lies under the shell encrustation. The arches, round and oval window openings with deep frames, and the domed ceiling are exciting architectural shapes to frame and drape with shell garlands and so forth. This room is like a beaded, bejewelled box that creates visual music! As with the china-covered risco fountain, there are no blank areas here.

**CB:** Ferdinand Cheval was another festeringly driven creator – another man living on the margins of society, for whatever personal reasons, yet

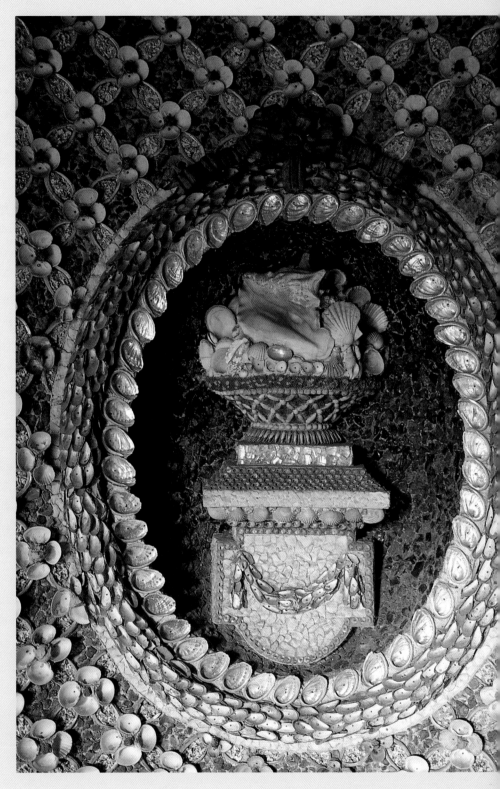

obviously obsessive and tenacious! What strikes me about his creation is the raw energy; the perseverance to give years of his life to one project, daily bringing home sacks of stones,

OPPOSITE PAGE Shell mosaics at Goodwood Park, West Sussex, England, made between 1739 and 1746. ABOVE A shell mosaic at Rambouillet in France.

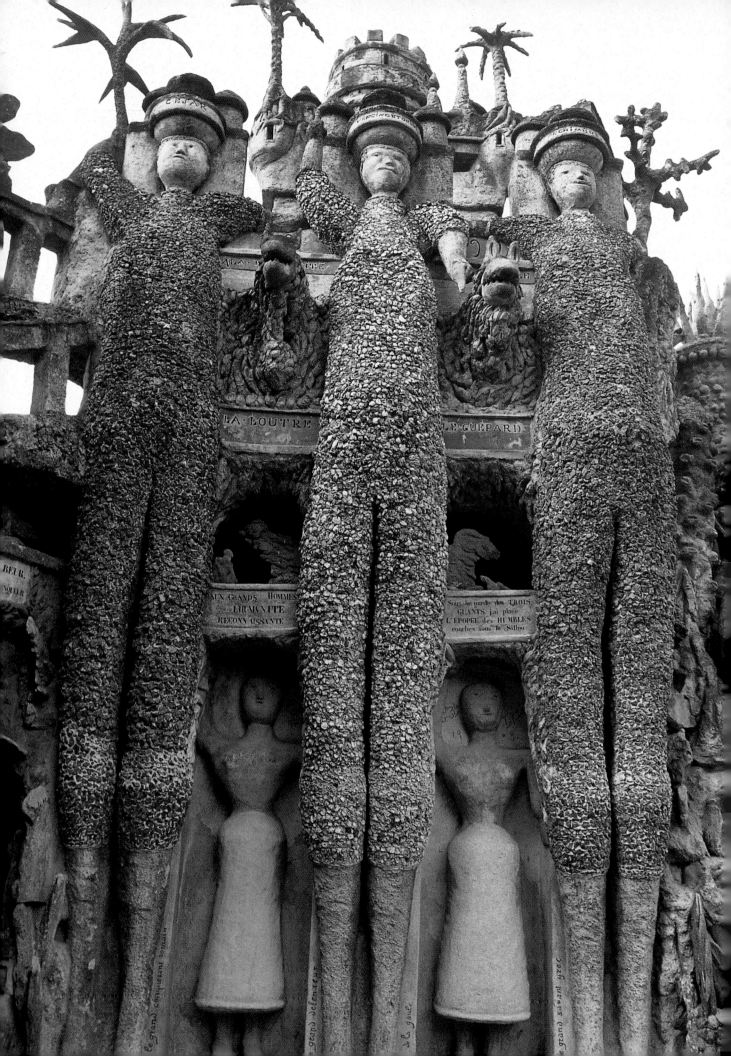

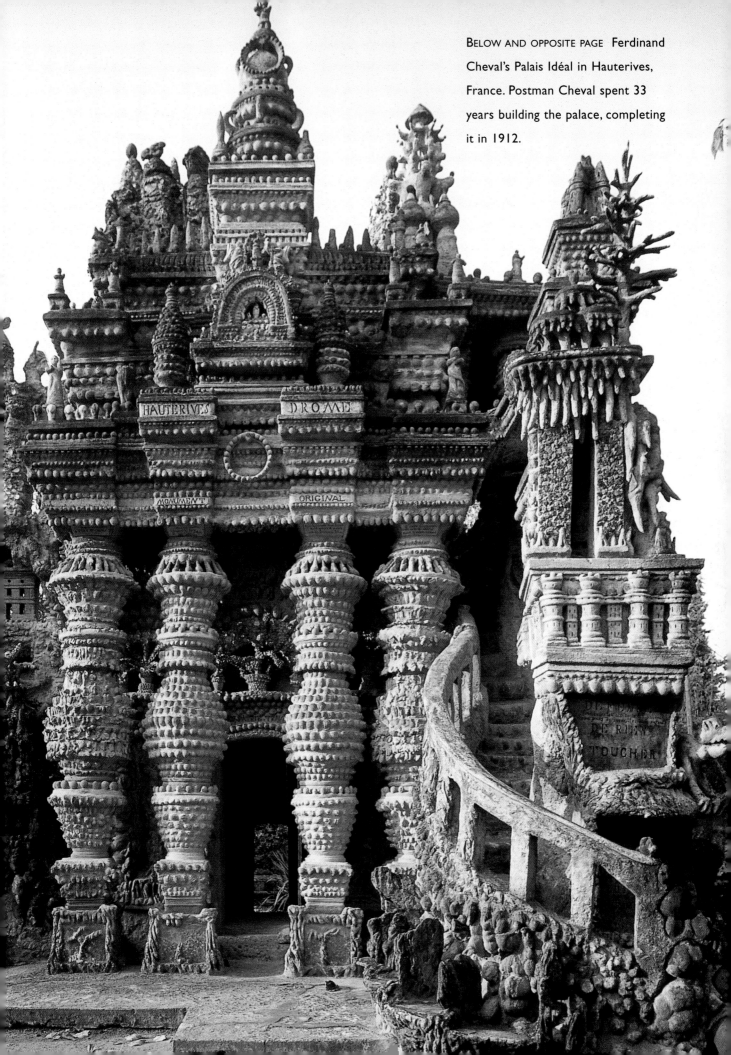

BELOW AND OPPOSITE PAGE Ferdinand Cheval's Palais Idéal in Hauterives, France. Postman Cheval spent 33 years building the palace, completing it in 1912.

BELOW AND RIGHT The mosaicked carpet covering Rudolf Nureyev's tomb in a cemetery in Sainte-Genevieve-des-Bois outside Paris. The monument was designed by sculptor Ezio Frigerio who collaborated with Nureyev for many years, designing ballet sets, and executed by a workshop in Ravenna.

pebbles and fossils and alone setting them into cement mortar.

**KF:** There are many of us who would instantly identify with Ferdinand Cheval, this French postman who fell in love with pebbles as he made his rounds. How often have you spotted rocks form all over the world in people's homes and heard of their fondness for each one? I myself, have collections of unputdownable stones that have been gathered on beaches and mountain tops, so I can do nothing but salute in admiration Cheval's great pebble-studded temple. How miraculous to have the passion to carry through with this dream palace even though it took thirty-three years of hard solitary labour. Emptying his pockets each evening, he'd often work deep into the night placing his finds like jewels in a tiara.

**CB:** Another wife left alone I suspect, with him working into the early hours like that. But what I love about the Palais Idéal is its intense organic pagan adoration of nature: elephants, monsters, reptiles, octopus, rams, camels, trees, fountains, all swirling, intertwining, undulating, It's a cave, a nest, a temple, a castle, a utopia, a paradise, a reunited view of the world, a place of rest; possibly the place where he was most content and yet animated in his zealous task.

**KF:** Cheval was not versed in building architecture or sculpture. He simply had a vision and did his best to carry it out. His work is just one more example of how emotion can overcome lack of knowledge and training when it comes to realizing our inner dreams.

**CB:** Remember our long excursion to the Russian cemetery outside Paris to find Nureyev's tomb? Remember walking deep into it, being struck by

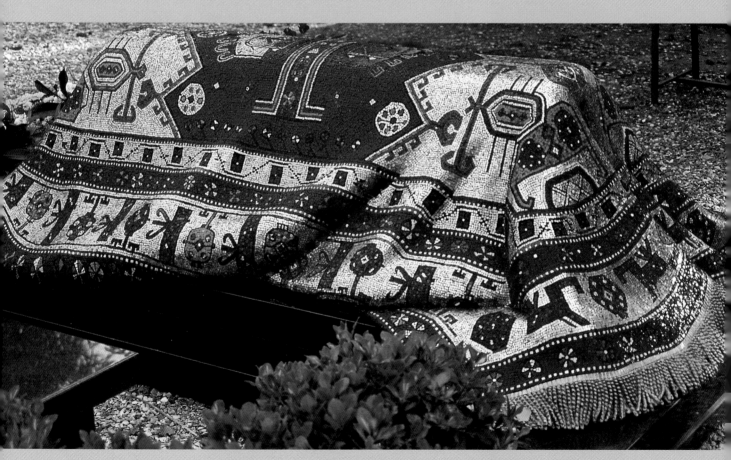

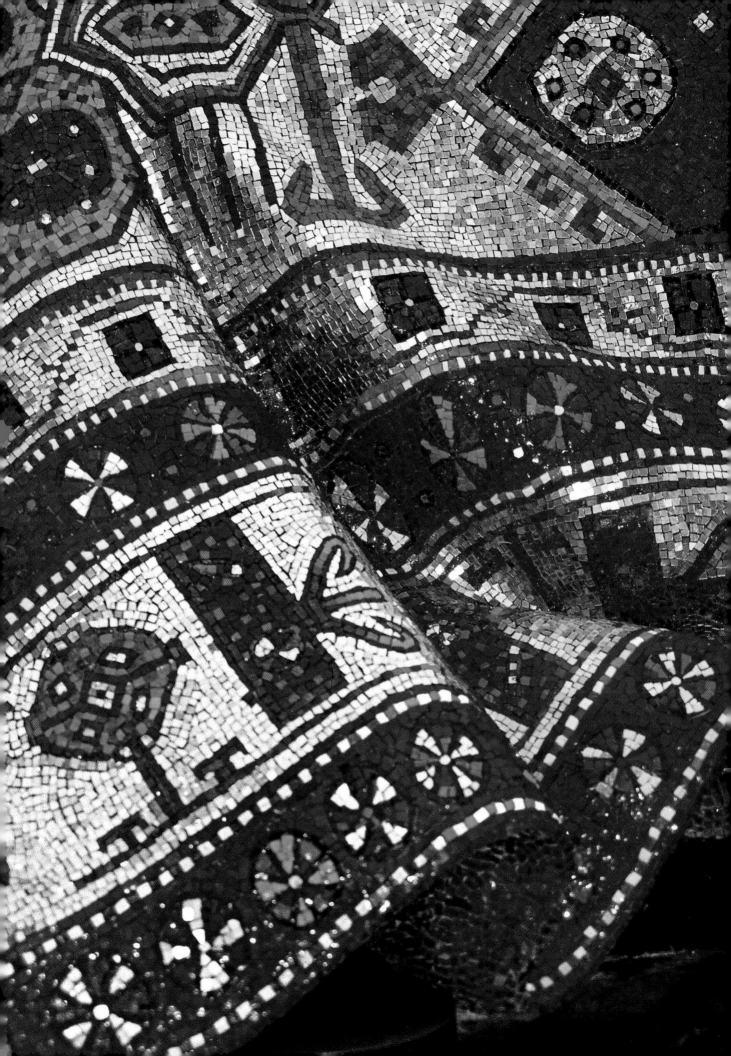

the closeness of the tombs, our eyes darting back and forth, not to miss what we had come to see? Suddenly we were confronted with the blinding vision of a large glittering gold and maroon draped mosaic carpet, evoking the shape of an ancient sarcophagus. This must be a favourite of yours Kaffe, as it's pure theatre.

**KF:** First of all, I love carpets, especially flung over couches, chairs and tables — but to drape a grave seems to me inspired! When I first saw a picture of Nureyev's tomb I thought 'what a good way to celebrate someone by draping the grave with their favourite carpet, but how long can it last?' Then when I realized the large sensuous folds and luxuriant fringe were made in fine smalti mosaic, I was on my knees with wonder and admiration. The smalti, even when close up, appears so textile-like.

**CB:** I admired that as well — the graceful folds looking so soft and fluid. The beauty of the Nymphaeum at Lainate for me also relates to a woven fabric: the pebbled designs are reminiscent of striking sixteenth-century damask or brocade. What a marvel these dozen pebbled rooms

RIGHT  A pebble-mosaicked room in the sixteenth-century Nymphaeum in Lainate outside Milan. The mosaic patterns are composed of black limestone and white quartz.

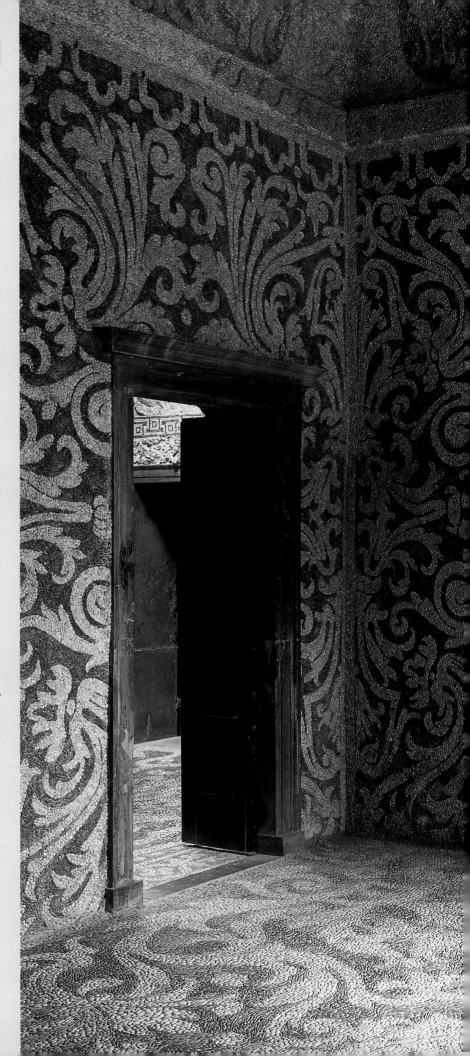

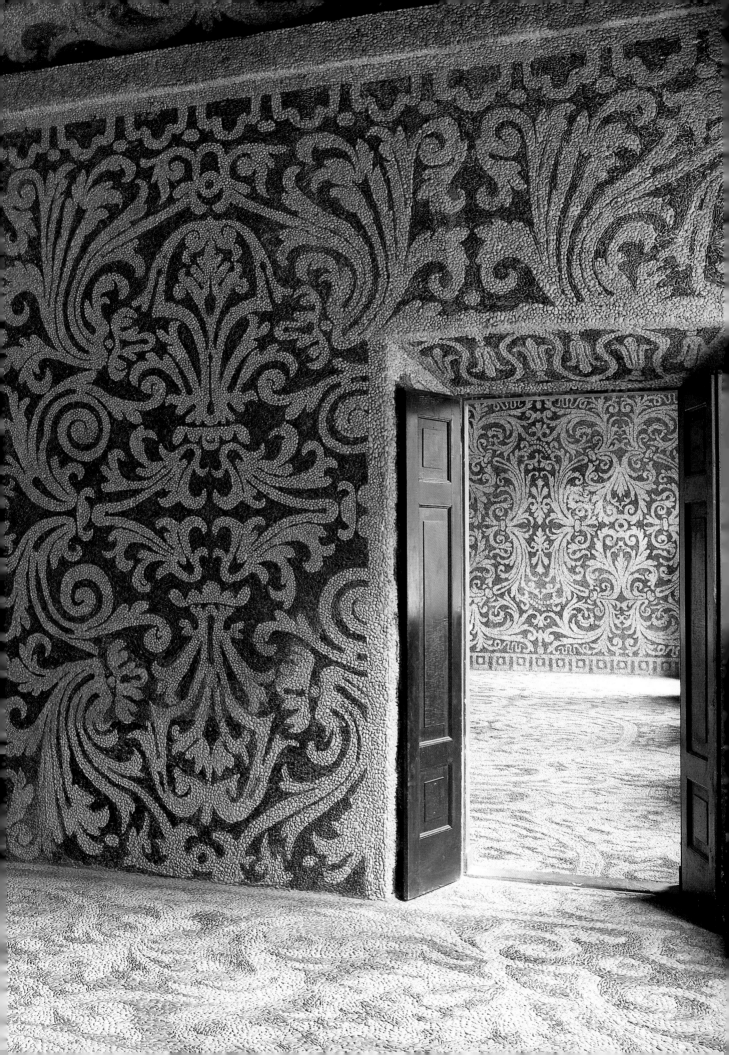

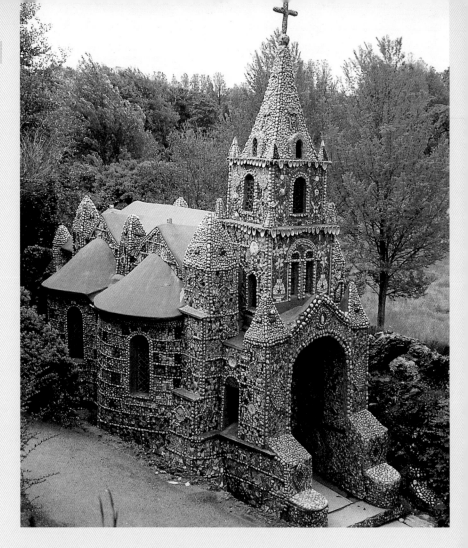

RIGHT AND OPPOSITE PAGE The chapel in Les Vauxbelets, St Andrews on the island of Guernsey in the Channel Isles. The chapel is covered inside and out with mosaic of broken ceramic and shells.

are, each different in detail yet displaying the same balance between black limestone and white quartz pebbles. The skill in execution of the mosaic is extraordinary.

KF: Whenever anyone complains that they can't get started with a project because they can't get the materials, I want to take them to rooms like these! Just find some dark and light pebbles and cover your house, floor, ceiling and walls with bold brocade patterns and you have one of the most elegant spaces ever known! I'm nearly always on a quest for the most complex colour in any subject, but the viewer would have to be blind not to recognize how stunning this restrained decoration is. Because they are natural stone, these walls would gradually reveal many subtle shades of white and black as you lived with them.

CB: The shimmering chapel in Les Vauxbelets on Guernsey has another stunning interior. It could be mistaken for the pearly gates waiting room! At any moment St. Peter might appear with his jangling set of celestial keys. The highly glazed and shell-covered

encrustation charges the atmosphere with an overwhelming luminescence. The play of light on the chunky pieces around the curves adds an exuberance and iridescent quality to this place of adoration.

KF: Yes, the colours are so ethereal. I can't help feeling this place was put together with the inspiration of an intense love. The choice china bits in the mosaic combined with shells and glass make the mosaic very special indeed. The overall pattern is wonderfully human with the primitive softness of the rendition. It almost feels like a rag-rug approach. When I saw the outside of the chapel I was knocked sideways by the fact that a

gem-filled interior would have such a highly detailed exterior as well.

CB: Do you remember Kaffe, as we walked through the narrow entrance to Raymond Isidore's house, hung over with wisteria, how touched we were by this man's delicate vision? I could have wept with joy at his innocence, the love and tenderness expressed in his work. It was as if hundreds-and-thousands sweets were sprinkled all over the exterior walls. On closer inspection, there were exquisite individual bits of crockery, glass, teapot lids, spouts, handles, figurines, painted tiles, et cetera, that he first gathered for 'their colour and sparkle'. There were birds in smashed

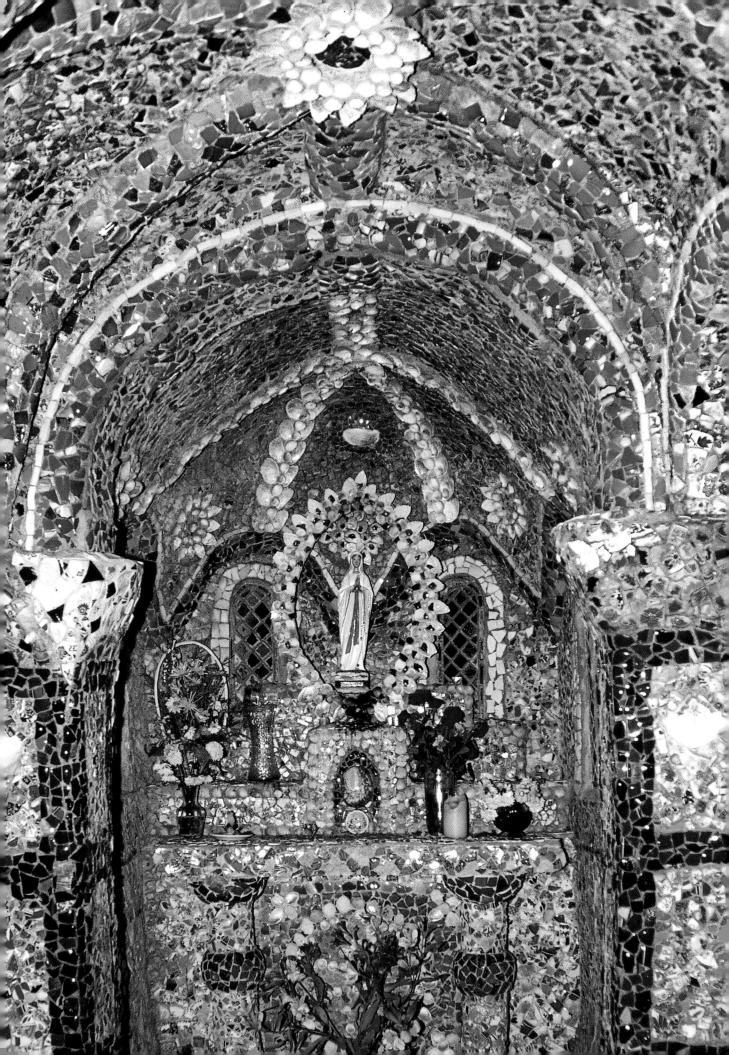

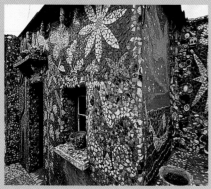

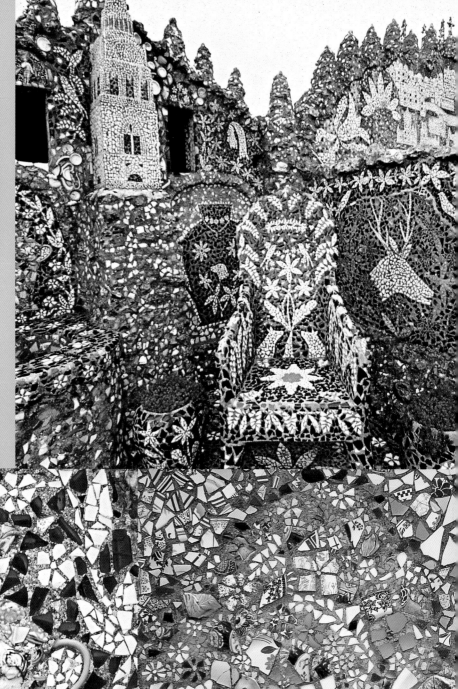

THIS PAGE AND OPPOSITE PAGE Mosaics at Raymond Isidore's house, Maison Picassiette, in Chartres. Isidore (1900–1964) covered both his house and garden with mosaics, including interior and exterior walls, furniture and even a large kitchen stove.

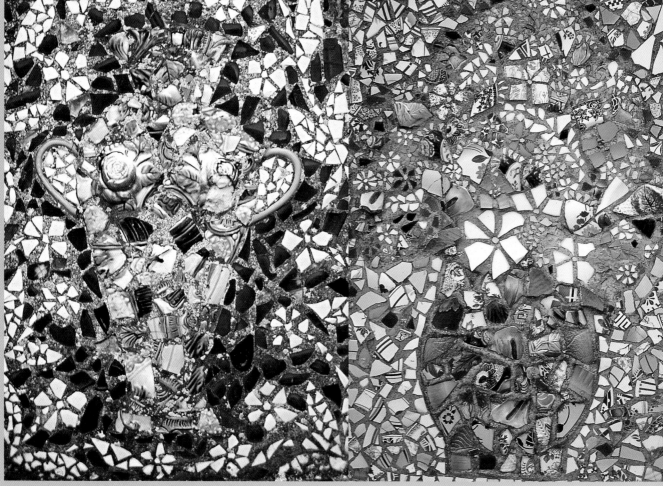

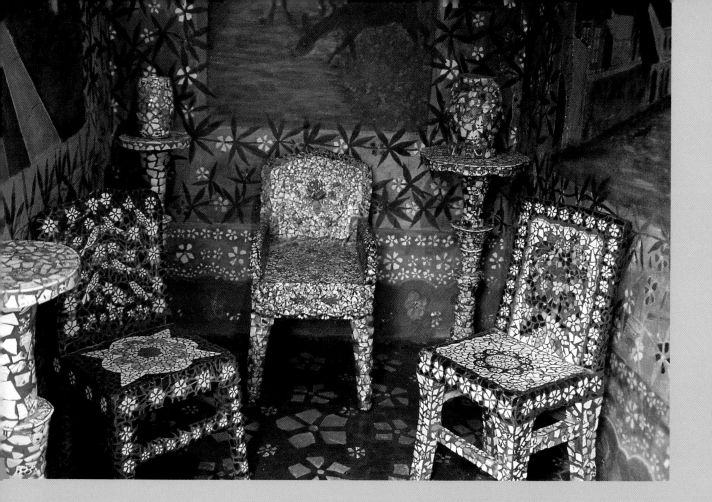

pink china, madonnas, hands, baskets, vases – an overall fairyland of dots against dark mortar.

**KF:** I like the vigorous big pieces of patterned china along with the tighter finer areas. Some of this mosaic is almost as loose and quickly done as mine, I was relieved to find. Our styles meet in the Maison Picassiette. The indoor and outdoor mosaicked surfaces completely charm me. One day I'd love to completely cover a small house like this, and Raymond gives me the courage to believe it would work.

Raymond Isidore's mosaics started to inspire me in my childhood when artist friends of my parents raved on about the amazing mosaicked house in Chartres. Isidore's desire and willpower to cover every surface with fragmented dancing pattern makes him a kindred spirit to many mosaicists that inspire us.

**CB:** Can you imagine the amount of broken crockery it would have taken to cover the paths, walls, courtyard, furniture, floors, ceiling, beds, stove, pots and sewing machine in this pointillist effect!?

**KF:** Niki de Saint Phalle is another visionary who had the confidence to realize her fantasy on the grandest of scales. Her work first came to my notice when she produced a giant woman in brilliant coloured paper mâché that was big enough to walk into. Now I see she has produced a whole landscape of buildings in the shape of giant figures, constructed in more permanent cement and mosaic. The garden's mirrored sky scraper, huge masks the size of houses, and sphinx-like lady with windows in massive breasts are all impressive. And the passageway studded with outlandish columns hints at the amazing detailed surfaces everywhere in this garden.

**CB:** I'm usually very excited by Saint Phalle's bold, direct and larger-than-life work, and her garden certainly wakes you up! Like a travelling fairground, it appears transient and frivolous yet has an electrifying, entertaining, garish and seductive impact.

**KF:** I think it is really extraordinary to see walls and columns as expressive as sequinned and bejewelled circus costumes. Imagine stumbling across

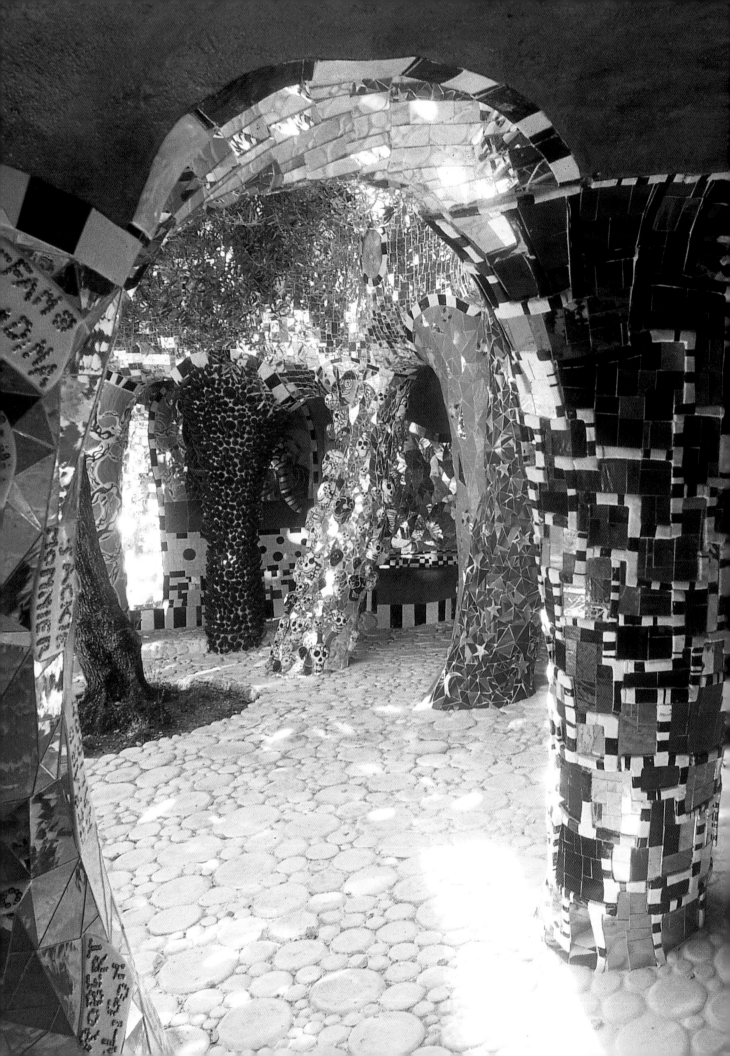

**ABOVE AND LEFT** Richly mosaicked pillars and a building in the shape of a giant figure in Niki de Saint Phalle's fantasy garden.

this apparition in a mist! Surely children would dream of this sort of manifestation for the rest of their lives. The blue mask building appeals to the surreal in me. I've always enjoyed faces in architecture, but this is face as architecture! Bravo!

**CB:** The most important thing about the zany cars we have chosen for this chapter of inspirations is that they are accessible to the general public and aren't exclusive. These fantasy cars really stop people in their tracks! They

**33**

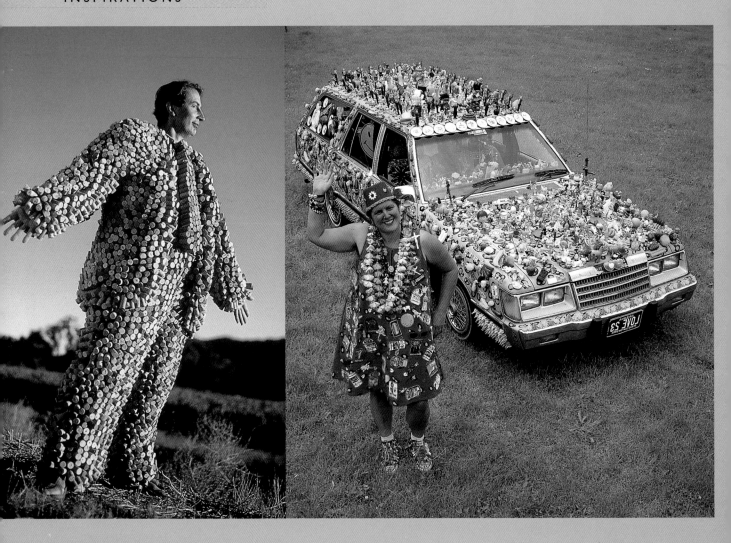

are festooned with all manner of knick-knacks: beads, lights, grass, religious icons, coins, plastic fruit and toys, cutlery, buttons and bells, shoes, flamingos, yo-yos, rubber nipples, family crests, statues, dolls – all manner of clutter.

**KF:** These cars display the spirit of personal obsession that has lit me up all my life. Whenever I stumble on a cheap crammed junk shop or rubbish dump, or spot piles of bottles discarded nightly by bars, my mind goes into gear figuring out what I could make of these raw materials. These magnificently inspired souls

obviously share my urge, and they have brought their found objects to glorious conclusion by using them to decorate their cars and in some cases themselves as well.

**CB:** In common with most bizarre forms of expression, these wacky, decorated cars are usually made by eccentric individuals living on the edge of mainstream society. They enjoy the ensuing performance and revel in their desire to be different. The owners are not only saying something about themselves, loud and clear, but their work is also their personal quest for expression in a

**ABOVE AND RIGHT** The work of magnificently inspired souls in the United States who have a passion for covering cars and even clothes with unusual tesserae like spoons, dolls, toys, buttons, medals, corks, plastic fruit, beads and marbles.

world that is becoming rapidly uniform and homogenized.

**KF:** And like every other decorator in this chapter they leave no empty areas. I used to say in my lectures when talking about my encrusted knitting patterns, 'I'm always nervous of restful spaces.'

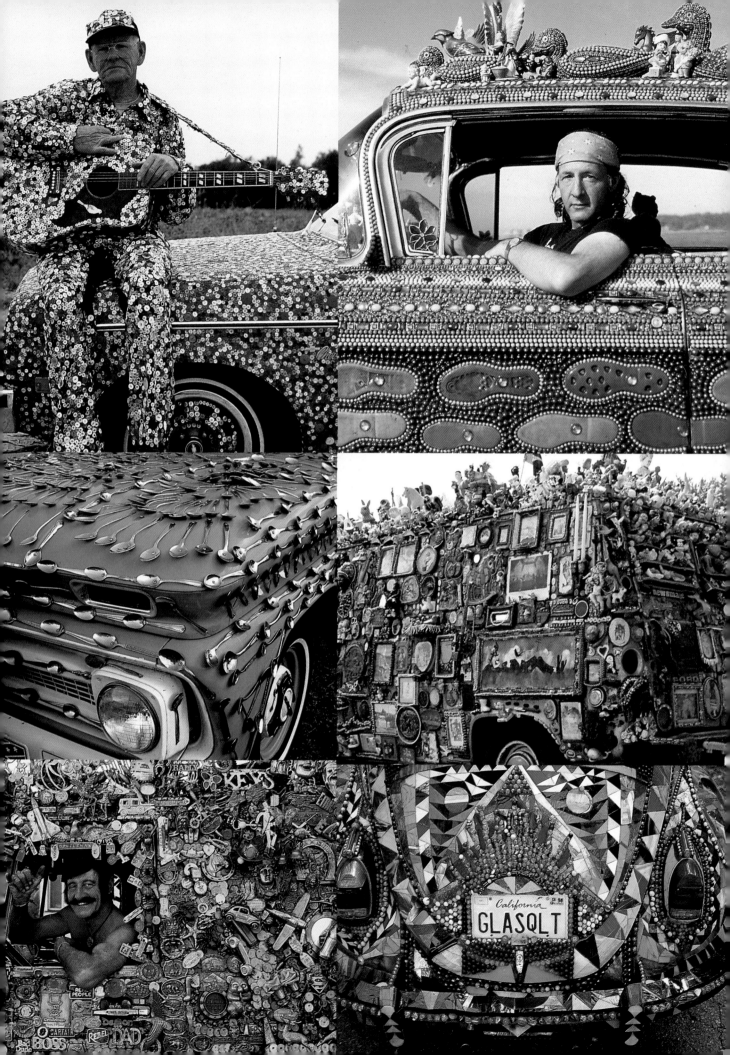

making mosaics

The ease and speed of execution and the beauty of the results make mosaicking one of the most enjoyable of the decorative arts. This chapter provides all the basic instruction you'll need to make a mosaic. Starting here with a detailed explanation of tesserae, the chapter covers everything from choosing a suitable base to how to cement and grout your design.

## Selecting and collecting tesserae

Tesserae are the individual units that are arranged to form a mosaic. The word used to bring to mind only little square tiles like those found in early Roman mosaics or those so common in modern swimming pools. But tesserae in contemporary mosaics have escaped the boundaries of this small geometric shape. Today the term covers a wide range of materials in an even wider range of shapes – anything, in fact, that could be pieced together to form a 'mosaic'.

The tesserae used for the projects in this book display a broad selection of both popular and unusual mosaic textures. They include broken china, tiles and mirror, shells and beads, as well as the traditional small mosaic glass and ceramic tiles. The most ancient of all tesserae – pebbles – make their appearance in the frame on page 69, the table on page 140 and the mural on page 145.

### Traditional tesserae

There are several types of small tiles that are manufactured specially for mosaic work. Fashioned to imitate the traditional cubes that appear in ancient Roman and Byzantine mosaics, they can be purchased in craft or tile shops that sell materials for mosaics.

Though most of these tesserae are exact squares, they are more versatile than they first appear. Because they are made specially for mosaics, they are usually quite easily cut or nibbled into any shape. Or, left as they are, they can provide an effective contrasting border for more irregular tesserae. Also, the range of colours and even materials these tesserae come in seem to be increasing as the popularity of mosaic grows.

Here are the most commonly available 'traditional' tesserae:

• **Glass tesserae** include vitreous glass, gold and silver leaf tiles, and smalti. *Vitreous glass tesserae* are non-porous, frostproof, stain resistant and durable, which makes them very popular for bathrooms and swimming pools. Mosaicists like them for decorative work because of the large colour range (some colours even come with metallic streaks or veins) and because they are easy to cut.

Although they are manufactured in a few sizes, the vitreous glass tiles most commonly available measure 2cm (¾in) square by about 3mm (⅛in) thick. Only the face of each tile is flat; the reverse side has bevelled edges and is ridged to enhance adhesion. Some craft shops sell small bags of these little tesserae either in a single colour or mixed. However, those sold pasted face down to brown paper or to a plastic mesh are more economical.

*Gold and silver leaf tesserae* are relatively expensive, but used sparingly in a mosaic make beautiful highlights. Found in Byzantine mosaics of the fifth and sixth centuries, gold tesserae sometimes covered large areas and were set in the cement at angles so that they appeared to shimmer. Today gold and silver tesserae are manufactured in 2cm (¾in) squares about 4mm (³⁄₁₆in) thick. They are made by pressing metallic leaf between two layers of glass. The top layer of glass is thin and transparent to show off the gold or silver and the underneath layer thicker and coloured – green for gold leaf and blue for the silver. These highly reflective tesserae are available with flat or attractively rippled surfaces.

*Smalti* have a very long tradition in mosaics, dating back as early as the Roman era. Still handmade in Italy today, they are irregular rectangles of opaque glass coloured with metallic oxides. Smalti are usually about 1cm by 2cm (⅜ by ¾in) in size and about

1cm (⅜in) thick. The way they are made explains their pitted, irregular and very reflective surface. First, coloured molten glass is poured on a flat surface, then it is pressed into a 1cm (⅜in) thick circular slab and finally split by hand into small rectangles. It is the uneven cut sides, with their hardly visible tiny airholes, that are used face up in the mosaic. The disadvantage of smalti is that they are slightly harder to cut than vitreous glass. Also, it is not advisable to grout smalti, since grout gets stuck in the tiny holes and can discolour the tesserae. (Smalti appear in the bottom left of the picture above.)

• **Ceramic tesserae** also have a long history in mosaics. Some of earliest mosaics, made in Sumeria, were composed of long terracotta cones with circular heads which were painted. Today you can buy *unglazed ceramic tiles* made specially for mosaicking in a range of subtle colours. They come in 2.5cm (1in) or 2cm (¾in) squares, which are stuck to paper or plastic mesh. Very flat on both sides, stronger and heavier than vitreous glass tesserae and slightly thicker, they make good floor mosaics.

Unglazed ceramic tesserae can be used on their own for mosaic designs (see the chair on page 79), but are equally effective mixed with other textures (see the portrait on page 101). Because they are non-reflective they tend to recede when placed next to shiny smalti or vitreous tiles, which creates a lively surface.

• **Natural stone** first appeared in mosaics in the form of pebbles at least a few thousand years ago. By the Roman era natural stone was cut into small cubes for tesserae. Although none of the projects in this book use modern-day stone tiles, they are worth a mention since they might provide just the tone or texture you are looking for in a particular design. Made specially for mosaic work, small marble, granite or slate tiles are available in various sizes from 1.5cm (⅝in) to 5cm (2in) square and are sold loose or on a webbed backing.

### Broken china and tiles

Broken ceramic floor and wall tiles and crockery are probably one the richest sources of tesserae for contemporary mosaicists. Many of the projects in the following pages rely heavily on this source for their luscious colour and enchanting pattern. The palette available from contemporary tiles includes an array of saturated hues. Add to that the even wider range of breathtaking colour and pattern you can get from broken modern and antique pots and china and it's easy to see how these tesserae have inspired so many stunning mosaics.

### Your tesserae collection

Collecting tesserae is one of the greatest enjoyments of mosaicking, and it is a wonderful way to get started in the craft. You can begin your collection on a shoe string by picking up damaged china that catches your eye at church charity sales, car-boot and garage sales, and flea markets. Or ask local tile shops if they have any broken goods available.

Whether collecting broken crockery and tiles or buying tesserae specially made for mosaicking, just remember to stick to colours and textures that you love. If you like, extend your tesserae to buttons, marbles, glass pebbles, or any *objets trouvés* that take your fancy. A collection that excites you can provide the inspiration that sparks off your mosaic design ideas!

# Basic tools and materials

The only tool you'll need to buy to start on a mosaic is a pair of tile nippers for cutting your tesserae. The other equipment for mosaicking can be improvised with simple household items. Aside from your tesserae, the materials required are an adhesive and a grouting compound.

## Preparation tools

Before you start a mosaic you'll need to prepare the mosaic base, which means scoring or sealing the surface, or both, depending of the material. Preparing a mosaic base is explained on pages 42 and 43 and covers the simple do-it-yourself tools required.

## Cutting tools

Unless you're using whole mosaic squares or discrete units like shells or pebbles, the first step in mosaicking is to start cutting tesserae into the desired size and shape. The three basic cutting tools are as follows:

• **Nippers** are designed for cutting tiles. Most models have tungsten-carbide cutting edges and sprung handles, and will cut most glass and ceramic tesserae that are up to 6mm (¾in) thick. They range in price according to their quality; the most expensive ones have replaceable jaws and compound leverage which makes cutting harder materials, such as natural stone, easier. Nippers are perfect for cutting crockery and the thin tesserae made specially for

mosaicking. A good quality pair of nippers is a wise investment for a mosaic enthusiast. For most cutting jobs a pair of nippers is all you'll need, and it is the only cutting tool a beginner need purchase.

• **Hammers**, even ordinary ones, are useful for breaking large tiles, crockery, or mirrors into randomly shaped pieces for mosaicking. For more precise cutting of thick tesserae, such as glass smalti or those in natural stone, a traditional *hammer and hardie* is preferred by some mosaicists. The hardie (also called a *bolster blade*) is a wide chisel blade with a shaft for mounting on an anvil, and the mosaicist's hammer has a curved head and two pointed, wedge-shaped carbide-tipped ends. Held in place on top of the hardie, a tessera is cut with a tap of the hammer blade.

The traditional mosaicist's hammer and hardie can be purchased from shops specializing in mosaic materials. If you can't find these tools, it is possible to improvise with a masonry hammer and a blacksmith's hardie.

• **Tile cutters** are designed for cutting large ceramic tiles. They consist of a tungsten-carbide scoring wheel and a gripper, which is used to snap the tile along the score. Tile cutters are useful in mosaic for cutting long straight lines through floor or wall tiles.

## Cementing and grouting tools

After cutting tesserae, the next stage in making a mosaic is cementing and

the final stage is grouting. The basic tools for these processes are usually sold in shops that specialize in mosaicking and tiling, but there is no need to buy them brand new. They are all items easily improvised from kitchen and do-it-yourself equipment you (or your generous neighbour) have around the house.

• **Containers**, such as old bowls, jugs and buckets, are needed during the cementing and grouting processes; you can never have too many. Bowls and buckets will be needed for mixing powdered adhesive cements and grouts, and for mixing colour into grout. They are also essential for carrying water to the work site. Most of the compounds used in mosaicking are water soluble before they set, so it's handy to have an extra bucket of water to dip tools or rags in.

Save odd-sized containers that you were about to throw out. You may have the best intentions to clean out your grout or cement before it dries, but you'll want containers you can dispose of if need be without regret.

If you are building up a collection of tesserae you will need containers for them as well. Strong cardboard or wooden boxes are good for floor and wall tiles, and chipped crockery. Some mosaicists keep small tesserae in colour groups in large, clear glass jars so what's at the bottom is clearly visible. Develop your own storage system as your collection grows.

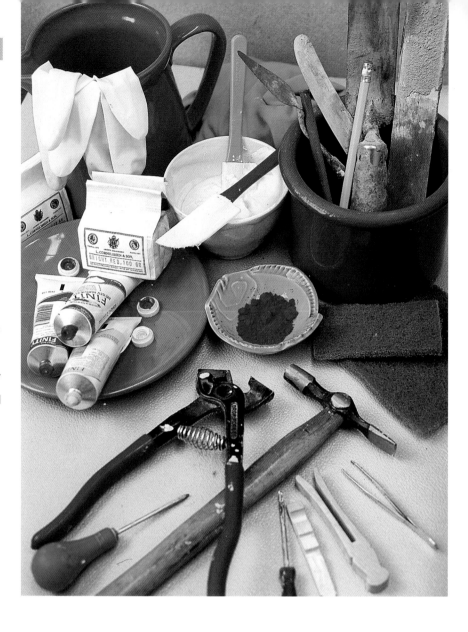

• **Adhesive spreaders** take many forms. The one you choose will depend on personal preference and on the type of adhesive. *Trowels* of various sizes, with rectangular or triangular ends, are suitable for spreading cement-based adhesives, especially over large areas. To spread mortar of a uniform thickness quickly, use a *notched trowel* or float – the larger the notches, the thicker the layer of adhesive. But for small mosaics and tiny tesserae, an ordinary *plastic spatula* works well. Trowels and spatulas can also be used for mixing mortar and grout.

For buttering individual tesserae, you can use just about anything, even an old butter knife, but the best tool for this is an *artist's palette knife* with a pointed end.

PVA-based adhesives and epoxy resins can be applied to surfaces with the plastic spreaders that come with the glue, or you can use a plastic straw or even wooden cocktail stick to individually butter tiny tesserae.

• **Grout spreaders** are used to spread the grout over the mosaic and push it into the gaps between the tesserae, so tools with flexible edges that won't scratch the surface are preferable. The same plastic spatula used for spreading adhesive can be employed for the job. A *squeegee* is a good spreading tool for large surfaces, like whole walls or floors. Squeegees have a long straight rubber edge designed specially for spreading grout. In areas that are hard to reach with a tool, you can spread on grout with whatever is at hand and push it into the gaps with rubber-gloved fingers.

• **Prodders and scrapers** of some sort should be kept at hand while you are mosaicking. Long, thin, pointed tools are useful for pushing or prodding small tesserae into exact positions or for scraping out partially set excess adhesive or grout between tesserae. Wooden sticks or wooden scrapers are handy for rubbing dried adhesive off the surface of the finished mosaic without scratching it. Tweezers, cocktail sticks, dental probes, wooden clothes peg, special grout scrapers or awls are just some of the things mosaicists make use of for these tasks.

• **Cleaning cloths and scrubbers** are needed for tidying up after mosaicking and for wiping off excess grout when finishing your mosaic. Lint-free rags and sponges are the most useful. But you can also use old newspapers to buff the mosaic surface and non-scratch nylon scourers to clean off partially set grout spots.

## Safety equipment

You are strongly advised to wear safety goggles when cutting tesserae, a dust mask or respirator when mixing powdered grouts and adhesives, and latex or rubber gloves when spreading grouts and adhesives. It is better to avoid risk than to regret it later. Always read all the safety instructions that come with tools and mosaic adhesives and follow them to the letter.

## Mosaic adhesives

The ready-mixed tile adhesives sold in tile shops can be used for small indoor mosaics. Beginners might like to try a ready-mixed tile adhesives on their first small project.

It will take a bit of trial and error until you decide which adhesive is best for you. There are three types of permanent mosaic adhesives – cement based, acrylic based and epoxy resins. Cement-based mortars are favoured by most mosaicists, but acrylic and epoxy resin glues have their own advantages as well.

• **Cement-based mortar** is the traditional mosaic adhesive. It is made by mixing powdered cement (such as Portland cement), fine or coarse sand, and water. The coarser the sand the harder the set mortar. A polymer additive or enhancer is sometimes mixed into the mortar to increase the strength and flexibility of the adhesive. Mosaic mortar mixture should be thick and smooth and similar in consistency to heavy mud. The speed of setting varies, and the slower setting varieties are better for exterior mosaics as they dry harder.

Cement-based mortar is economic and provides a good neutral colour. For exterior mosaic, you should use a waterproof and frostproof variety.

• **Acrylic-based adhesive** is often used for interior mosaics that will not be exposed to the elements. Sold under various brand names, the type of acrylic adhesive suitable for mosaic work is a thick white liquid that dries clear (see *PVA* in glossary on page 158). The advantage of this glue is that it is very strong and can be used to adhere tesserae to slippery surfaces like glazed ceramic (see instructions for the lamp on page 90). It can be water-resistant or non-water-resistant, so always pay attention to the labels and choose the water-resistant version for mosaicking.

Diluted with water, PVA can be brushed on surfaces to seal them prior to mosaicking (see page 42).

• **Epoxy resins** are two-part adhesives consisting of a resin and a hardener which are mixed together right before use. They are the only type of adhesive that will permanently stick mosaic to a metal surface. Epoxy resins can be used for all exterior mosaics, but are expensive. Since they are not water soluble before they set, they are also very messy. Epoxy resins have a working time from five minutes to one hour and a setting time from 15 minutes to 16 hours, depending on the type chosen. These glues give off noxious fumes until cured.

## Grouts

Pressed into the gaps between tesserae, grout unifies the design and strengthens the mosaic. It is made in the same way as cement-based mortar but contains a finer sand. Purchased in powdered or ready-mixed form, grout comes in fine and coarse versions for narrow and wide gaps. Some grouts contain polymers that add strength and flexibility.

Tiling shops sell grout in neutral colours such as white and grey, and a few bright colours. For a specific grout colour, you can mix pigments or artist's acrylics with white grout (see page 48).

## Cleaning agents

Thin hazes of grout or specks that remain on the surface of your mosaic after the grout has set can be removed with a dilute solution of hydrochloric acid or a dilute solution of the type of lime descaler sold for electric kettles. The acid residue left on the mosaic must be washed away immediately with fresh water.

Because acids are caustic, they should only be used as a last resort and with great care. Even diluted, acids should be used out of doors, and preferably under the supervision of an experienced mosaicist. Always wear safety goggles and rubber gloves when working with acids.

# Choosing mosaic bases

Cnce you are hooked on mosaicking, more and more surfaces around you will look like they are crying out to be covered with tesserae. The choice of mosaic bases is endless. Tables, chairs, shelves, walls, terraces, frames, flower planters and vases are just a few of the possibilities. Here are some tips for what to look for when choosing a base and how to prepare the surface before you start the mosaicking process.

### Types of mosaic bases

Your choice of mosaic base is as limitless as your own imagination. Avid mosaicists have been known to cover cars, stoves, whole rooms or even whole buildings – inside and out – with tesserae of all sorts (see pages 14–35). If you are not ready to go quite that far, keep in mind the more conventional surfaces that could be enhanced with mosaic.

Suitable indoor bases include objects like urns, vases and lamps; furniture like shelves, chairs, benches and tables; and surfaces like cabinet doors, sink splash-backs, walls, floors, and door, window or fireplace surrounds.

Outdoor bases can be garden furniture and objects such as benches, tables, flower planters of all shapes and sizes, bird baths and fountains; and architectural subjects like walls, pergolas, terraces and verandas, fences and concrete paths.

If you are a beginner, pick something for your first mosaic that really catches your interest. Mosaicking a piece of board may be a good way to test your tesserae and adhesive, but you'll get a lot more satisfaction if your first design is something that goes beyond a rectangle – mosaicking a simple frame, vase or shelf holds more possibilities and interest. The sculptural quality of even the smallest object adds dramatically to the beauty of a mosaic. Take a look at the various projects included in this book. They cover a whole range of skill levels and are sure to spark your imagination.

### Suitability of a mosaic base

There are four things to consider once you have chosen your base:

First of all, the base should be strong enough to hold comfortably the combined weight of the tesserae, adhesive and grout.

Secondly, the shape of the base should be suitable for mosaicking and for the type of tesserae you have chosen. Shapes with flat surfaces or very gentle curves are the easiest to work on. Those with extreme curves can be difficult to cover smoothly and require fairly tiny tesserae for the mosaic to bend with the curves.

Thirdly, study the shape of the base and make sure it has an appeal of its own – remember, you are creating a sculpture. If you start out with a totally graceless chair or vase, or a picture frame that is too narrow or

has awkward proportions, even the best coat of mosaic won't remedy the unshapely base.

Lastly, when deciding on the mosaic base, consider whether a mosaic adhesive will stick to it. Concrete, wood and ceramic surfaces are all fine for mosaicking on to. Cement-based mortars are the obvious choice for concrete surfaces. Both cement- and acrylic-based adhesives will adhere to wood and unglazed ceramics. Acrylic-based glues are best for glazed ceramics. Metal bases will take mosaic as well, but the harder to handle epoxy resins are the recommended adhesive.

### Scoring surfaces

Scoring your mosaic base will benefit adhesion on some surfaces, especially wood. For scoring, use a sharp knife. You can also use a hacksaw blade on wood. A surface keyed in this way will provide a 'tooth' for the adhesive.

### Sealing surfaces

After scoring you can further improve adhesion by coating the surface of the mosaic base with a diluted solution of PVA or a similar acrylic-based bonding agent, using an ordinary paint brush. Sealing is essential for wood bases which should be bonded on all sides before mosaicking.

If you are making an original base out of wood, for instance a board for a picture or portrait, or a handmade table or mirror frame, the best types of wood to use are an exterior-grade

plywood or a moisture-resistant medium-density fibreboard.

## Preparing walls

Both internal and external walls should also be scored before mosaicking. The best type of wall surface is one covered with a sand-cement render, which will work even in wet areas like showers and outdoors. The recommended adhesive is a cement-based mortar. As for ordinary tiling, the wall surface should be as flat as possible.

If you are in doubt about the strength of the wall surface or its suitability for mosaicking, get advice from a professional tiler. A well-prepared surface will ensure a smooth and long-lasting mosaic.

## Preparing floors

Before mosaicking internal timber floors cover them with a stable moisture-resistant plywood about 15mm (¾in) thick. So that the ply doesn't move, screw it down at 23cm (9in) intervals. Then score and seal it as explained above.

For an outdoor terrace, you will need a level concrete base for your mosaic. Any dips in the surface will trap pools of water.

As when preparing walls for mosaic, if in doubt get an expert to prepare your floor or terrace, or at the very least seek the advice of a professional.

## Testing adhesives

It is important to read the label on your chosen adhesive before using it,

and you should also test your adhesive and tesserae on a small piece of the base material before starting a project. Be especially careful with your choice of adhesive for outdoor mosaics. If a mosaic cannot be

brought inside, it will be exposed to the ravages of the elements. Extreme heat and cold can create cracks if the adhesive is inappropriate; water will then seep into the cracks and cause breakage over time.

# Preparing tesserae

After having chosen the base and prepared it for mosaicking, you are ready to plan your design in more detail to suit the base. Final decisions on the exact colour scheme and the approximate size and shape of the individual tesserae should be made before starting to cut tiles or china. Each project in this book suggests tesserae colours, but these are only guidelines. Alter the colour scheme to suit your collection of tesserae and your own taste.

## Getting ready for cutting

It is recommended that you wear safety glasses or goggles when cutting tesserae, so make sure you have a pair! Also, if you are cutting small tesserae shapes with nippers, you might be holding tiles or china close enough to your eyes to be at risk of breathing in tiny splinters, so a dust mask is advisable.

Prepare your work area both for cutting and for subsequent cementing and grouting. Mosaicking can be quite messy; even cutting tesserae can create more mess than you'd imagine, spraying specks of shards every which way. It is best to work in a designated 'studio'-type area that is away from precious floors, rugs and furniture. A garage or basement is best, or even a work area set up outdoors. Protect the work surface and the surrounding floor from stray shards and adhesive by covering them carefully with plastic

sheeting and old newspapers. Make sure the space has good lighting. For certain types of adhesive, you will also need good ventilation.

Tesserae should be cleaned before they are cut, since any grease, dirt, or dust will impede permanent adhesion, and they are harder to clean after they have been cut into tiny shapes. Wash crockery or large tiles, or if

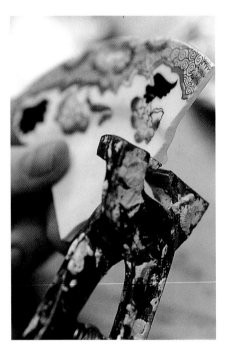

they are only lightly soiled, clean them with a damp cloth.

If you are using tesserae that are stuck to paper or a nylon mesh, soak them in warm water to remove the backing and the glue. Then leave to dry overnight. (For preparing shells and pebbles, see pages 50 and 51.)

For figurative mosaic designs, make a life-size pencil drawing before starting to cut tesserae. If drawing is not your forté, you can always trace

shapes from a book or magazine, then blow the tracing up to the right size.

Cut or break tesserae following the instructions below, preparing only enough pieces to test your colours and design features.

## Breaking tiles and crockery

To break large tiles or pieces of crockery that are too thick or tough to cut with nippers, use an ordinary

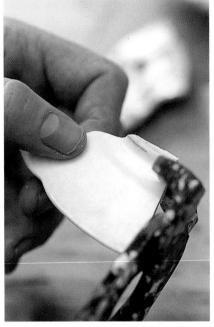

hammer. ( You can prevent flying shards by placing the item inside a plastic or paper bag before striking it.) This technique is also suitable for achieving random-sized tesserae or for making the first break in a piece of china that is going to be cut down further with a tile nipper.

More precise breaks with a hammer, can be achieved with a traditional mosaicist's hammer and hardie, which is explained on page 39.

## Cutting china

When cutting printed or painted crockery, be sure to look at motifs and see if you can incorporate them in your design. Small repeating patterns can be cut apart at random, but try to cut around whole motifs, like interesting flowers or large landscapes, to save them. If a motif is larger than the desired tesserae size,

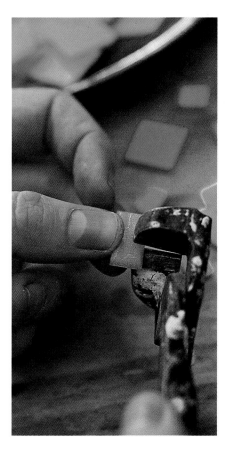

you can break it apart and then fit it together again in the mosaic, leaving gaps for grout (see the large roses on the *Rose Table* on page 77).

To cut a printed or painted design off of a piece of china, such as a plate, begin by cutting a section of it into a manageable size. Overlap the nipper blades only about 3mm (⅛in) over the edge of the crockery and press the handles. Next, cut away unwanted areas – such as the plain white in the

centre of a plate (OPPOSITE PAGE, LEFT). Ensure that the piece is as flat as possible by cutting away ridged areas like the rim on the base (OPPOSITE PAGE, RIGHT) or curved sections.

Save chips that include the smooth finished edge on the rim of the china. These can be used along the edge of your mosaic base, for instance along the edge of a table top.

In some designs you will be able to use pieces of china that are not flat, so be careful what you discard. For example, curved shards can be saved for covering round table legs or round pot planters. The circular rims on the bases of vases, saucers, plates and bowls make good sculptural

features, and writing on the crockery bottom adds charming detail to a finished mosaic. China lids and handles can also be stuck into a mosaic, for even higher relief.

## Cutting square tesserae

The small square glass and ceramic tesserae that are produced specially for mosaics are already fairly small, but for detailed designs they will need to be cut into quarters or into other small straight-edged or curved shapes. For design variation you may want to use some whole squares, for instance for borders, and cut others into precise or random shapes. Another advantage of cutting square tesserae into smaller squares is that it eliminates the very regular edge of the manufactured square. A less precise tessellation adds energy and movement to a design.

To cut a traditional square tessera into quarters, place the cutting jaws of the tile nippers at the centre of the tessera so that they overlap the edge of the tile by about 3mm (⅛in). Squeeze the nipper handles while holding the tile firmly in the opposite hand (FAR LEFT). Make the next cut into the centre of the half tile (ABOVE LEFT). For curved shapes, use the nipper blades to make several short cuts – this is called 'nibbling'.

Nippers can be used on thin wall tiles in the same way. The more you practise on various thicknesses, the more control you gain with your cuts.

# Cementing or gluing tesserae

Traditionally mosaics have been made in two different ways. The *direct method* is the most well-known. In this technique the tesserae are stuck face up directly on to the mosaic base. The other technique is called the *indirect* or *reverse method* because the tesserae are stuck face down to a paper drawing with a water-soluble glue. The composed indirect mosaic is then either flopped on to a bed of mortar on the mosaic base and pressed into place. The paper facing is soaked off after the adhesive has set, then the grout is applied.

With the indirect method, you can prepare a mosaic ahead of time in a studio. It also creates a very flat surface. The disadvantage is that the design is composed face down, which won't work for tesserae that are a different colour on each side.

The direct method allows a great deal more spontaneity. Using the direct method, you can stick tesserae on to any three-dimensional surface with ease. You can also mix thin and thick tesserae, sinking thick pieces deep into the cement or allowing them to protrude.

All of the projects in this book were made using the direct method, which is much easier to master than the indirect method. There are two techniques for applying adhesive: the cement or glue can be spread directly on to the mosaic base, or each tessera can be 'buttered' and stuck individually in place. Spreading the adhesive on to the base is quicker, but buttering may be preferred if you have drawn a design on to your base.

## Testing designs

Be sure to test your design before you begin sticking the tesserae to the base. Arrange part of the design either on the base or on a table to see if the colours, shapes and sizes are working as desired. Think about the gaps between the tesserae that will be filled with grout, and study the effect of placing the pieces closer together or farther apart.

You can cut all your tesserae beforehand, arrange them to the same size as your base and then transfer the design carefully on to the base as you cement or glue. But if you are creating a random mosaic pattern or working on to a non-flat surface, this is not really necessary. Trying out and arranging just a small area before cementing will probably be enough to get you into the swing of it.

## Transferring designs

If necessary, transfer any figurative motifs in the mosaic design from your pencil drawing on to the mosaic base using carbon paper. Alternatively, draw the motifs in reverse on a piece of tracing paper using a soft pencil, lay

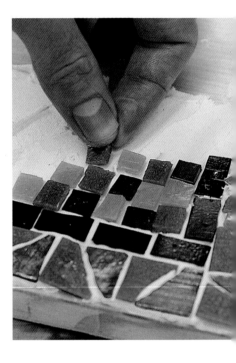

the design pencil-side down on the base and rub over the outlines with a hard pencil to transfer them on to the base. The more adventurous can draw directly on to the base.

## Cementing

If you are using a cement-based mortar, read the manufacturer's instructions carefully, paying particular attention to the setting time and the safety directions. Wear a dust mask when mixing powdered cements, and

put on latex gloves if your hands are going to come into contact with the mortar. (These instructions are for making mosaics that will be grouted. For ungrouted mosaics, see page 50.)

Prepare the cement as instructed (unless you are using a pre-mixed adhesive). The best consistency for cement mortar is one similar to a heavy mud or a cake batter. Spread the mortar on to a small area of the pre-sealed mosaic base, using a spatula or notched trowel (FAR LEFT). The thickness of the cement depends on the thickness of the tesserae. Once the tesserae is pressed into place the cement should not ooze up above the level of the mosaic surface, and there should be sufficient space for the grout, so apply the cement quite thinly for thin tesserae.

Begin the mosaic in the desired area, at the corner of a table for instance, leaving gaps between the tesserae and pressing them into the mortar (LEFT). Fill in the mosaic in the cemented area before spreading on more adhesive. Cement-based mortar can also be buttered on to each tessera with a small trowel or artist's palette knife, but this is not suitable for very tiny tesserae.

If you want to leave the mosaic and continue later, scrape away the mortar up to the edge of the last tesserae.

### Gluing

Acrylic-based adhesives can be spread on to the mosaic base in the same way as cement-based ones. But if you are fitting the tesserae into a design drawn on the mosaic base, you will want to individually butter the pieces instead so you can see the design outlines. Because acrylic-based glue is thinner than mortar, it is possible to butter quite tiny shards with it.

Dab the adhesive on to the back of the tessera with a cocktail stick or a

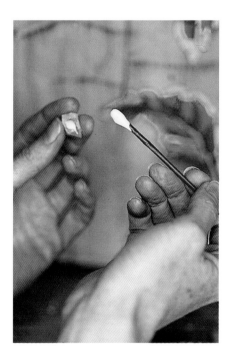

thin plastic straw (ABOVE). Place the tessera on the mosaic base leaving a gap for the grout (ABOVE RIGHT), then press it firmly in place.

Be sure to make any adjustments while the glue is still tacky. Although it is possible – once the glue has set – to chip away glued tesserae with a hammer, it isn't as easy as chipping tesserae out of cement mortar. Refer to the manufacturer's label for curing times and safety instructions.

### Tips for positioning tesserae

Wherever two surfaces of the mosaic base meet, such as the edge of a table top and the table rim, be sure to mosaic both edges at the same time so you can create a neat corner with the overlapping tesserae while the cement is still wet.

It is also a good idea to start mosaicking at the bottom on vertical

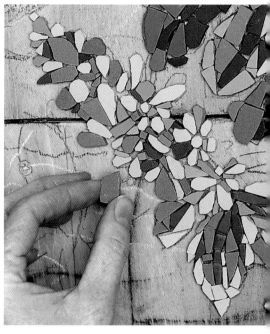

surfaces such as walls, chair legs, urns, et cetera. Once the adhesive has cured under the first row of tesserae, the pieces being stuck on above are prevented from slipping downwards.

Another good positioning tip is to start your tesserae about 3mm (⅛in) above the bottom edge on objects like vases, urns and chair legs. Tesserae that are too close to the mosaic base are easily damaged when the object is moved.

# Grouting Mosaics

Grouting is the technique used to fill the gaps between tesserae level with the mosaic surface. The grout itself is a fine textured form of cement-based mortar. It adds strength to a mosaic, and is also an important element in the overall design. The swirling, cross hatched or random lines of grout draw the design together, and the grout colour enhances the brilliance or quality of the tesserae hues.

**Colouring grout**

Choosing the right colour for the grout can make the difference between a successful and dazzling mosaic design and one that falls flat. Remember that the choice of grout colour is limitless. Although you can buy some ready-mixed shades, you can also mix your own colour by adding pigments or artist's acrylics to a white grout.

After cementing the tesserae, wait at least 24 hours for an indoor mosaic or three days for an outdoor mosaic before grouting.

Having decided on a colour, prepare powdered grout following the manufacturer's instructions and wearing a dust mask. Then mix in a little colouring at a time until you achieve the correct shade (RIGHT TOP). Remember that the grout will become slightly lighter once dried.

It is advisable to try out the grout on a separate test piece of your mosaic, for instance on the piece of board you tested your tesserae and adhesive on. Alternatively, test in an area of the cemented mosaic that will not be very noticeable. Allow the test piece to dry thoroughly, then if necessary alter the grout colour before beginning the final grouting.

It is not necessary to use the same colour grout over a whole mosaic. Several colours can be used in one

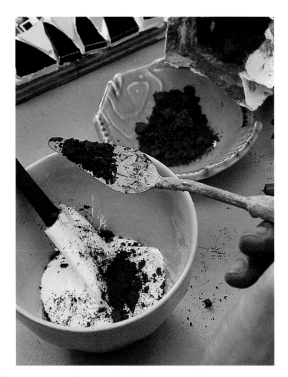

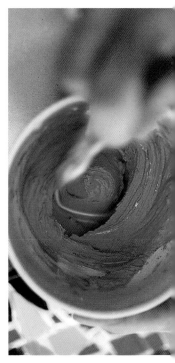

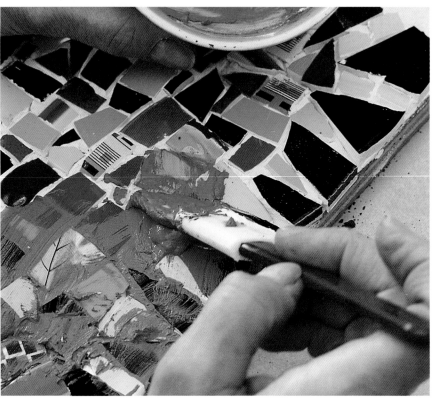

piece, for instance a different shade can be used in contrasting borders, or the shades can change gradually, following differing colour themes.

## Spreading on grout

Using a pointed instrument, scrape out any excess cement mortar that stands proud of the mosaic surface. Then, wearing rubber gloves and using a plastic spatula or squeegee, begin spreading the grout over the mosaic (OPPOSITE PAGE, BOTTOM). Cover the entire mosaic, pushing the grout down into the gaps as you

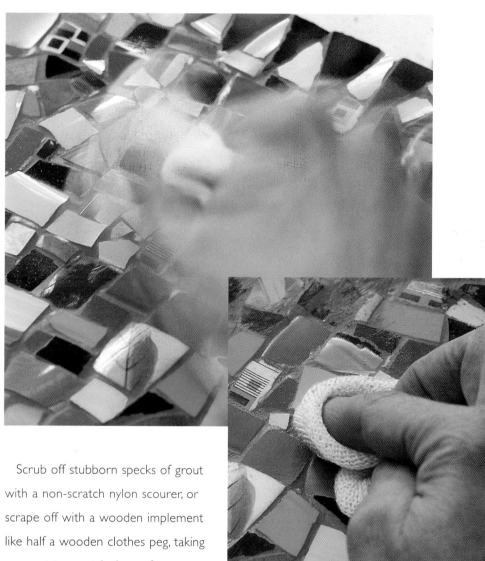

(BELOW). Then buff the mosaic with another clean cloth or a piece of scrunched up newspaper.

water from a grout-filled rag or sponge down the sink drain as the sand in it can clog the drain!

spread it (ABOVE). In difficult to reach areas, use your glove-covered hand to press the grout into the gaps.

## Wiping off excess grout

Allow the grout to cure for about 20 minutes until partially set, then wipe off the excess with a clean lint-free cloth or a barely damp sponge

Scrub off stubborn specks of grout with a non-scratch nylon scourer, or scrape off with a wooden implement like half a wooden clothes peg, taking care not to scratch the surface.

Dried films of grout or hardened specks can be removed with a dilute solution of hydrochloric acid, but only use this as a last resort (see page 41 for more about acid cleaners and about safety precautions).

If any grout sticks to your hands, rinse them with vinegar to neutralize the alkalinity, then wash with soap and water. Do not throw the rinsing

## Colouring grout after grouting

If you want to slightly alter the colour of your grout after you have finished a mosaic, it is possible to do so as long as your tesserae are not porous. Prepare a thin acrylic wash and brush it over the mosaic. Wipe the tint off immediately with a lint-free cloth.

# Mosaicking without grout

It is possible to make many types of mosaic without grout. Small, flat tesserae can be fitted together so tightly that there are virtually no gaps, or big pieces can be pushed into a thick bed of cement mortar which creates a 'self-grout'. These techniques are especially important for tesserae that are unsuitable for grouting, such as porous smalti and sculptural tesserae like shells and pebbles.

### Choosing an adhesive

To fix in place smalti or other types of tesserae that will fit together with barely any gaps, use either acrylic-based or cement-based mortar as desired. But with 'sculptural' tesserae – shells, pebbles and large-scale tesserae of varying thicknesses – it is best to use cement-based mortar. These sculptural tesserae are bound to leave gaps and the cement mortar will provide a 'self-grout'.

You can colour white mortar in the same way as grout to suit the design. (Be sure to follow all the safety precautions on page 41 when working with cement-based mortar.)

Before trying out any of the techniques that follow, read the positioning tips on page 47. Also, remember to be very careful to keep your hands clean. Any cement on your hands could be transferred to the mosaic surface. Cement is especially hard to remove from shells and pebbles.

### Working with shells

Shells are perfect candidates for an ungrouted mosaic. They are not only too sculptural for grout, but are also too porous. To prepare shells for a mosaic, soak them in water for a few days, changing the water every day. Then rinse them one last time and drain off the water. Leave them a few days until they are thoroughly dry.

Colour the cement-based mortar to match the shell tones if necessary. An off-white shade is fine for creamy shells. Spread the cement on to a small area of the pre-sealed mosaic base (BELOW LEFT). Start sticking the shells firmly into the cement, buttering the inside of open shells (BELOW). Fit the shells as closely together as possible (BELOW). If the gaps between

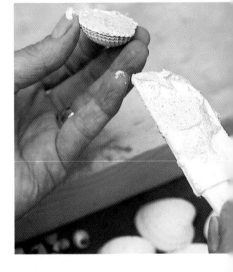

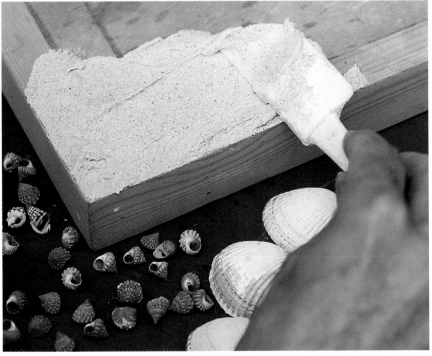

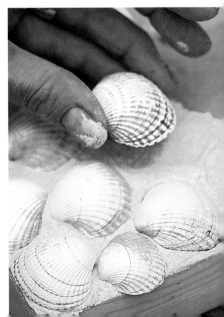

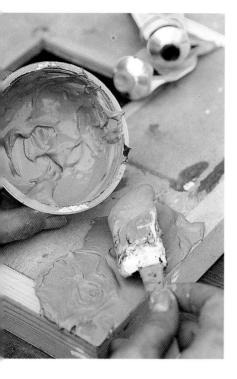

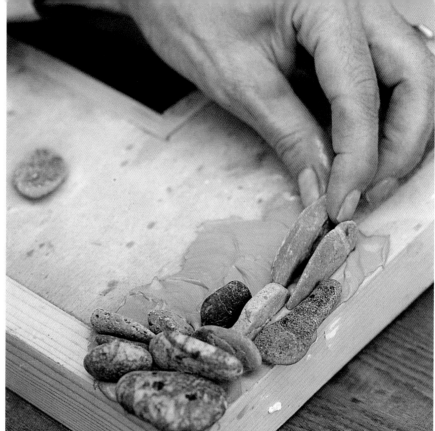

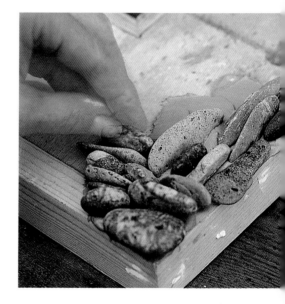

the large pieces look too wide in places, fill them in with tiny shells. Continue in this way spreading cement over a small area and filling it in before moving on to the next area. Avoid jarring the shells and breaking the suction created between the cement and the shells.

If you want to use an acrylic-based glue on your shell mosaic, remember that it will not be strong enough to be left outside. And make sure that you paint the mosaic base the desired shade beforehand; the colour showing through between the shells will greatly effect the design.

## Working with pebbles

Soak pebbles in water overnight to clean them, then rinse them several times until the water is clear. Allow a couple days for the the pebbles to dry out properly.

If necessary, colour the cement mortar then spread it on to the pre-sealed mosaic base, covering only a small area (ABOVE LEFT). Begin pushing the pebbles into the cement, fitting them snugly together (ABOVE AND RIGHT). Fill in the cemented area before adding more cement.

## Tesserae of different thicknesses

The mural on page 145 is a good example of a mosaic that does not suit grouting. The tesserae used range from broken crockery and tiles of varying thicknesses to shells and pebbles, and all are relatively large scale. For this type of mosaic, a thick layer of cement-based mortar is applied to the mosaic base, then the tesserae are sunk into the cement to the desired level (and at the desired angle). The cement pushes up between the tesserae to form a 'self

grout'. With a little practice you will be able to achieve just the right thickness of cement, so it is best to try it out on board before beginning.

As for shell and pebble mosaics, make sure your cement is the desired colour before you begin. Use the same colour throughout, or vary it from area to area to suit the design.

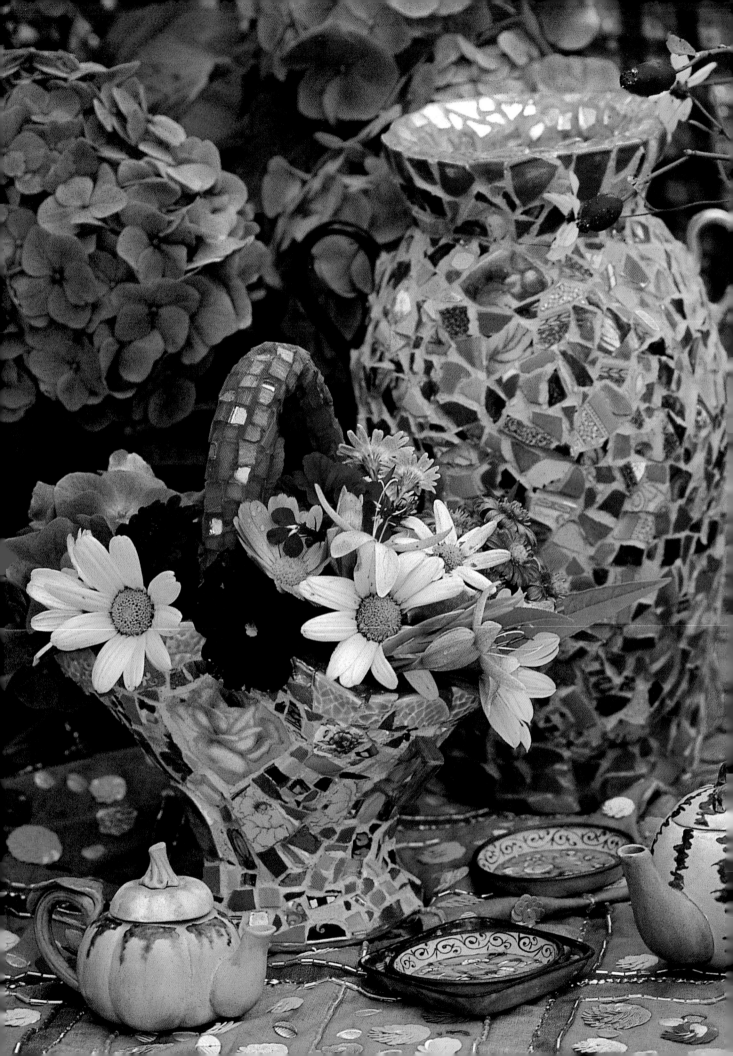

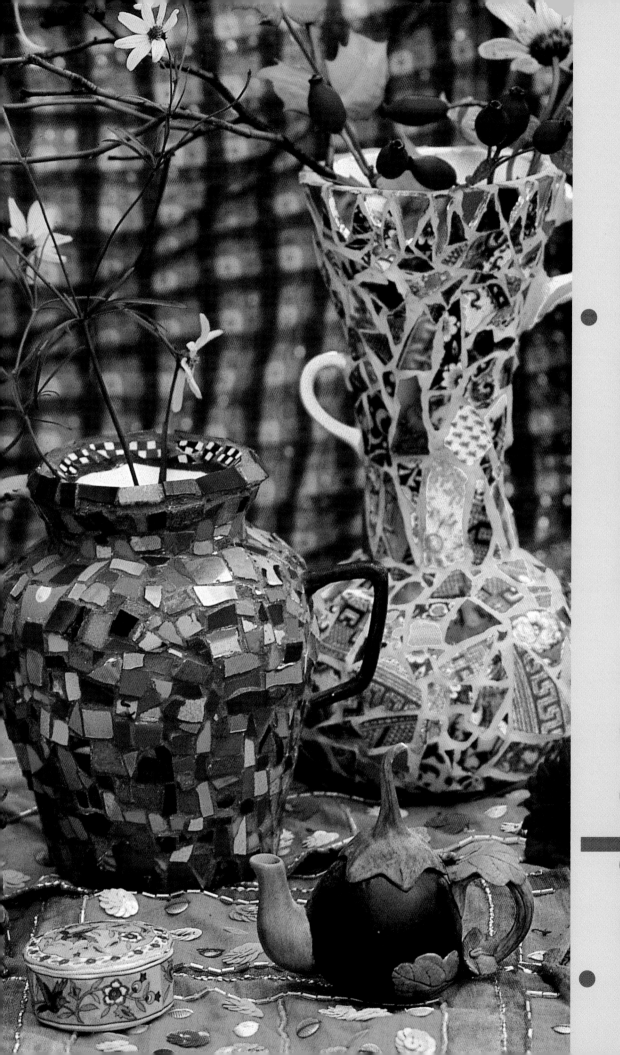

indoor mosaics

In this chapter Candace Bahouth and Kaffe Fassett present original indoor mosaics. The designs featured in this introduction and the projects on the following pages provide ideas to enhance a wide range of interiors. They include mosaicked furniture such as tables, a shelf and a chair, objects to add accents to rooms such as vases, a lamp, a picture, frames and a portrait, and even a whole mosaicked bathroom!

In addition, there are all kinds of mosaic tesserae textures to stimulate your imagination – broken china, artificial pearls, traditional mosaic tiles, mirror, shells and pebbles. Many projects use two or more types of tesserae materials

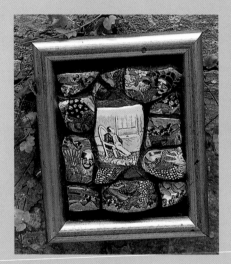

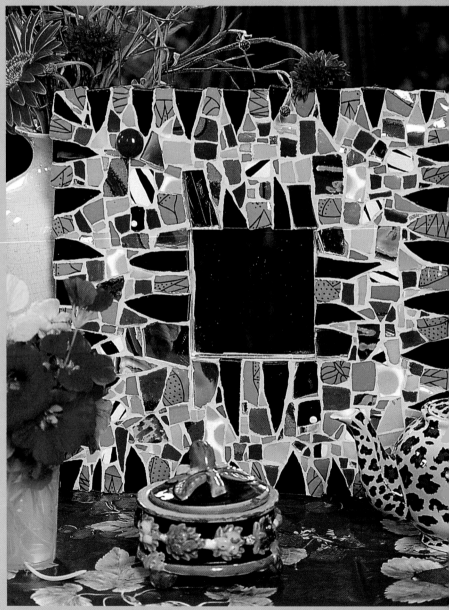

ABOVE Candace Bahouth's picture shows an excellent way to use very precious pieces of broken china.
RIGHT Perpetually surrounded by tesserae in a spectrum of colour, Candace was able to use her collection of hot yellows, tangy oranges, sharp reds and vivid blues for her *Jazzy Mirror Frame*.
FAR RIGHT Candace introduced rays of gold into her hearts to suggest that love is an energized thought, an active power, a transformer, the generator that propels us to create.

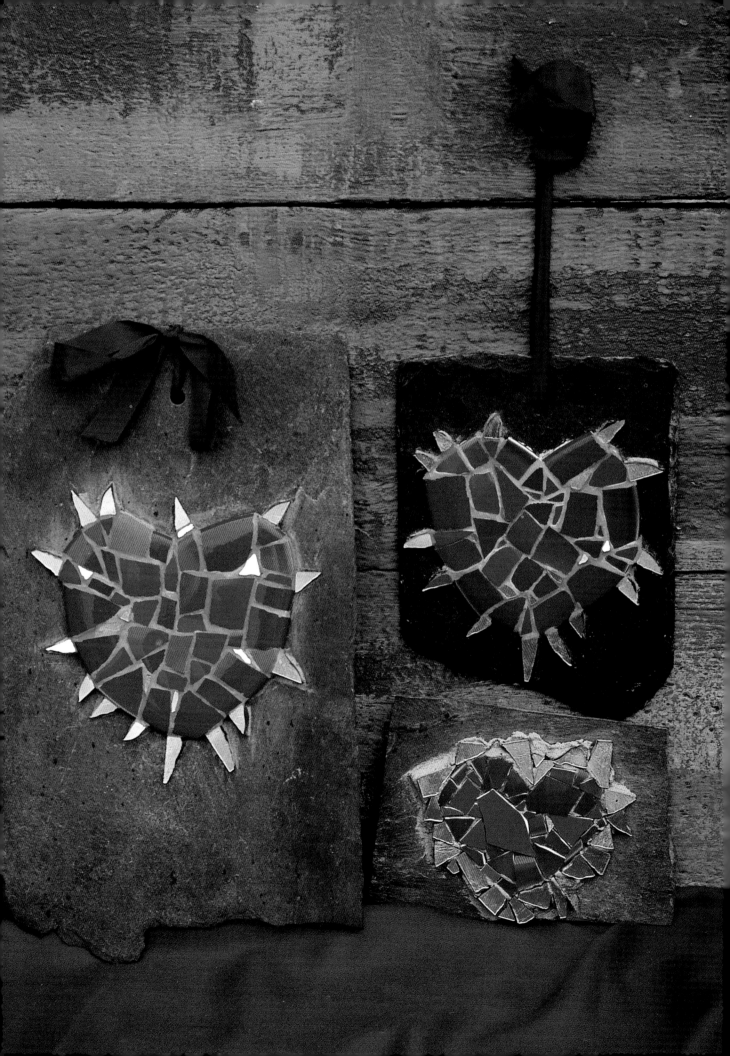

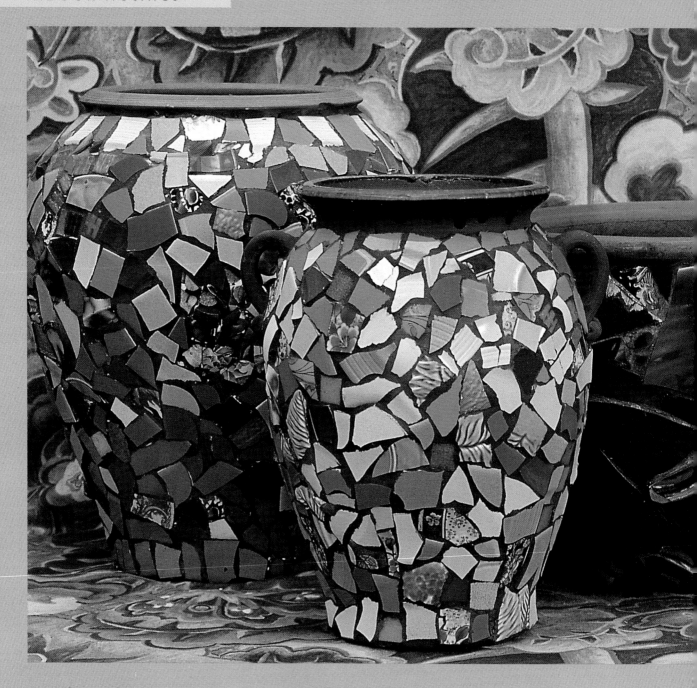

together which gives them lively surfaces. The sophisticated colour schemes and the unusual placements of regularly and irregularly shaped tesserae pieces should inspire you to create your own variations.

Most of the projects are accompanied by detailed explanations of how to achieve similar results. You will find that Candace's and Kaffe's relaxed attitude to technique means that all of their mosaics are technically uncomplicated, though some projects are larger or more intricate than others. Even if you are a beginner, you will find something within your ability in these pages. For

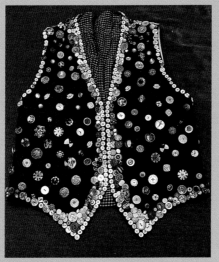

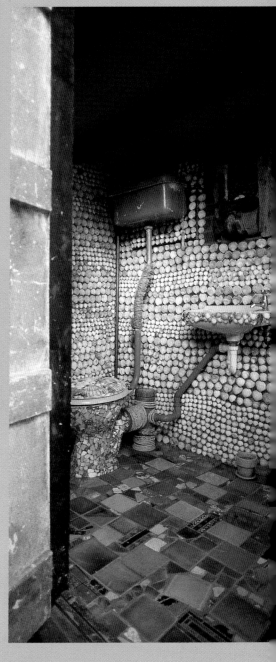

ABOVE Kaffe Fassett has covered a simple waistcoat with his collection of buttons in the spirit of the mosaic visionaries. LEFT Kaffe's bold urns show how large, inexpensive terracotta pots from garden centres can make exciting vessels for abstract mosaic. RIGHT For this mosaic in Brandon Mably's privy in Rye in southern England, Kaffe decided to use the same type of shell on the whole design. Sorted into size and shade groups, the shells were used to form simple and organic stripes.

instance, Candace's mosaic picture made from only a few precious patterned chips, some from Japanese Satsuma pottery, couldn't be easier to achieve and yet holds a truly captivating quality (see page 54).

If you want a slightly more ambitious project, look to Kaffe's *Apple Shelf* (page 97) or Candace's *Blue and White Vase* (page 85). And those of you in search of something challenging might want to try covering a regal chair like Candace's on page 79, or a whole bathroom like Kaffe's on page 66. The techniques even for these are within everyone's reach, all you need is the passion!

# Transferware Table

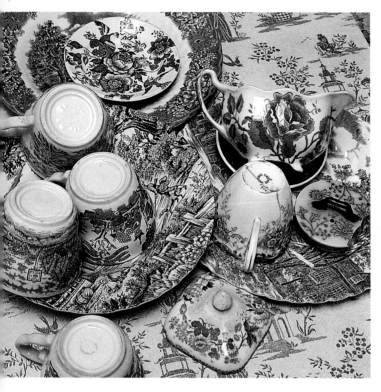

The restrained freshness and lacy effect of transferware crockery and toile de jouy fabrics have always fascinated me. Seeing different colours of lace used together as a border on a cushion gave me the idea that a mosaic of broken transferware crockery would create a delightful patterned surface. The lacy texture of the transferware comes from its delicate bucolic scenery in red, blue, brown or green on cream grounds. Because the designs use just one colour on creamy white or off-white, they provide the perfect building blocks for making bands of mosaicked colour.

English transferware pottery originated in Staffordshire in the early nineteenth century. The first pieces were covered with blue and white transfer scenery taken from travel book engravings. In the 1840's this printed tableware really took off with the introduction of red, green and brown colourways. Ever-popular, the designs have continued to be imitated up to the present day,

When I started on this mosaic table and mirror set I was lucky to find lots of inexpensive reproduction transferware plates and cups in car boot sales and junk shops. From more up-market shops I started collecting plates to extend the lacy texture. The shades I concentrated on finding were wine pinks, olive greys, ochre browns and ultramarine blues. The grounds on the china are generally creams and off-whites, often tinged subtly with hints of the main pattern colour.

Though contemporary imitations of transferware crockery cannot compare in beauty to the delicate antique originals, when broken up and used to make mosaicked bands of colour they seem to come alive and take on an unexpected elegance.

RIGHT  Kaffe Fassett's lacy mosaic *Transferware Table* and mirror against a backdrop of soft chinoiserie wallpaper from Alexander Beauchamp and surrounded by transferware plates. See the following pages for instructions for mosaicking the table. ABOVE LEFT  A selection of the contemporary reproduction and antique transferware crockery used for the table and mirror mosaic.

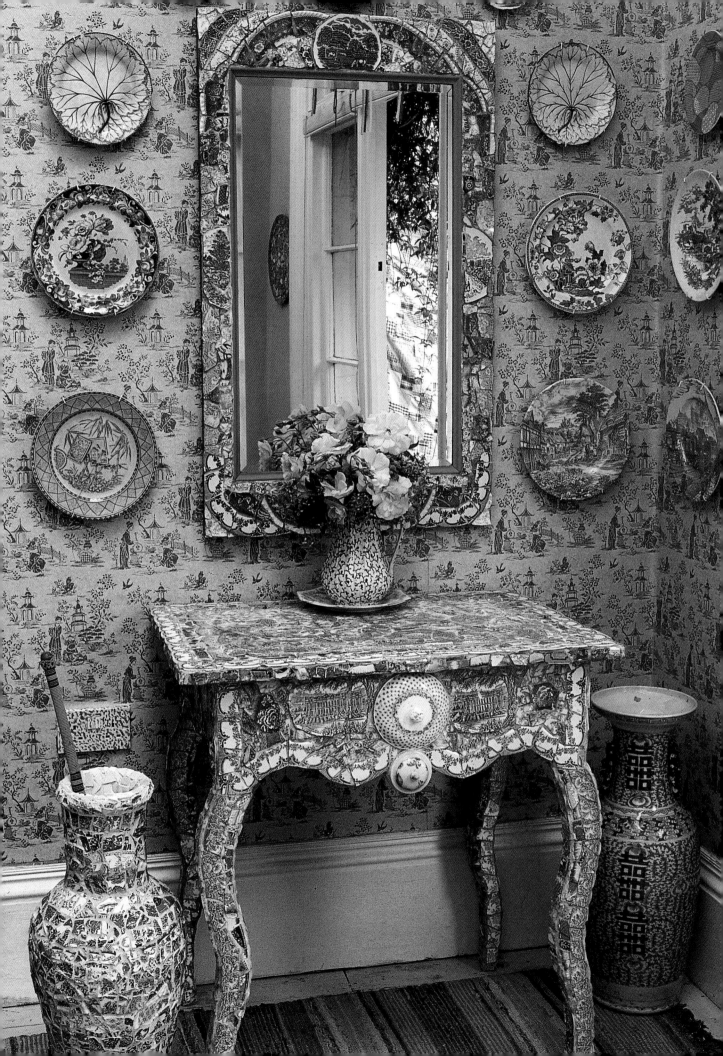

# Mosaicking the table

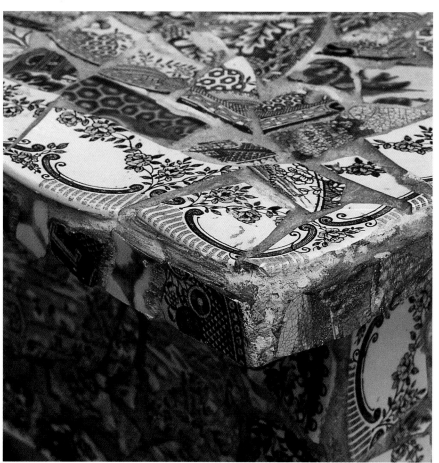

**Materials and tools** Transferware crockery in four different colourways (TOP ABOVE); wooden table, wood sealant and paint brush; nippers, cement and grout spreaders, and lint-free cloths; cement-based mosaic adhesive, white grout and acrylics for colouring grout.

**Instructions** Before beginning, make sure that the table you have chosen has flat enough surfaces for the crockery tesserae. (Quite small shards are needed to fit neatly around round legs.) Prepare the table for the mosaicking, scoring and applying wood sealant (see page 42).

**1** Begin cutting the crockery with the nippers. Make tesserae that are as flat as possible, dividing curved items into smaller pieces. Save the smooth, rounded rims of saucers and plates to cover outer edges. Cut only enough pieces to get started and keep them in colour groups.

**2** Using the brown colourway chips, arrange a band of colour at one corner to get an initial feel for how easily the random shapes can be fitted together. Next, arrange some of the blue colourway tesserae along the brown band (LEFT). A brown, then a blue, then a green band of colour will be mosaicked around the table edge. These bands should merge into each other without forming straight-edged lines.

**4** Study the following design features on the table before preparing more tesserae and before beginning the cementing and grouting:

• Brown and white plate borders were used to create a finished edge along the table top perimeter. The

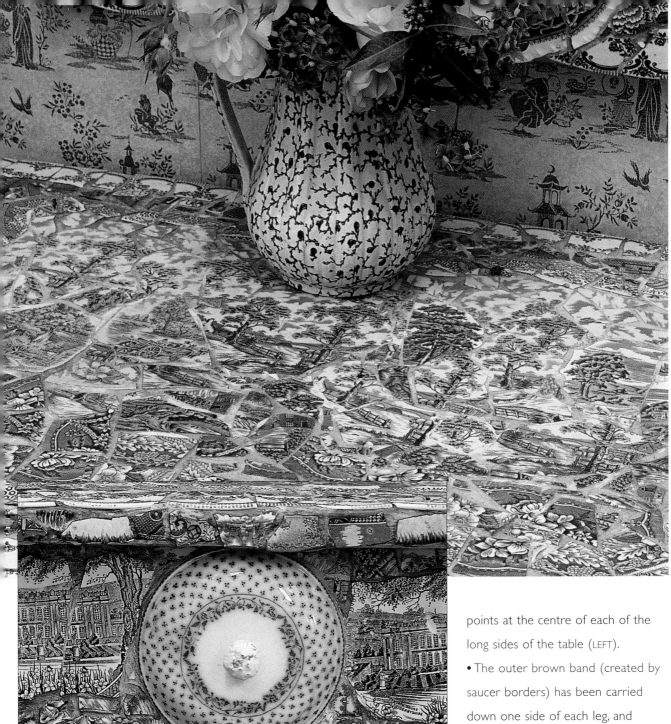

smooth rims protrude slightly so that the blue chips along the lip fit neatly under them (OPPOSITE PAGE, RIGHT).

• The largest pink-and-white transferware pieces cover the centre of the top of the table (ABOVE TOP).

• Each of the four table sides of the table under the top is mosaicked with pink pieces framed with a brown band. Large and small transferware lids and large brown colourway architectural landscapes form focal

points at the centre of each of the long sides of the table (LEFT).

• The outer brown band (created by saucer borders) has been carried down one side of each leg, and alternates around the leg with red and blue bands.

**5** Once you have decided on the basic design plan, start applying the mosaic. Mosaic the table top first, working from the edge towards the centre. Then cover the sides and lastly the legs.

**6** Colour the grout to a pale grey and apply it. See pages 46–49 for how to cement and grout mosaic.

# Shell Urn

Wells Reclamation yard is where I would like to live, waking up amongst all those fabulous railings, statues, bath tubs, cupolas, pillars, doors and tiles! It was there I found a graceful 18-inch-high cast iron urn to cover in an extravagance of creamy shells. These exquisitely designed mollusc mobile homes are a natural wonder. The variety of form, colour and texture seems infinite – painterly streaks, dots, spirals and swirls. Some are marked like animal skins, others mottled or marbled or stained in diverse colours ranging from rust browns, to raspberry, olive green, tangerine orange, even livid blue, with surfaces from as smooth as a pearl to as rough as prickly spikes.

Shells have the unfathomable beauty and grace of a timeless jewel, and link us with some of the earliest forms of life. Wonderful derelicts of real estate in the natural world, their simplicity in mosaic has a calming, almost serene influence, reminding our souls of the simple pulse of creation.

Some of the shells for the urn were collected in Wales, others were foreigners. With what I had gathered, I sat down and started 'playing'. A few shells just didn't work with others because of colour or shape. Using ivory cement, I laid a strip down the whole urn to see how the various shells fit together. The best solution to a design problem is actually found through trial and error – it will have it's own organic resolution. I added mirror on the plinth base for a touch of elegance. Mirror also has the advantage of reflecting whatever surface it's placed upon.

When covering an urn with shells, try to accentuate the urn's original shape – its essence. Also, bear in mind that because shells are porous and extremely difficult to clean, they can't be grouted. This means that you need to pay particular attention to the spaces between the shells when cementing them.

Concentrate on the depth of adhesive: too much and it will ooze out on to the shells, too little and they won't adhere. Much patience is needed and clean fingers!

RIGHT  Decorated with exquisite shells and broken mirror, Candace Bahouth's *Shell Urn* displays a frothy yet elegant mood. ABOVE LEFT  Some of the tesserae that Candace drew on for her urn, including an array of shells and some broken mirror.

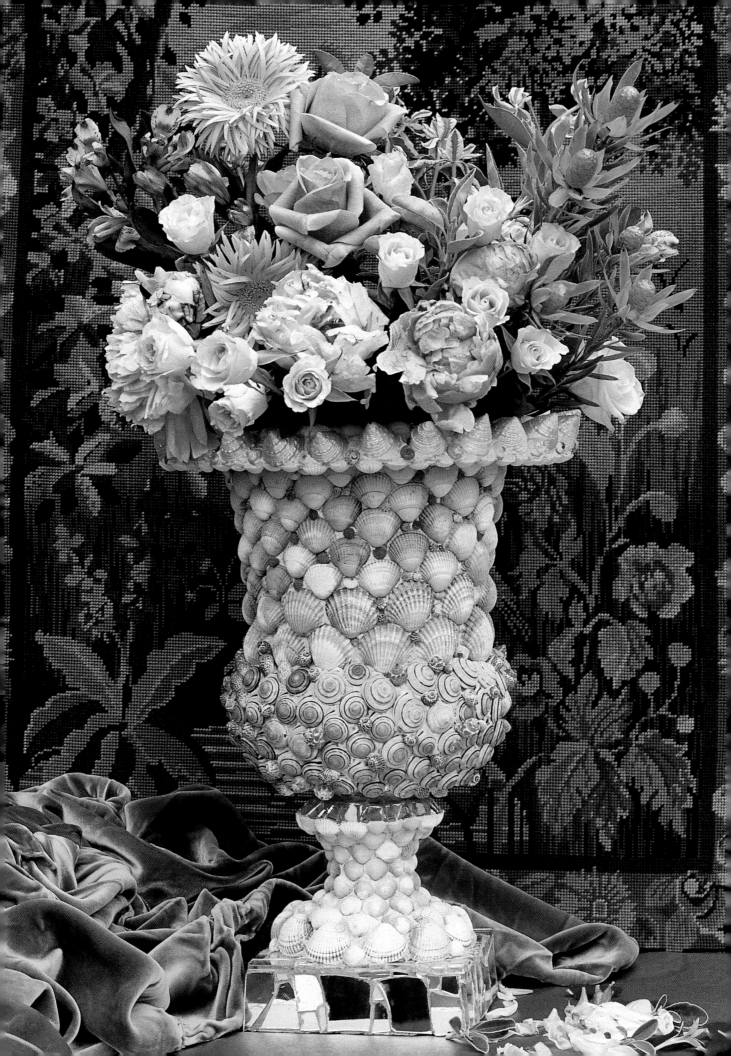

# Mosaicking the urn

**Basic materials and tools** Both plain and patterned shells in a variety of sizes and shapes, all predominantly in pearly whites or delicate beiges for an overall frothy yet elegant mood, plus some broken mirror; large concrete or cast iron urn, sealant and paint brush; nippers, cement and grout spreaders, and lint-free cloths; ivory cement-based mosaic adhesive and dry stiff artist's brush for removing excess adhesive; ivory grout for mirror mosaic only.

**Instructions** Choose a fairly plain urn that is large enough to accommodate your chosen shells (RIGHT). Before beginning, prepare the urn for the mosaicking by applying sealant. (Note that this urn will be suitable for indoor use only.) See page 42 for more about preparing mosaic bases prior to cementing.

**1** Study the design features on the urn before starting the mosaic:

• Neat rows of open-mouthed shells have been used to cover the upper part of the urn bowl; these shells decrease in size as they move upwards and are smallest under the lip of the rim. Shells of the same shape have been used on the stem of the urn, again graduating in size. These open-mouthed shapes fit nicely around the curving body of the urn.

• The bulging lower half of the body of the large urn has been mosaicked with medium-sized spiral-shaped,

patterned shells positioned close together but not in exact rows.

• The outer edge of the rim at the top of the urn is covered with a neat row of shiny mother-of-pearl spiral-shaped shells all the same size. Inside this row is a row of small white open-mouthed shells (OPPOSITE PAGE, TOP).

• The smallest spiral-shaped shells have been used to fill in gaps between the rows of larger shells wherever necessary on the urn.

• Mirror mosaic has been used on the flat plinth base, at the crease where the urn bowl joins the stem

and from the top rim down into the mouth of the urn (OPPOSITE PAGE, TOP AND BOTTOM).

**2** Once you have studied the basic design plan of the *Shell Urn* for ideas, decide on a design plan for your own urn, holding your shells up against your urn to test that the various sizes you have will fit in the desired positions. Make sure that you have sufficient tiny shells to fill in gaps that might arise in the shell rows.

**3** Using the nippers and wearing protective gloves, cut some mirror into random shapes. Begin cementing

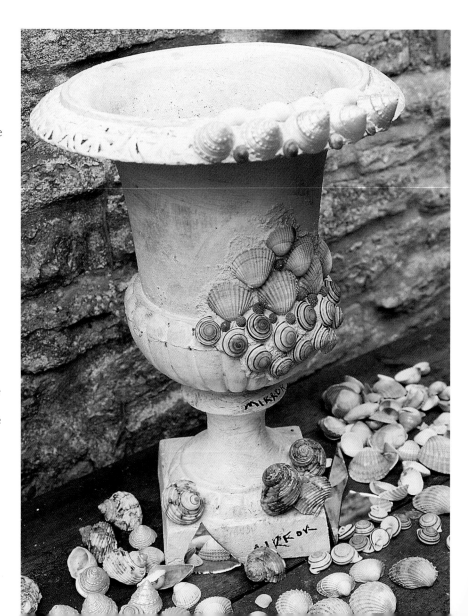

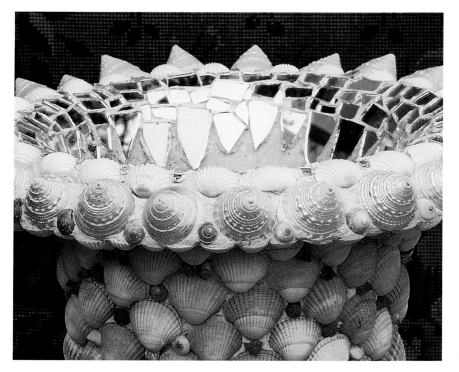

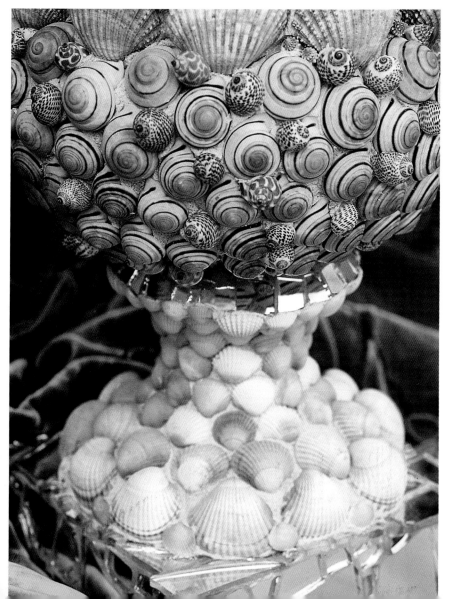

mirror tesserae on the flat plinth at the base of the urn, overlapping the shards on the horizontal surface over those on the vertical sides. Leave a gap of 3–6mm (⅛–¼in) above the bottom edge, since any tesserae too close to these edges could be damaged. Cutting more mirror tesserae as you need them, cover the flat plinth, each side of the crease between the urn stem and bowl, and at least 5–8cm (2–3in) of the urn from the rim into the inside of the urn bowl (LEFT). See pages 46 and 47 for full cementing directions.

**4** Grout the mirror mosaic before beginning with the shells. See pages 48 and 49 for how to apply grout.

**5** Then start applying the shell mosaic, working from the bottom upwards. Spread cement over only a small area about 13cm (5in) square and press in the shells, before moving on to the next area. Keep your hands clean at all times as shells are very difficult to clean. Make sure the cement spread on the urn is thick enough for the shells to adhere but not so thick that it oozes up too high between the shells. Fill in open-mouthed shells with cement before positioning them. Use a dry stiff brush to remove any excess cement and to spread it evenly between the shells if necessary, but be careful not to break the seal between the shells and the cement. See page 50 for detailed cementing instructions for shells.

# White Bathroom

Many of my mosaics are pastel to saturated hue; therefore I accumulated boxes full of left-over white shards cut away from around flower motifs, white plate centres cut away from decorative borders and so on. When I stumbled on a pile of discarded white tiles on the street, my mind went into overdrive and the white bathroom idea was born.

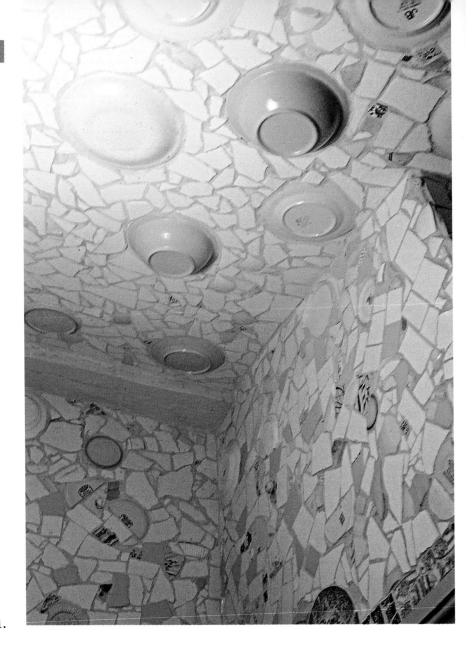

Subtle contrast and a simple framework for the mosaic design are provided by the borders of lacy transferware chips. Blue-and-white, red-and-white, brown-and-white and grey-and-white transferware form the border that runs around the door, around the sink and at the same level around the whole room.

I saved the more elaborate panel over the toilet till last. The simple flat square of mirror with a transferware border looks quite elegant on this white wall.

Whenever possible I used the bottoms of plates, cups and saucers – many with labels – for textural relief and quirky design detail. They are dotted about the room at random for the viewer to discover.

A delicate off-white grout with a touch of yellow and grey gave the desired glow to the mosaic palette. One excited visitor said that viewing the room was like lying on the floor of a dining room looking up through a glass table!

**RIGHT AND ABOVE** To imitate the theme of Kaffe Fassett's *White Bathroom*, collect a palette of broken crockery in whites and off-whites, with smatterings of cream, and for the borders, china with lacy softly toned patterns. To prepare and mosaic the walls, follow the instructions on pages 37–49.

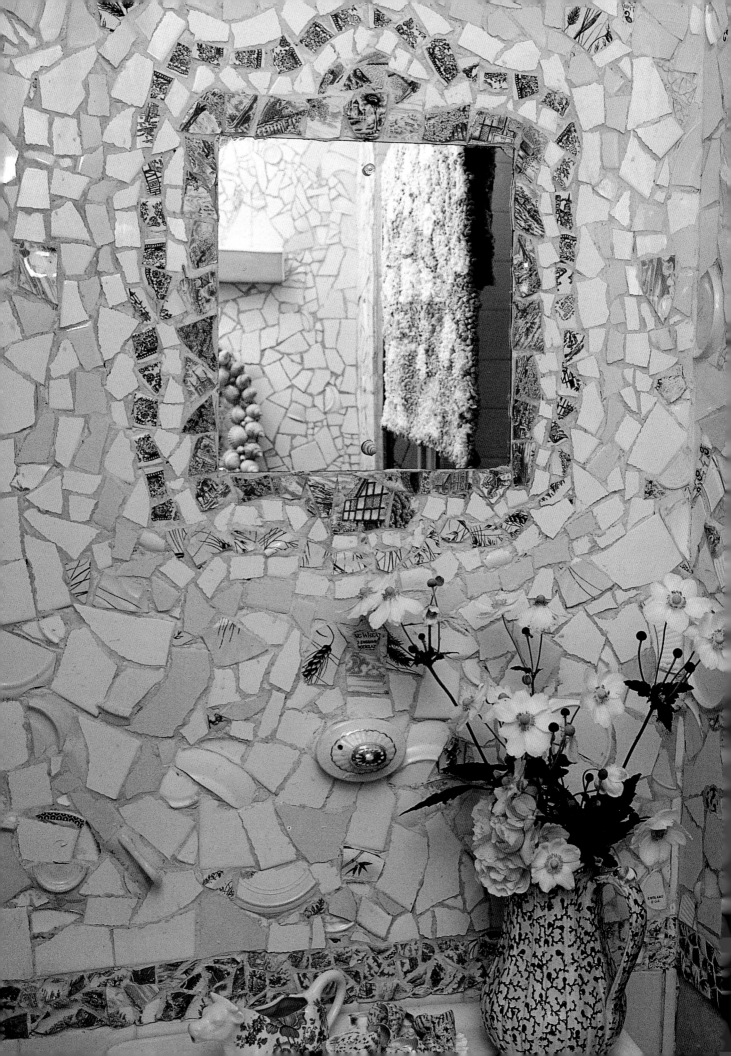

# Pebble Mirror

Some years ago I gave a mosaic course on a Greek island for a couple of weeks each summer. In late afternoons, as a treat to myself, I'd go to the beach and immerse myself in the obsessive search for pebbles – sparkling jewels at the water's edge, but soft and chalky when dried off. I wasn't sure what I'd do with my collection; I just had faith that something would develop.

Observing nature, I came to the idea of an unfurling fern, an accented swirl, a whirlpool, a drift of pebbles, with the colours blending gradually. People think I've painted the stones on my *Pebble Mirror*. Why, I reply, when nature gives us such captivating hues, every beach a different palette. They are all there for you to discover.

RIGHT Candace Bahouth's *Pebble Mirror*.
LEFT Examples of the naturally coloured pebbles used in the mosaic.

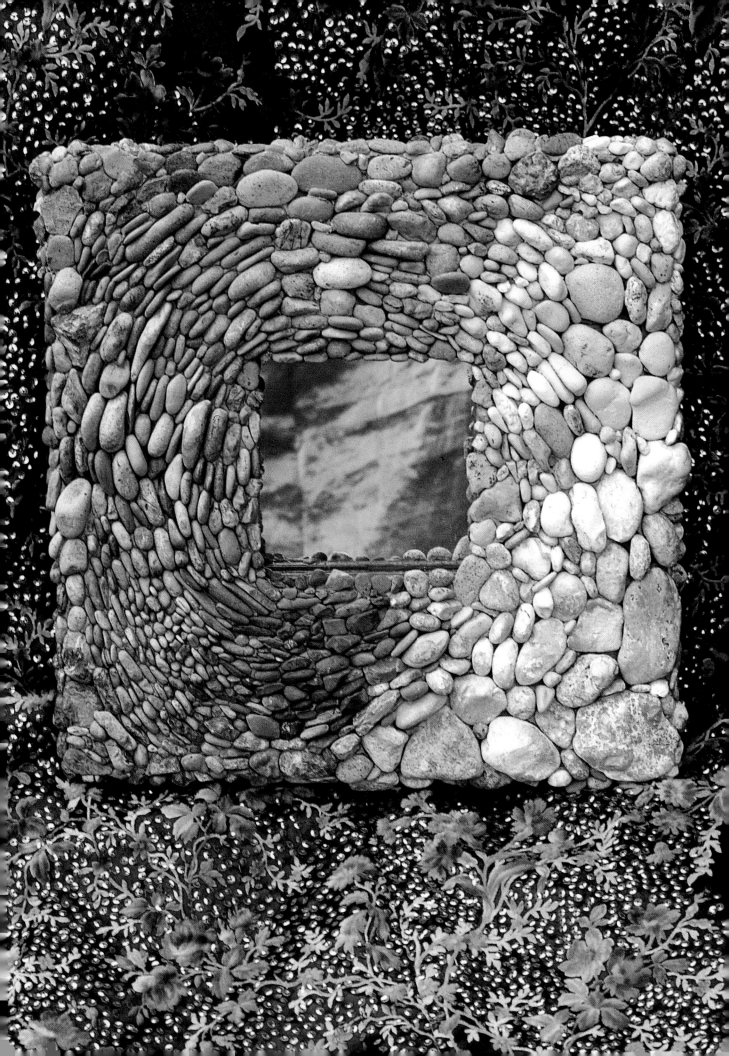

# Mosaicking the frame

## Basic materials and tools

Pebbles in various sizes and in six shade groups – chalky whites, peachy pinks, purply terracottas, grey-greens, sandy umbers and soft ochres; wooden frame, wood sealant and paint brush; cement spreader; white cement-based mosaic adhesive and dry stiff artist's brush for removing excess adhesive; acrylics for colouring cement to desired shades.

**Instructions**  Choose a wooden frame that is wide enough to accommodate your selected pebble sizes (RIGHT).

Keep in mind that very large frames will be very heavy once the pebble mosaic has been applied with the cement-based mortar. If you are making your own frame or having it made, use a water-resistant medium-density fibreboard or plywood. Also, be sure to incorporate an indent at the back of the frame for the mirror to slot into.

Before beginning, prepare the frame, scoring the surfaces that will be mosaicked and applying sealant to all sides. See page 42 for more about preparing mosaic bases prior to cementing the tesserae.

I  Begin by organizing your collection of pebbles. If it doesn't contain all of the shade groups suggested above, create your own palette with the colours you have at hand – perhaps blacks and terracottas, or all creams and beiges. Whatever your palette, sort the stones into shade groups and eliminate any that are too big and heavy to use. Make sure there are a sufficient number of flat stones – when turned on their side flat stones create thin strips useful for forming a swirling movement in the pebble mosaic arrangement.

2  Next, lay a large piece of brown craft paper on a flat surface. Lay the frame face up on the paper and trace the outlines around the inside and outside of the frame using a pencil or

felt-tipped marker. Remove the frame from the paper and set it aside.

Then plan your pebble mosaic roughly on the paper. Begin arranging the stones inside the outlines, starting with one shade in a corner, gradually leading into the next shade, then into the next.

Continue laying the pebbles on the paper, trying to create a swirling movement with the various stone shapes (RIGHT). Lay out all the shades in this way around the entire frame. You will need to add more stones when you begin cementing since many of the pebbles will be turned on their sides; but this loose arrangement is a good guide for the gradual shade gradation and the swirling movement of the shapes.

**3** Because pebble mosaic is not grouted, the cement will show between the stones, so it should be coloured to match. Decide which shade of pebble you are going to cement first, then colour some cement to match these stones. Remember that the cement will dry lighter than it appears when wet.

**4** Spread the coloured cement over a small area and begin sticking on the pebbles, transferring them from the paper sheet and adding more of the same shade where needed as the work progresses. Turn flat stones on their edges so that they form a thin strip when viewed from above. At the perimeters of the frame, where two surfaces meet, cement pebbles along both sides at the same time, overlapping the stones on the top of the frame over those on the side edges. Keep your hands clean at all times; the cement mortar is hard to remove from the porous stones. See page 51 for detailed cementing instructions for pebbles.

**5** Cement the pebbles in place all around the frame in the same way, mixing a new colour of cement for each of the shade groups. When the mosaic is set, insert the mirror.

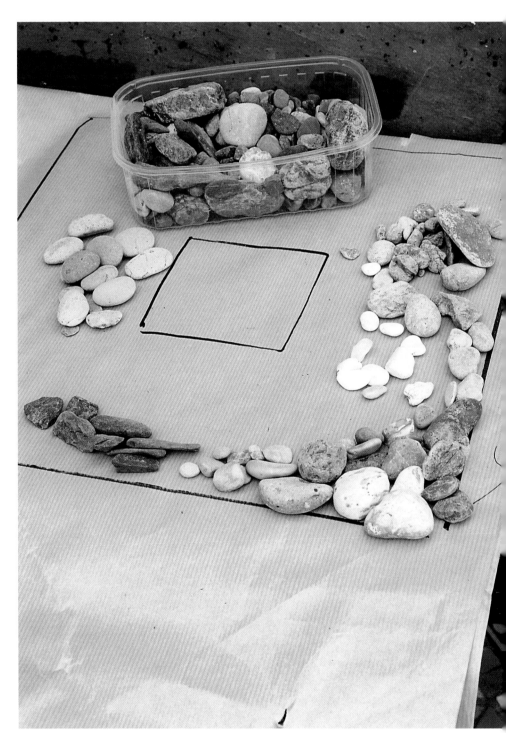

# Rose Table

What is it about roses that keeps dragging me back to them as a subject? Of course they are the king of flowers – but a big part of my attraction is the delight that naïf artists all over the world take in using them for decoration. In the Islamic world you can find rose motifs on everything, from perfume bottles to trucks; Scandinavians paint roses boldly on their furniture; and the Spanish and Chinese embroider great silk shawls with this voluptuous bloom.

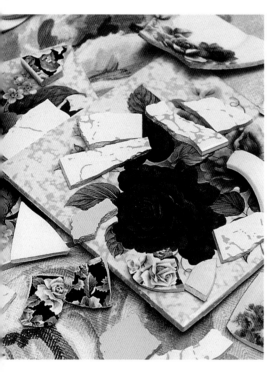

For years, I saved bits of red and pink rose china and rosy tea sets with the idea of doing this confection of a table. Then right before I started the mosaicking, I even got a potter friend to make me some nice rose tiles from old transfers, as overblown roses are hard to come by at a price that warrants breaking them up for mosaic.

These rose tiles were to become the focal points on the table top. The table shape is based on a Dutch side table I spotted in an antique shop and had copied in MDF. Its flat-sided surfaces were ideal for easy mosaicking.

I began the table top by sticking on a border of rose-print ceramic pieces alternating with shards of yellow-veined bathroom tiles. The centre of the top is a mélange of broken ceramics sprinkled with rose chips. You will notice that I simply broke apart any really good large rose motifs and placed the pieces together again in the mosaic. This way the energetic flow of broken mosaic is introduced, while the luscious images of overblown blooms remain intact.

To keep the effect as light and airy as possible, I added chips of white china to the mosaic and left a lot of white background around the motifs on the rose crockery shards.

Many people think that I never use white in any of my work because I so often point out that one of the great pitfalls of designing with colour is the indiscriminate use of white. Actually, like any colour it has its place, and when it's called for, nothing else will do such an effective job as white.

RIGHT  Kaffe Fassett's *Rose Table* with the artist's own still life, his fresco rose fabric and his rose needlepoint cushion. ABOVE LEFT  Tesserae materials used for the table mosaic. OVERLEAF  A flat view of the table top.

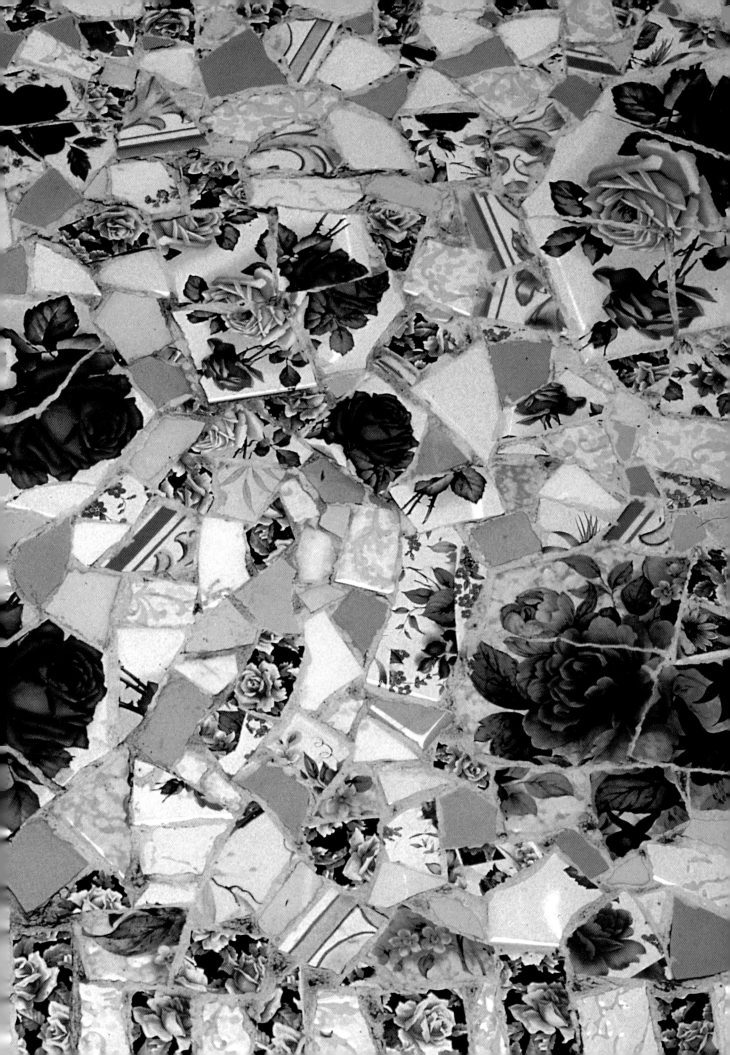

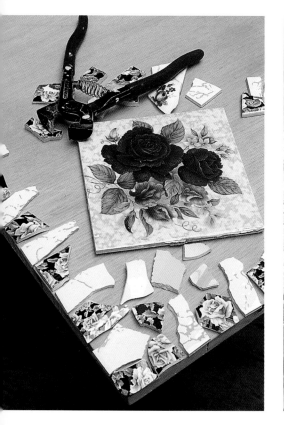

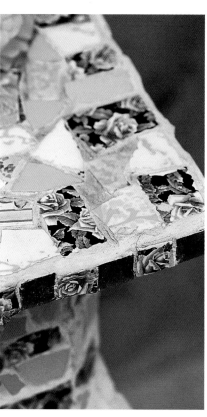

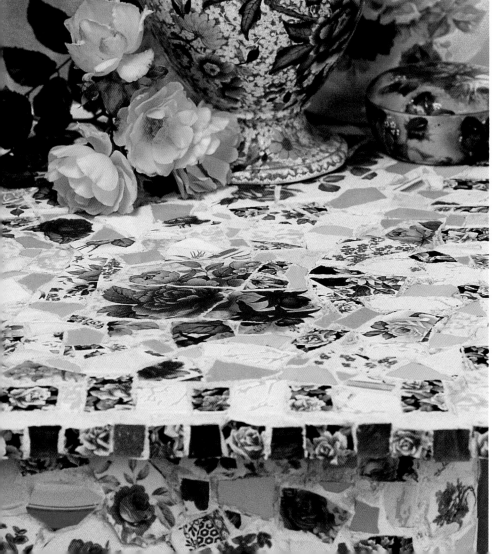

# Mosaicking the table

**Basic materials and tools** China and thin wall tiles predominantly in whites, off-whites and rose flower prints, with a smattering of shards in pale shades of pink, green, green-blue and yellow for an overall light and frothy mood, plus maroon vitreous glass tesserae for table lip border; wooden table, wood sealant and paint brush; nippers, cement and grout spreaders, and lint-free cloths; cement-based mosaic adhesive, white grout, and acrylics for colouring the grout.

**Instructions** Before beginning, make sure your table has flat enough surfaces for mosaic. (If your table has rounded legs, you will have to use quite small shards to fit neatly around the cylinders.) Next, prepare the table for mosaicking, scoring the surfaces and applying wood sealant. See page 42 for more about preparing mosaic bases prior to cementing.

1 Using the nippers, begin cutting the crockery into pieces. Make tesserae that are as flat as possible, dividing curved items, such as those from jugs and tea cups, into smaller pieces. Pay particular attention to the rose patterns on the china, carefully cutting around the blooms to get whole roses when possible. Very large flowers can be broken apart and then reconstituted in the mosaic with grouted gaps between the pieces (OPPOSITE PAGE, TOP). Save pieces with the smooth, rounded rims of saucers

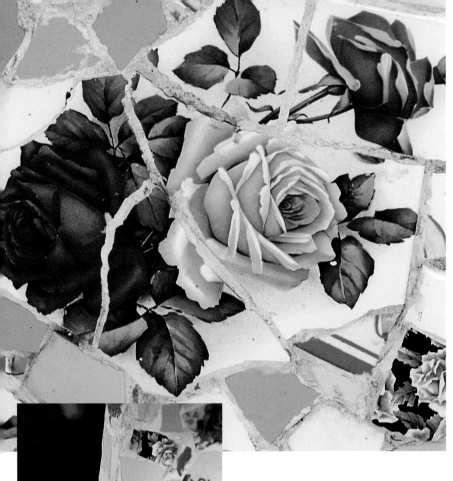

(OPPOSITE PAGE, BOTTOM). The largest flower prints on the table top have been spaced apart and the smaller prints, pale solid colours and whites filled in around them (see pages 74 and 75 for a full, flat view of the top).

• Each side of the table under the top and above the legs has been edged with the same border as the top and filled in with the random mixture of tesserae.

• On the legs, the borders of saucers with a tiny floral print have been added along the edges in some places (BELOW LEFT). For texture and movement, the bottoms of white saucers with their circular ridges were mixed in with the other large tesserae pieces on the legs.

4  Once you have studied the basic design plan, prepare more chips. Then start applying the mosaic. Cement the mosaics on the table top first, sticking on the checked border along the lip first, adding the border next, then filling in towards the centre. After completing the top, cover the sides under the top and then the legs. See pages 46 and 47 for cementing instructions.

5  Before grouting, colour the grout very slightly to give it an antiqued look. For the table pictured, only a pinch of black and a teaspoon of yellow acrylic were added to about three cups of white grout for this pale tint. See pages 48 and 49 for detailed grouting instructions.

mosaic along two sides of one corner of the table top, alternating the two colours (OPPOSITE PAGE, TOP LEFT). This exercise will give you an initial feel for how easily the odd, random shapes can be fitted together. The varying sizes of the border tesserae will soften the transition from the repeating band around the edge to the more 'crazy' centre.

3  Study the design features on the table before preparing more tesserae and before beginning the cementing:

• First of all, note that the lip of the table top is covered with a checked pattern of maroon vitreous glass tesserae alternating with pink rose chips (OPPOSITE PAGE, TOP RIGHT).

• The table top and the rest of the table have been kept light and frothy, with a predominance of whites

and plates to position along corner edges. Cut only enough pieces to get started and divide them into their various colour groups.

2  Using white chips flecked with yellow, and shards of a rose print with a dark ground, try arranging a band of

# Tapestry Chair

My initial idea for a mosaic chair was to dream up something bold, funky and colourful, but I couldn't make the vision appear in my head. So I started sketching some ideas to see where they would lead me. The ideas ranged from plates and teapots sticking out at all angles, to Klimt-like swirls extending outwards, to a painterly look which developed into a red chintz-style design.

In the meantime, while searching junk shops for a suitable chair base, I found a typical wing-backed armchair, which my husband Andrew stripped back to the basic wood frame. The back and side seat rails were reduced to add perspective and drama, the wings removed and the castors were replaced with cabriole legs. Then Annie Scotland, a friend and accomplished sculptress, covered the entire base frame in a segmented plywood skin, forming rounded contours.

Upon seeing the final wooden chair, a huge elegant throne, I immediately visualized a *trompe l'oeil* verdures tapestry. These 'green' tapestries, dating from the thirteenth century, were of leaf motifs instead of human figures. The scenes were usually centred around a flowering tree, which later developed into entire gardens. Water often played a symbolic role, signifying 'the source of all life'.

The tesserae used on the chair were matt unglazed square-inch tiles that came in sienna tones of terre vert and jade, creams, smoky blues, rusts, dark ochres, raw umbers, warm browns, greys and blacks. With some visual reference at hand, I began drawing on the chair. Using PVA acrylic adhesive to fix each individual piece enabled me to follow my simple pencil sketch – and it didn't add the weight that cement would have to this massive chair. To unify the whole and for practical reasons, I grouted the final composition.

The landscape was the most difficult area to mosaic – the intricate broad foliage, the bridge, water and trees with small curved leaves. My pieces seemed to become smaller and smaller slivers, and the whole project took an inordinate amount of time. But I enjoyed the incongruousness, the bizarreness of it – a fanciful notion, a caprice, a conceit!

The circle is complete. My journey began with the soft warp and weft on the tapestry loom and has taken me to the serenity of a crystal stream flowing through a garden consisting of a multitude of tiny, hard ceramic shards.

RIGHT **Inspired by woven tapestry, Candace covered her** *Tapestry Chair* **with slivers of ceramic tesserae.**

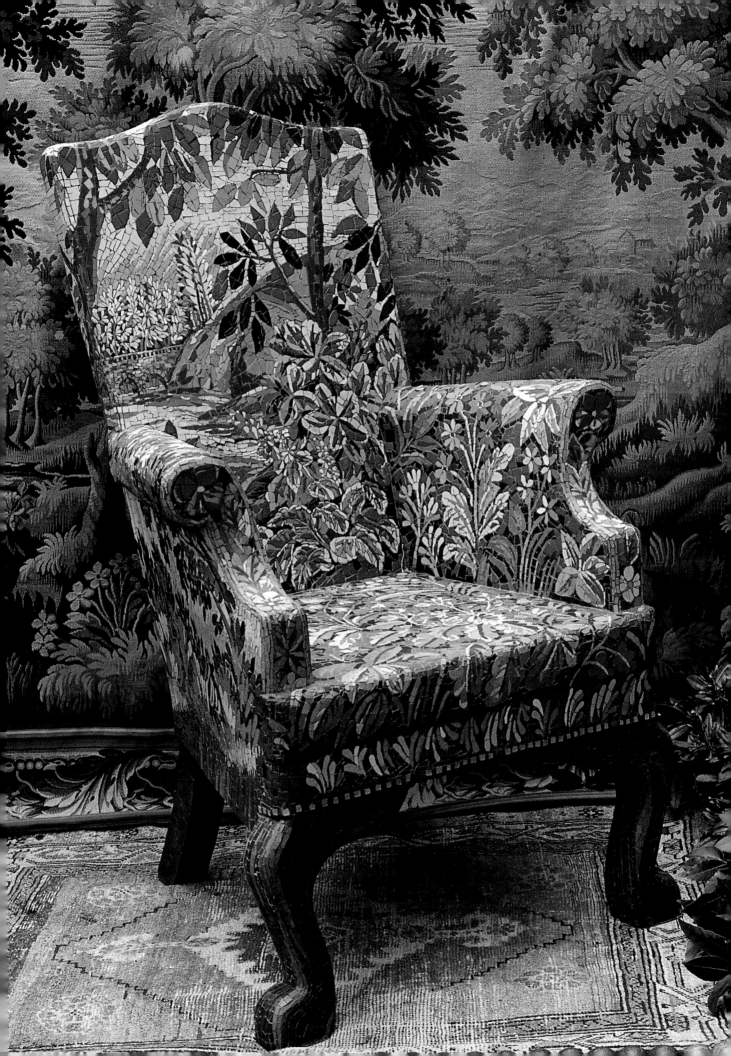

# Mosaicking a chair

### Basic materials and tools

Unglazed ceramic mosaic tiles (those used here are terre vert green, dark ochre, pale umber, coffee brown, black, slate blue, pale viridian, rusts, greys, cream, Naples yellow, rosy red and turquoise) and some gold-leaf glass mosaic tiles; wooden chair, wood sealant and paint brush; nippers, thin plastic straw, awl and hammer, grout spreader and lint-free cloths; water-resistant PVA adhesive; grey grout, and black acrylic for darkening grout.

**Instructions** These directions explain the process of planning and mosaicking a wooden chair with unglazed ceramic tiles to create a faux tapestry look. Although the wooden chair used as the base for this mosaic was made specially in the shape of a stuffed armchair for a *trompe l'oeil* effect (RIGHT), the tapestry patterns could be adapted to fit other bases, for instance an armless 'padded' chair or a 'padded' footstool.

If you do not know a willing woodworker to help you with such an ambitious project, take design and technical tips from this project to design a mosaic for a simple second-hand wooden chair. Just remember when choosing your chair that curved surfaces will require quite small tesserae to fit the shape, and that flat surfaces are easier to mosaic. Also, keep in mind that a chair requires a smooth surface which can only be achieved by using tesserae of the same thickness throughout

Before beginning, prepare the wooden chair for the mosaicking by scoring and applying wood sealant to all surfaces (see page 42).

**I** Start a chair mosaic by planning the design. For ideas on the types of woven tapestry patterns to use for mosaic, study the features of the chair on page 79 before proceeding:

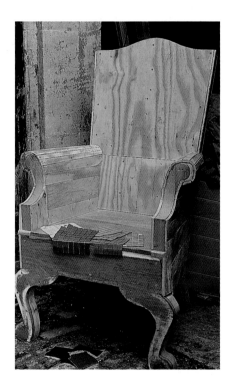

• Each of the surfaces on the chair has a different pattern on it. All the designs are various combinations of flowers, leaves, trees and other simple landscape features.

• Because the flowers and foliage are so detailed many of the tesserae have been cut very small, with the exception of the background where some of the mosaic tile pieces are larger. All of the tesserae are fitted closely together with only minimal gaps for the dark grey grout; this enhances the 'textile' appearance of the mosaic surface.

• Many of the flower petals on the chair are made from a single tessera. The contrasting flower centres are outlined with thin slivers of pale tiles.

• The large leaves have dramatic shading and thin contrasting veins. Where whole trees are depicted they are formed in billowing shapes that stand out in silhouette against their contrasting neighbours. Grasses have been created with close shades of thin upright tesserae strips.

• The feet of the chair are mosaicked with shades of brown to look like

wood, and gold-leaf glass tesserae have been used along the edge above the legs to imitate upholstery tacks.

• The back of the chair is covered with mosaic of simple ikat stripes on a green ground.

**2** Once you have decided on your design, make a paper template for each surface of the chair and draw the designs on to the templates. If you want to use tesserae shards that are larger than those used on the featured chair, limit the amount of detail in the design and use bolder, simpler shapes.

**3** Before transferring the outlines on to the chair, try arranging a few of the design elements – such as a leaf, a flower and a stem – to see if the shades work well together and to practise cutting the shapes. Lay your

drawing on a flat surface. Using the nippers, cut and nibble tesserae to fit the designs, then lay the pieces close together on the paper. Make any desired alterations to your design plan at this stage before continuing.

**4** Next, transfer the design outlines on to the chair or draw the shapes freehand directly on to the chair.

required shapes as you need them. (If necessary, odd mistakes can be chipped off with an awl and hammer.) After finishing the front of the chair back, mosaic the seat from the back towards the front, then the inside of the arms from the seat up over the curved top, the outside of the arms, the front edge of the arms,

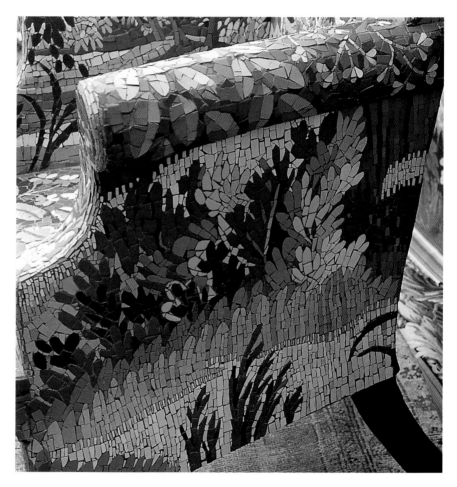

**5** Starting on the front of the chair back, begin gluing the tesserae in place, working from the bottom upwards and filling in the background last. Use a thin plastic straw to dab the glue on the wrong side of each tessera piece before pressing it in place. Cut the tesserae into the

the front side of the chair below the seat, the back of the chair and lastly the legs. See pages 46 and 47 for more about gluing.

**6** Before grouting, darken the grey grout slightly with black acrylic. Apply the grout following the instructions on pages 48 and 49.

# Blues Bathroom

Made of a mixture of ceramic tiles and china, this bathroom mosaic was inspired by the rich Rupert Spira floor tiles. After laying the tiles on the floor, I painted the bathroom walls a deep ochre, the ceiling dust blue and the window frame and decorative architrave periwinkle. I kept in mind these paint colours and the amber in the floor when composing the mosaics. Restraining the mosaic colour palette to mostly blues and lavenders creates just the right balance for the room and doesn't steal too much away from the tile floor.

For the mosaic covering the recessed sides of the window, I used ordinary bathroom tiles in teal, forest, grey-greens, turquoise, maroon and periwinkle, and added blue-and-white plate fragments here and there. The intermittent touches of ochre tile echo the wall tone. The dark grey grout with just a hint of blue ties the mosaic together.

For the mosaic panel under the window I used heavy, broken-up floor tiles in rich rusty reds and greeny blues for the most part. To interrupt the busy, random mosaic shapes, I included a few unbroken tiles, and introduced a sculptural quality to surface by adding large curved pieces of solid-coloured crockery.

Adding unexpected pieces to my mosaics – like handles, lids or these rounded bits of china

– comes naturally to me due to early encounters with the medium. Growing up in California, the eccentric Watts Towers made a lasting impression; every surface is covered in bright pastel tiles, shells, kitchen utensils, machine parts and broken crockery.

RIGHT AND BELOW  The mosaics in Kaffe Fassett's *Blues Bathroom* are composed of pieces of ceramic tiles and plain and patterned crockery in jewel colours. To attempt this treatment in your own bathroom, see pages 37–49 for detailed instructions on how to prepare and mosaic walls and wooden surfaces.

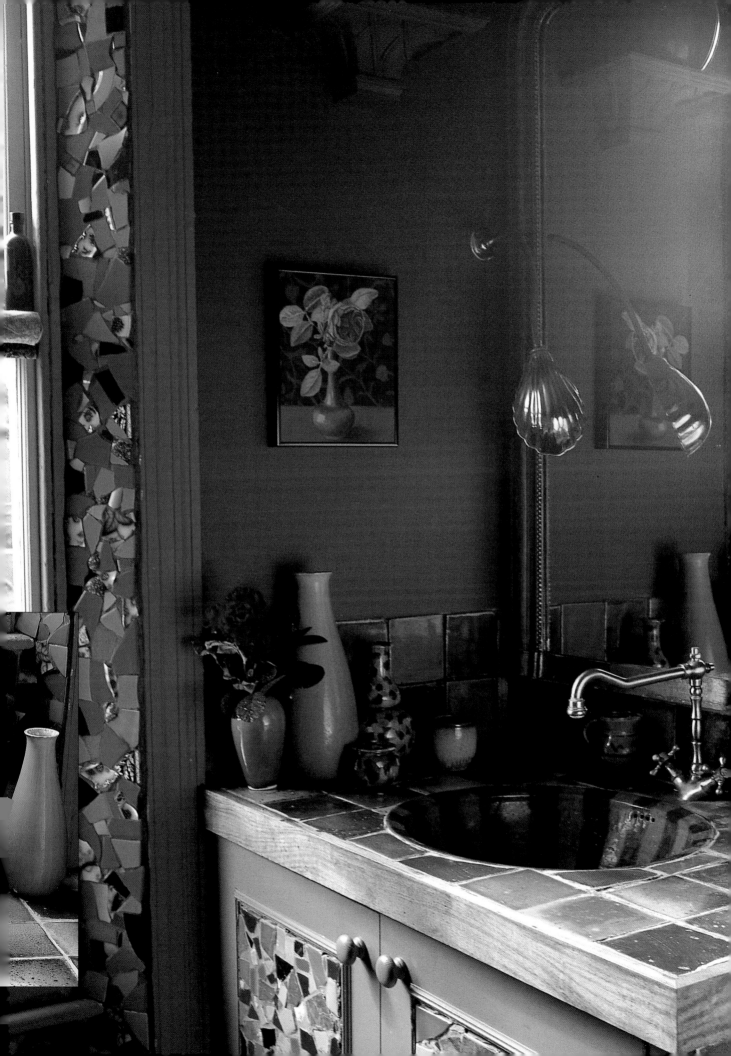

# Blue and White Vase

Blue-and-white china turns up everywhere – at jumble sales, in bric-a-brac shops, the garden, forgotten boxes in the attic, cobwebbed jars under the sink. This vase is probably the most straightforward of all my vases to make, since the raw materials are the easiest to find.

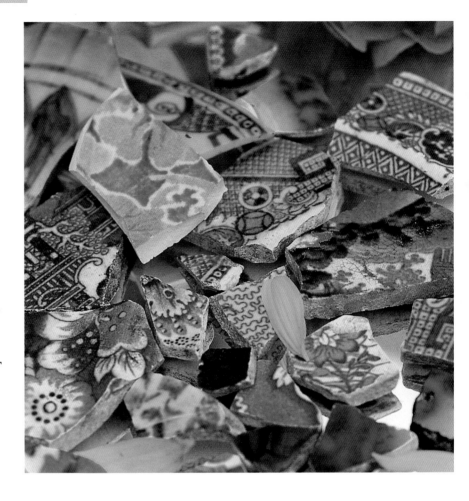

Indeed, when the word is out, the broken china arrives. Sometimes friends bring the most graceful teacups and saucers only slightly cracked or chipped, and I confess it is hard to introduce them to my hammer. Their delicate lines convey a sense of gentle civility, quiet conversations belonging to a time gone by, a pastoral serenity.

The first mosaic vase I designed is called *Confetti* because of the tiny specks of intense oranges, blues, greens and tomato reds scattered over

its surface (see pages 52 and 53). The yellow grout electrifies the work and the two odd handles are from another collection of goodies on my studio table. The blessed spout, that elegant handle, those delicate feet – treasures indeed and never too many!

The second vase I found to mosaic, a squat pot, cried out for a more masculine theme. The mosaic started at the inner rim of black and white squares, flowed outwards with a host of plummy colours and was grouted with chocolate brown.

Unusual forms for mosaic bases, like my little basket, are worth searching for. It was a truly lucky find and carried with it a very feminine mood of ribbons, sweets and daisies. Shards of candy pink, primrose yellow, lilac, heavenly blue, spring greens, and some rose- and tulip-patterned fragments added to its innate prettiness (see right and page 52).

RIGHT Candace Bahouth's *Blue and White Vase* and her feminine *Mosaic Basket*. ABOVE A selection of china used on the *Blue and White Vase*.

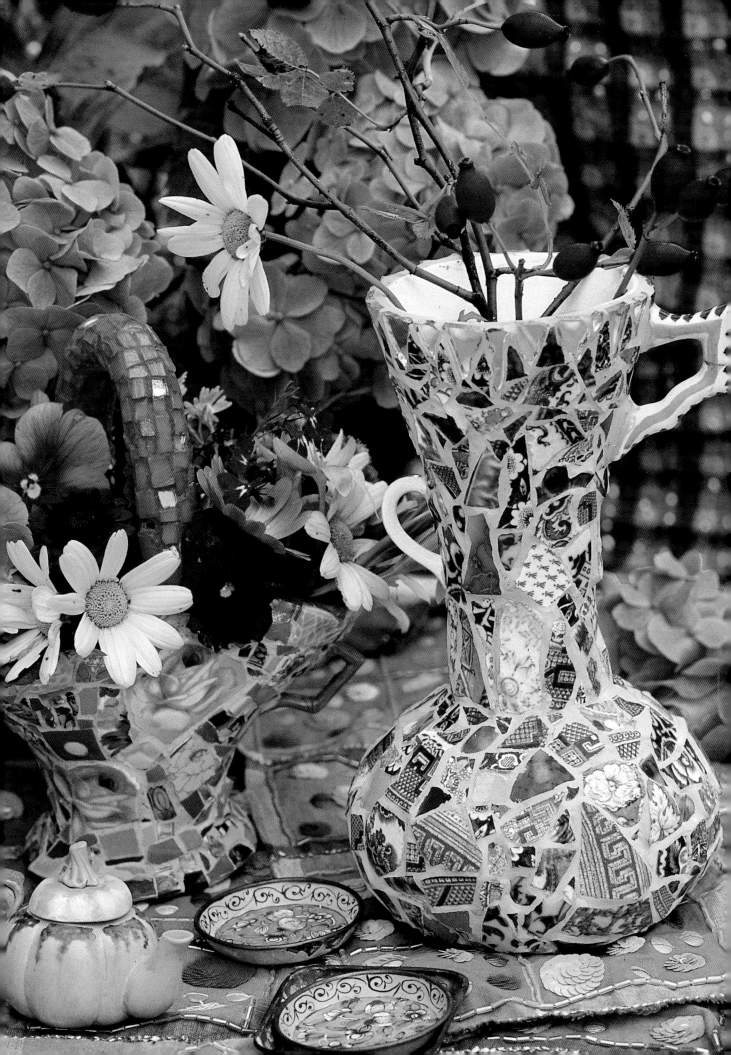

# Mosaicking the vase

**Basic materials and tools** Broken and chipped blue-and-white china in a mixture of patterns and slightly varying blues (but in the same thickness), and some broken mirror; ceramic vase, sealant and paint brush; nippers, cement and grout spreaders, and lint-free cloths; white ready-mixed all-purpose tile adhesive; white grout and cadmium yellow acrylic to colour the grout.

**Instructions** Choose a vase that is large enough and strong enough to mosaic, and one with a gently curving, graceful shape (RIGHT). Note that the two oddly matched handles on the finished *Blue and White Vase* have been added as part of the mosaic and are not part of the base vase. (If you are looking for other mosaic vase designs and colourway ideas, see Candace's mosaicked vessels on pages 52 and 53.)

If your vase base is terra cotta, before beginning prepare it by sealing the surface. See page 42 for detailed instructions on how to seal surfaces prior to mosaicking.

**I** Using the nippers, begin cutting the china into random shapes and sizes. Flat pieces are preferable, but slightly curved tesserae shards can be used if they fit snugly around the curve of the vase, or they can be cut into smaller pieces to flatten them. Be sure to pay attention to the patterns on the china, carefully cutting around

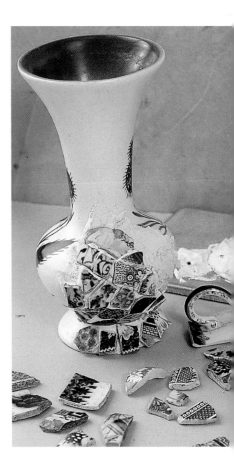

images you might want to use intact – such as small flowers or other attractive motifs. (When possible, save handles on teacups and jugs to add to your mosaics for sculptural effects.) Cut only enough pieces of china to get started and to practise your cutting technique. See pages 44 and 45 for more about preparing crockery tesserae and using nippers.

**2** Try arranging a few pieces of the cut china on a flat surface just to get a feel for how easily the odd, random shapes can be fitted together. Rearrange them a few times to see the different effects achieved by different arrangements. Note how the design changes if the tesserae pieces

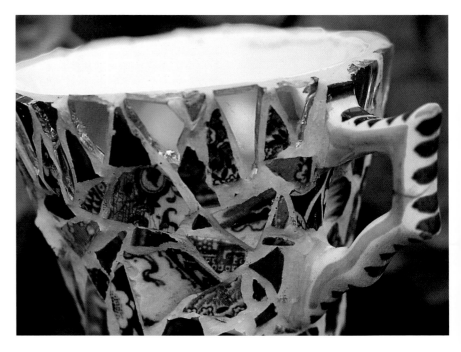

are fitted tightly together or with wider gaps between them.

**3** Study the mosaic on the finished *Blue and White Vase* on page 85 before cutting any more chips or beginning the cementing:

• The sizes of the tesserae vary considerably, and the various sizes are

mixed randomly together. The gaps between the pieces are not exactly the same width but are no larger than about 5mm (³⁄₁₆ in). Very small chips are used in places to fill in spaces between medium-sized and large shards (RIGHT).

• Matching patterned chips are mixed throughout the design and not concentrated in one area.

• Two handles from different pieces of china have been attached into the mosaic on opposite sides of the vase but at different levels.

• Triangular pieces of broken mirror have been used to form an energetic border along the top edge of the vase (OPPOSITE PAGE, BOTTOM).

• The entire mosaic has a bright yellow grout which accentuates the varying shades of blue and acts as a unifying element.

**4** Once you have established your design plan, prepare a few more chips. The shapes can be trimmed to more exact shapes as the cementing progresses, and the remaining pieces cut as they are needed.

**5** Next, start applying the mosaic to the vase. Leaving a gap of about 3mm (⅛ in) above the base of the vase, start at the bottom and work upwards. (Any tesserae too close to the lower edge can be damaged when the vase in moved about.) Spread adhesive over a small area of the vase each time, mosaic that area then spread on more adhesive. When

the mosaic reaches the middle of the vase, attach the handles and stick on the mirror chips around the top edge of the vase so that you can fit the blue-and-white mosaic around them. If you want to stop the mosaic at any

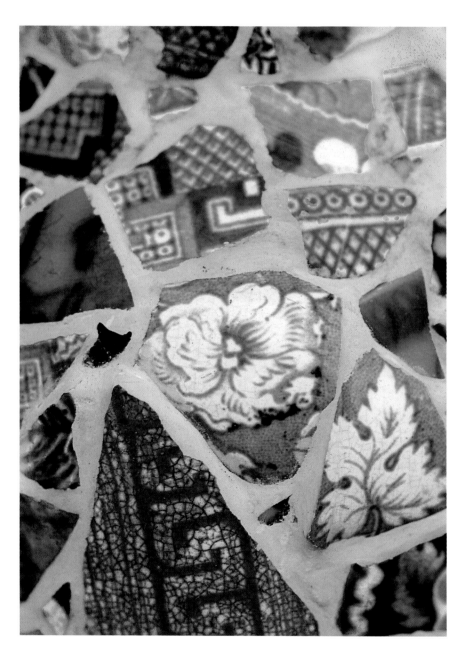

time and leave it to work on later, be sure to carefully wipe away any adhesive that extends past the mosaic you have completed so far. See pages

46 and 47 for detailed cementing directions and tips.

**5** After the mosaic has been completed, colour the grout to the desired shade with the cadmium yellow acrylic. Keep in mind when

colouring the grout that it will turn slightly lighter once dry. Apply the grout following the instructions on pages 48 and 49.

# Pearl Lamp

Those of you who have flipped through my seventh book *Glorious Interiors* will know I have a fatal attraction to kitsch. This is a nod to that world and to the religious icons I came across on my travels, in Greece, Russia and Turkey. The use of jewels, especially pearls, surrounding portraits of the Virgin Mary or Christ in the great churches never fails to quicken my blood. In fact, my first

instinct when starting this lamp was to find religious images to surround with pearls, but I couldn't find any so settled for roses.

The mosaic base for the lamp is ceramic. Because of the smooth glazed surface, the crockery shards and pearls slipped madly when I started gluing them on, even with the lamp lying on its side. As the work progressed I developed a technique of letting the glue almost dry on each pearl and china piece before sticking it on, so it wouldn't have to be held in position so long.

Applying the rose china bits first, I then built rows of pearls circling around each rose. The pearls came from car-boot sales and flea markets, and I enjoyed using the many shades I found – from gleaming white to palest greens, beiges and greys.

Perfectionists, in an ideal world, would carefully turn all the pearls so that the holes didn't show! Hurrying to see the delightful result of the mosaic, I overlooked the odd pinhole poking outwards. But now I think it actually adds subtle texture to an otherwise unrelentingly shiny surface.

The finished pearl lamp base needed a fairly simple pale lampshade, but one with a touch of kitsch that would smile at my pearl confection. All the lampshades I came across had too strong or too boring a look. Finally I bought a little cheap bedroom shade in a junk shop and raided my local upholstery shop for a length of ball fringe that actually looked like pearls. Hurrah! Isn't it satisfying to frame a work with just the right touch.

RIGHT Kaffe Fassett's *Pearl Lamp* sitting on the *Rose Table*, with his fresco rose fabric created for Designers Guild on the wall behind. ABOVE LEFT A selection of the broken rose china and artificial off-white pearls used for the mosaic.

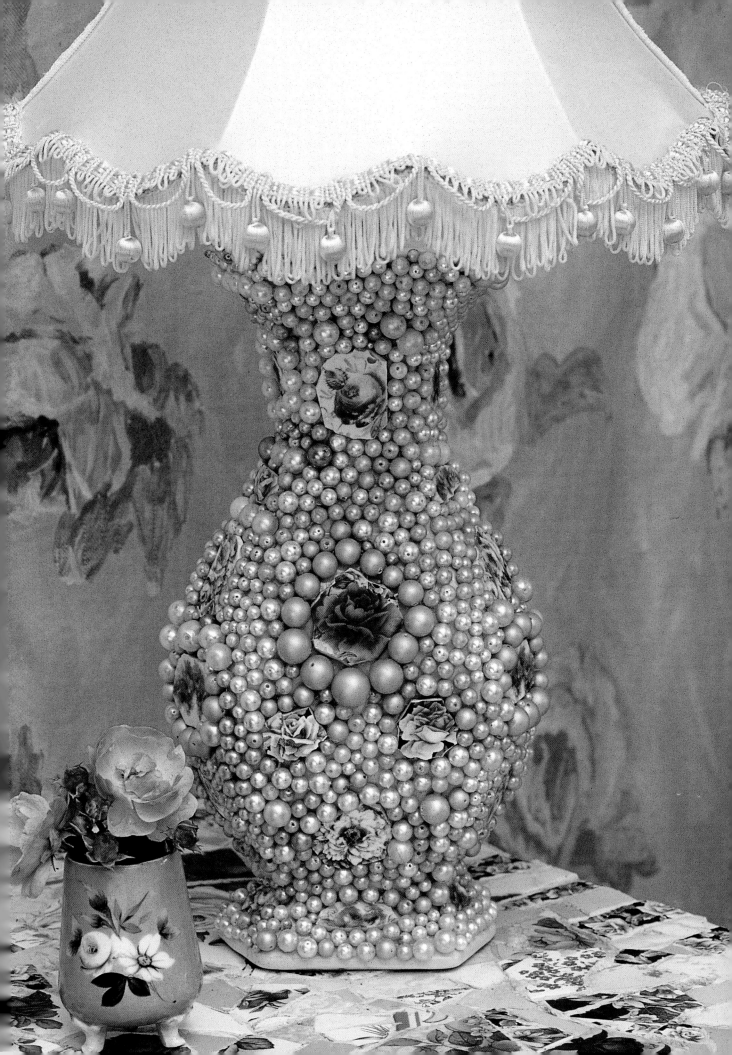

# Mosaicking the lamp

**Basic materials and tools** Broken china with bold pink rose motifs, and second-hand artificial pearls in a range of sizes (including giant-sized) and in a wide variety of off-white tones faintly tinged with greens, beiges and greys; ceramic or wood lamp base, sealant and paint brush; nippers and glue applicator; an acrylic-based glue such as PVA; lamp shade to suit the finished mosaic.

**Instructions** Choose a lamp base that has flat sides (RIGHT TOP), or one that is a gently rounded in shape. If the lamp is wooden, score and seal it before proceeding (see page 42).

**I** Using the nippers, begin cutting individual rose motifs out of the broken china. Nibble away the background as close as possible to each rose without cutting into the rose outline. Make sure that the tesserae are as flat as possible. If, however, your lamp base is rounded, you might be able to use tesserae pieces that form a curve matching that of the lamp base. For variety choose motifs in slightly different shades of pink and in a few sizes. Prepare as many roses as desired; the lamp featured has about six on each of the four sides.

**2** Lay the lamp base on its side to begin gluing on the china tesserae. Butter the wrong side of the first rose motif with the acrylic-based adhesive and allow the glue to dry slightly

before pressing the rose on to the lamp base in the desired position. Hold the tesserae in place until the glue has cured enough to keep it from slipping. Continue applying rose motifs until there are enough on this side of the lamp. Leave enough space between the motifs to fill in with pearls (BELOW). Allow the glue to set.

**3** Make absolutely sure that the glue on the china tesserae on the first side is set before continuing, or they will

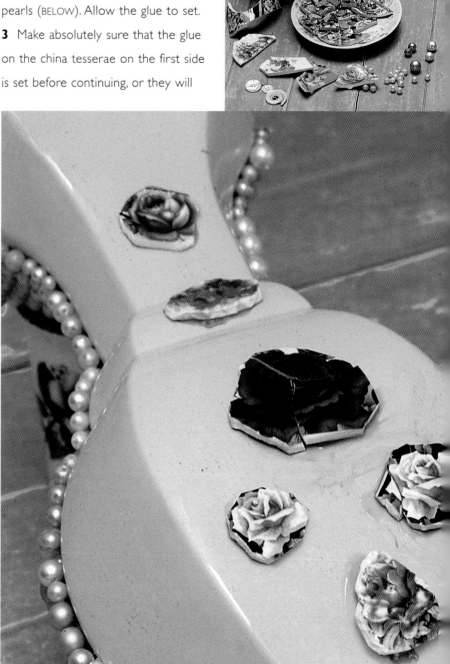

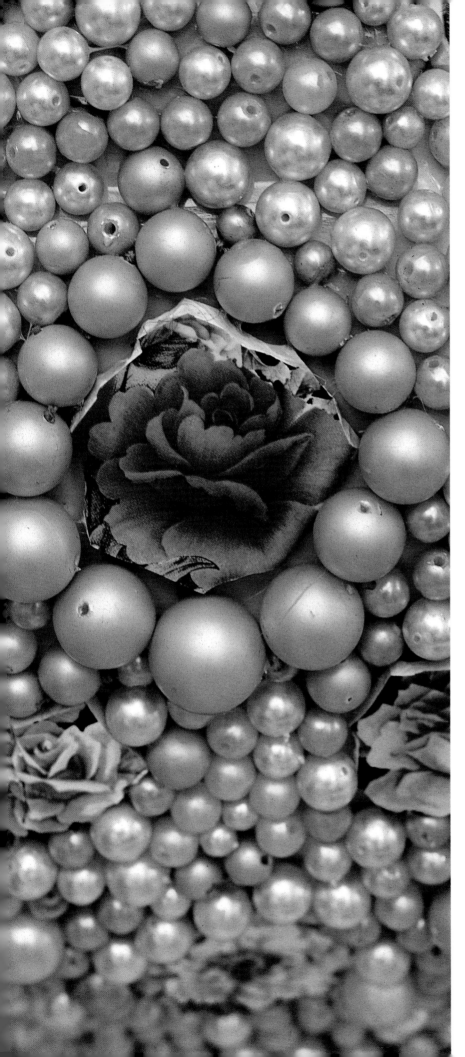

be dislodged when laid face down on the work surface. Then turn the lamp to begin work on the next side. Glue on all the rose motifs before beginning to add pearls.

**4** Unstring the pearls and separate them into a few general size groups. Spread each group out on a large plate or a big upturned box lid. With the pearls organized in this way it will be easier to pick out the sizes and colours as you need them.

**5** Lay the lamp base on its side again. Use the largest pearls to form a frame around the largest rose motifs (LEFT), and use a mixture of large and medium-sized pearls to ring the smaller motifs. Butter each pearl individually with the acrylic-based adhesive and allow the glue to dry slightly before pressing it on to the lamp base. Hold the pearl in place until the glue has cured enough to keep it from slipping.

After circling each rose motif on that side of the lamp, fill in the background with the smaller pearls, mixing the shades randomly. Do not cover the lamp base all the way to the bottom edge, but leave about 3mm (⅛in) uncovered. Pearls too close the bottom edge could be easily dislodged when the lamp is moved around. Allow the glue to set.

**6** Then turn the lamp to begin the next side. Continue in the same way, allowing the glue to dry completely before turning the lamp each time.

# Pastel Frame

The mosaic frame could be thought of as a form of temple or shrine. It is the embellishment of the image within, a tribute, a form of homage to the picture or photo. It also gives you an excellent opportunity to create mosaic on a relatively small area with a regular, flat surface. This 'blank canvas' provides a great chance for self-expression in the development and composition of a visual statement. The theme can be a dialogue between image and surround, or a reflection of a personal memory – perhaps visions of a Caribbean holiday. And the wider the frame, the greater the area you have to 'dream on'.

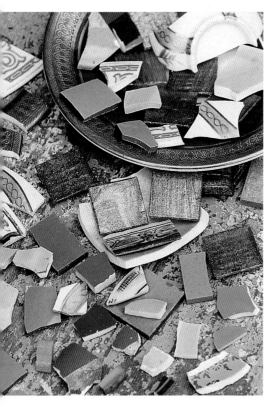

The first in my series of mosaic mirror frames, was the *Jazzy* version (see page 54). Having a leaning towards potent colours and unexpected contrasts, I started with a medley of primary colours: zingy oranges, lemony yellows, electric blues and some shards with bold lines or shapes. With this dazzling kaleidoscope of colours, I composed an improvisation of hot rhythm. The black triangles around the edge surround and amplify the energy within.

Another colour theme I explored for my mirrors was a harmonious melody in blue-and-white china pieces with an inner border of sharply contrasting orange. Wanting to produce a softer, sophisticated mood for the *Pastel Frame*, I looked to nature – pinky-beige hydrangea petals and delicate roses with their tender green leaves. I collected some dusky rose glittery tesserae, fragments of gold, a few flower-patterned shards, then added some of my cherished white-dotted blue crockery and, to unite this perimeter, some biscuity unglazed ochres and greys. By chance I had four pink, gold-flecked glazed miniature tiles, and placed one in each outer corner to unify and give balance to the design. The sandy coloured grout provides a neutral bonding that allows the intrinsic character of the mosaic to stand out.

If you have a wooden frame already at hand or you are going to have one made, be aware of the depth of the edges and how your pieces will join at the perimeters. I usally place the top shards over the side edges for a smooth, tidy finish.

RIGHT Candace Bahouth's subtly toned *Pastel Frame*. ABOVE LEFT Shards used on the frame mosaic.

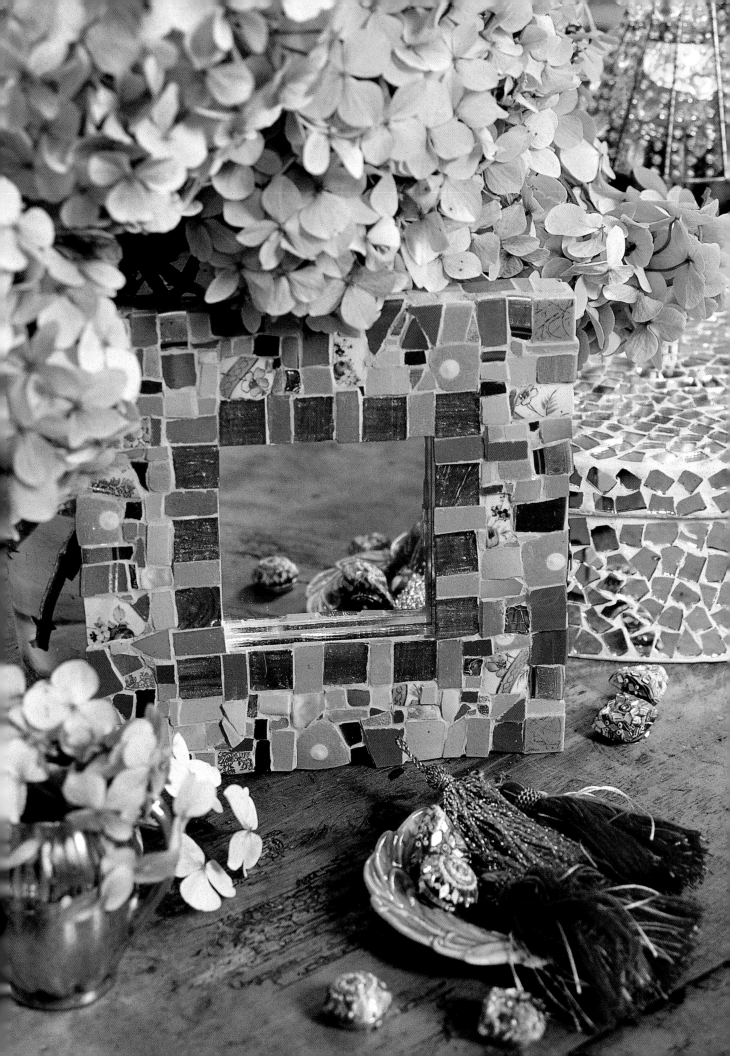

# Mosaicking the frame

**Basic materials and tools** Broken china and vitreous glass tesserae in pastel shades, unglazed ceramic mosaic tiles in ochres and greys, glittery dusky rose glass tesserae and glass gold-leaf tesserae – for a soft sophisticated mood; small strips of mirror for inner edge of frame; wooden frame with flat surfaces, sealant and paint brush; nippers, cement and grout spreaders, and lint-free cloths; ready-mixed white tile adhesive; white grout and acrylics for colouring grout.

**Instructions** Choose a frame for the mosaic that is wide enough to accommodate an interesting tesserae arrangement. Keep in mind that very large frames will be quite heavy once the mosaic has been completed, due to the extra combined weight of the tesserae, cement and grout.

If you are making your own frame or having it made, use a water-resistant medium-density fibreboard or plywood. Also, be sure to incorporate an indent at the back of the frame for the mirror to slot into.

Before beginning, prepare the frame, scoring the surfaces that will be mosaicked and applying sealant to all surfaces with a paint brush. See pages 42 and 43 for more about preparing mosaic bases prior to cementing and grouting.

**1** Study the design features on the finished *Pastel Frame* on the previous page and in the detail pictures on this page and the next before beginning to cut any tesserae pieces:

• The inner edge of the mirror frame has a border of uncut squares of glittery dusky pink glass mosaic tesserae, alternating with half squares of unglazed ceramic mosaic tiles in ochres and greys.

• A row of tesserae cut in irregular rectangles and squares (and an occasional triangle) in random shades runs along the outer edge of the

frame, and the area between the two borders is filled with smaller tesserae pieces also cut in irregular rectangles and squares.

• An identical small square pink tesserae flecked with gold has been placed in each of the four outer corners of the frame to unify the design (ABOVE RIGHT).

• The outer sides of the frame are covered with rectangles and squares in random shades, and the inner sides are covered with strips of mirror (OPPOSITE PAGE).

**2** Next, using the nippers, begin cutting the crockery and mosaic tiles into small, irregular rectangles and squares, and the occasional triangle. Make the broken china tesserae as flat as possible, dividing curved shards, such as those from jugs and teacups, into smaller pieces to flatten them. Cut only enough pieces to get started and to practise your cutting technique.

**3** Try arranging some of the cut tesserae on the frame itself. Lay the frame on a flat surface. Begin to form the border along the inner frame edge with uncut squares of glittery

dusky pink glass mosaic tesserae, alternating with half squares of unglazed ceramic mosaic tiles in ochres and greys. Then start the row of irregular rectangles and squares around the outer edge and lastly fill in between the two borders (OPPOSITE PAGE, LEFT).

This exercise will give you a feel for how easily the cut pieces fit together and is a good way to test your colour scheme. Remove the tesserae arrangement on the frame and set it to one side so you can begin the cementing. (If desired, you can trace the shape of your frame on a piece of brown craft paper as for the *Pebble Mirror* on page 70, and arrange the whole design on the tracing. But because the design is simple and the tesserae arrangement random, this is not really necessary unless you are still unsure about creating your colour scheme successfully.)

**4** You are now ready to begin the cementing. Spread some adhesive on a small area on the frame and press the tesserae into it. Stick on the tesserae along inner and outer edges first and then fill in between these two borders. Continue in this way. Remember to stick on the tesserae along both surfaces at the same time where two surfaces meet, such as around the perimeter where the sides of the frame meet the front. Top tesserae should overlap the side tesserae for a neat and smooth edge

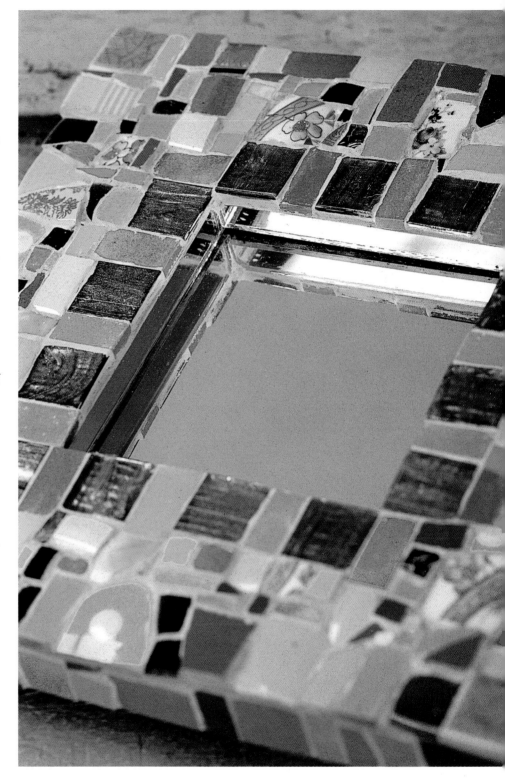

(ABOVE). See pages 46 and 47 in the Making Mosaics chapter for full cementing directions and tips.

**5** Once the mosaic has been completed, allow the adhesive to cure thoroughly before beginning the grouting. Then colour the grout slightly to a sandy, buff colour. Apply the grout following the detailed instructions on pages 48 and 49.

# Apple Shelf

This little shelf is a favourite of mine. It was made to my design most charmingly by mosaicist Sarah Kelly. The combination of geometric pattern and plump, colourful fruit motifs could be a never-ending source of juicy ideas for mosaics. Kitchen splash backs or cupboard doors covered with this sort of treatment would spring to life.

There is something magical about little objects completely covered with pattern and detail. As fiddly as it might be to mosaic a scalloped edge with tiny pieces of crockery and tiles, its effect on this shelf is so charming that it was definitely worth the effort. Sarah covered the scallops beautifully with the small, neatly and snugly fitted random-shaped tesserae. I had her alternate the pink scallops and green scallops to create an awning effect.

The simple flat leaves that border the edge of the shelf top look quite dimensional with their delicious variation of greens and yellows. Placed next to the bold rounded leaves, the multi-coloured chequerboard pattern adds an energetic contrast. For a shelf top you need to remember to keep the tesserae the same thickness for a level surface. I do use rounded cups and saucer edges on table tops, but in quite small pieces to minimize the curvature.

The apple mosaic on the side panel of the wooden shelf contains a china chip with an actual apple print on it. I have seen this sort of thing done heavy-handedly – an image made out of china shards with motifs of that image on them – where the colours weren't sensitive enough to make it work. But this mosaic apple is light-handedly and rhythmically rendered.

When mosaicking on a good little shape like this wooden shelf, simple borders and well placed motifs become very ornate looking with the minimum of fuss.

The soft grey grout added after the mosaic was stuck in place provides the perfect background for these high chalky pastels. The grout virtually disappears leaving the colours to dance and twinkle!

RIGHT Kaffe Fassett's delightful *Apple Shelf* mosaic with its charming scalloped 'awning' and multi-coloured chequerboard top. A single mosaic apple boldly fills each of the side panels on the wooden shelf. The shelf mosaic is made from a mixture of vitreous glass tesserae, thin wall tiles and broken crockery in predominantly high chalky pastels. See pages 98 and 99 for instructions for how to prepare, mosaic and grout the wooden shelf.

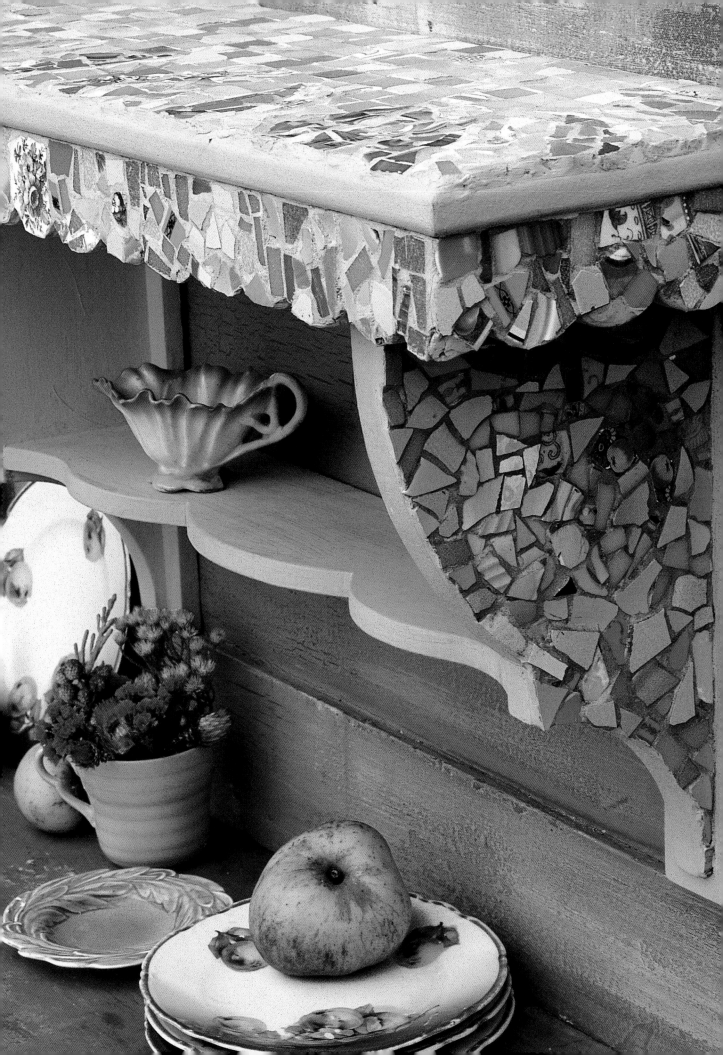

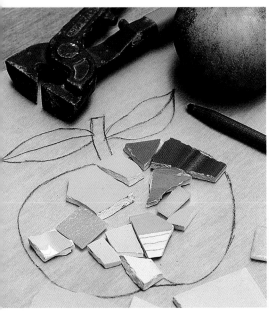

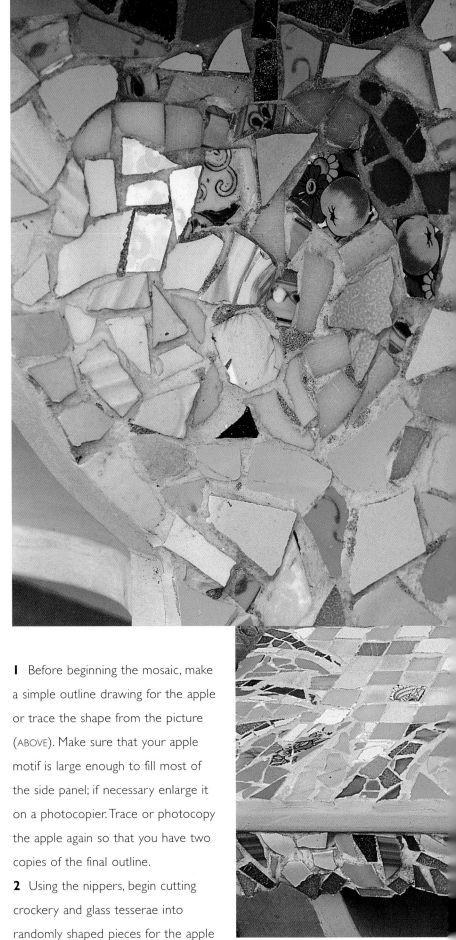

## Mosaicking the shelf

**Basic materials and tools** Broken crockery, thin wall tiles and vitreous glass mosaic tesserae in predominantly high chalky pastel shades of blue, turquoise, green, pink, peach and yellow, and a few oranges and orange-reds for the apple motifs; wooden shelf, shelf paint in desired shade, wood sealant and paint brush; nippers, cement and grout spreaders, and lint-free cloths; cement-based mosaic adhesive and light grey grout.

**Instructions** Choose a shelf that has side panels for the apple motifs. If desired, make a shelf using water-resistant MDF for the shelves and panels, and waterproof plywood for the scalloped 'awning'. Paint the areas of the shelf that will not be mosaicked, leaving enough paint for touching up once the mosaicking is complete. Score and seal the surfaces that will be mosaicked (see page 42).

1 Before beginning the mosaic, make a simple outline drawing for the apple or trace the shape from the picture (ABOVE). Make sure that your apple motif is large enough to fill most of the side panel; if necessary enlarge it on a photocopier. Trace or photocopy the apple again so that you have two copies of the final outline.

2 Using the nippers, begin cutting crockery and glass tesserae into randomly shaped pieces for the apple

mosaic. Make tesserae that are as flat as possible, dividing curved items, such as those from jugs and tea cups, into smaller pieces to flatten them. If you have any apple motifs in your broken china collection, carefully cut around them to preserve whole apples if possible. As you prepare the tesserae, fit them together on top of one of the apple drawings (OPPOSITE PAGE, LEFT). While trying out mosaic arrangements in this way, remember that when actually sticking on the pieces you will be leaving small gaps between the tesserae for grout. This exercise will give you an initial feel for how easily the odd, random shapes can be fitted together. To start, cut only enough mosaic pieces for one apple.

**3** Study the following design features on the shelf before preparing more tesserae and before beginning the cementing and grouting:

• First of all, note that large abstract leaf shapes form the border along three edges on the shelf top. Each leaf has a narrow pale-coloured vein running down the centre, and a lighter and a darker side (BELOW). Straight cut edges of tesserae run along the shelf edge; after the mosaic was finished the cut edges were painted with the shelf colour.

• The background on the shelf top has a chequerboard pattern. Some of the squares on the chequerboard are whole glass tesserae tiles and the others have been cut from broken china and thin wall tiles to roughly the same size. The various colours have been sprinkled randomly yet evenly across the chequerboard (BELOW).

• Each side panel on the shelf has a large apple. The background around the apple is filled with chips mainly in shades of blue (OPPOSITE PAGE, RIGHT).

• The scallops along the shelf top have been covered alternately with pink and green tesserae (BELOW).

**4** Transfer one apple motif outline on to each side panel of the shelf. Then draw the bold leaf shapes along the front and side edges of the shelf top.

**5** Next, start applying the mosaic. Cement the mosaic on the shelf top first, working from the edge towards the centre and cutting more tesserae as you need them. After completing the top, mosaic the apples on the side panels, then fill in the background around the apples, and lastly cover the scalloped 'awning'. See pages 46 and 47 for cementing directions.

**6** Colour the grout if necessary and apply it. See pages 48 and 49 for grouting instructions.

**7** When the mortar has completely set, touch up the edges of the mosaic with the shelf paint.

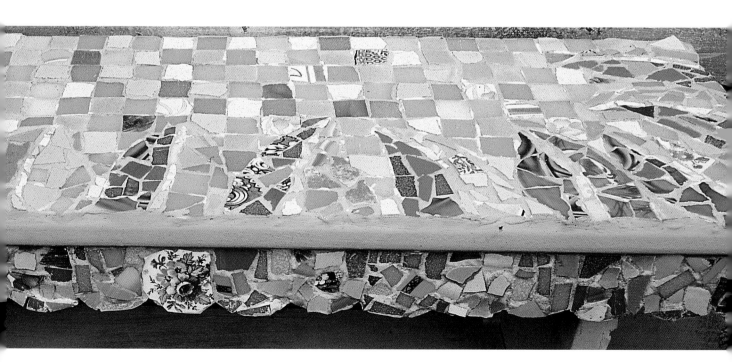

CANDACE BAHOUTH

# Mosaic Portrait

My fascination with 'the human face divine' has been with me since my early teenage years. It's a family trait, since my father drew excellent portraits for as long as I can remember. Kaffe encouraged me to try a mosaic face, something I had not contemplated before. It took some persuading, but on a visit to the British Museum to see an Etruscan exhibition I found my inspiration and was hooked! After drawing a rough sketch on the wooden base board, I glued the pieces on individually, beginning with the large luminous eyes. This is my favourite starting point; having succeeded in portraying the 'windows of the soul', I feel more confident to continue. Striving for a liquid quality, I added some black glass tesserae to the otherwise matt pupil, and a dot of white. Three different greys suggest shadow on the edge of the iris, and a line of light ochre underneath enhances the depth. Shadows under the eyes and expressive eyebrows in warm umbers emphasize the contours.

Invariably in portraiture, a source of light illuminates one side of the face to dramatize and maximize the three-dimensional effect. I shaded my face by using darker tones on one side of the forehead, cheekbone, nose and neck. The forward extremities of the face are emphasized by a suggestion of light, and the darker outline around the portrait brings the whole subject forward.

Flowing lines in a mixture of skin tones give structure to the face, and the rows of varying colours on the neck echo the curve of the jaw. Tinged with rust, grey and black, the red-stained lips provide a flash of brilliance in the otherwise muted mosaic hues. Combining shiny and matt black tesserae in the hair was an attempt to portray volume and varied highlights. The traditional blue background of early mosaic portraiture gives the design an exotic splendour, and the lack of grout keeps the colour definition crisp.

RIGHT  Candace Bahouth's *Mosaic Portrait* with its skilful andamento. ABOVE LEFT  The Etruscan inspiration painted on wood with hot wax, and the mosaic palette.

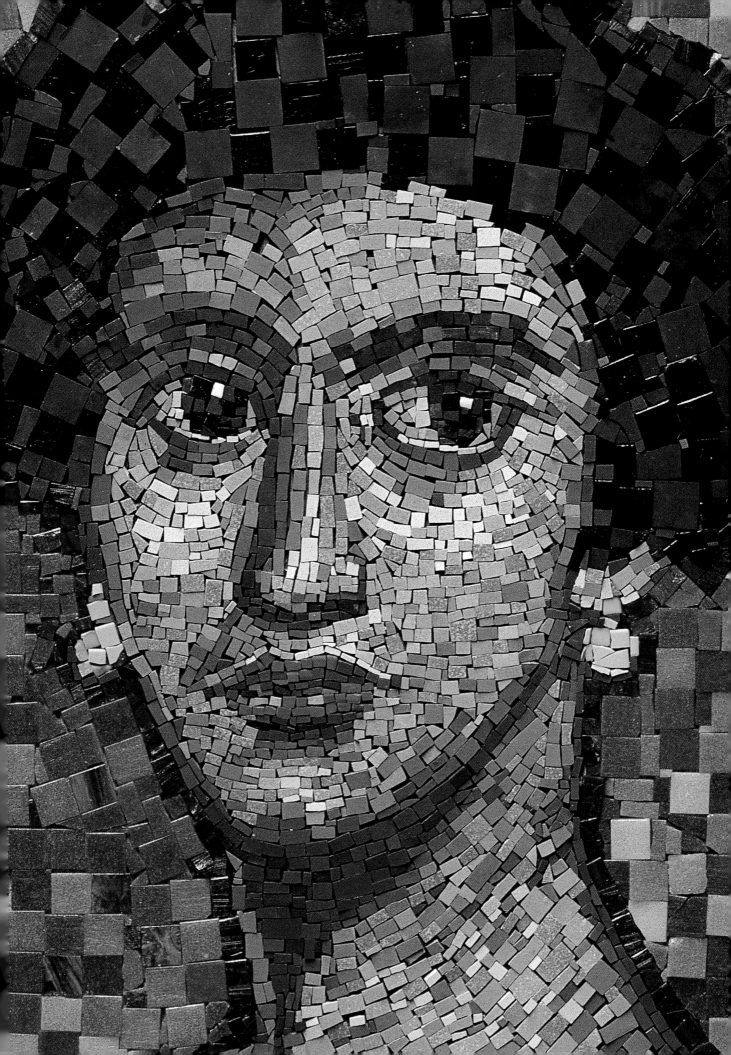

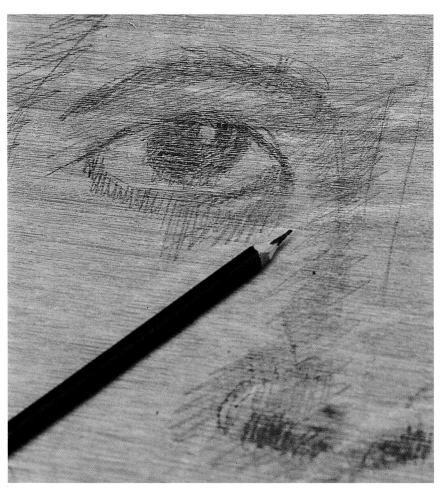

here as the basis of your portrait or create your own. Before beginning, score and seal the board.

**1** To imitate the portrait shown here, trace the outlines and fill in some of the shadows. Enlarge the drawing to the actual size (the measurement between, and not including, the earrings is 23.5cm/9¼in). Or, sketch an original portrait.

**2** Study the face on page 101 to see how a portrait mosaic is built up:

• The tesserae have been cut into small squares and rectangles of varying sizes, with the exception of the larger pieces in the hair and background. Because no grout is used the pieces are fitted snugly together.

• Note the mixture of colours used for the eyes, mouth and skin, and how

# Mosaicking a portrait

### Basic materials and tools

Unglazed ceramic mosaic tiles (those used here are yellow ochre, Naples yellow, sienna, slate green, coffee browns, white, cream, raw umber, greys, rust, soft pinks, rose red, black and turquoise) and vitreous glass tesserae in blues and black – for a saturated Siennese colour scheme; wooden board, wood sealant and paint brush; nippers, tweezers, thin plastic straw, and an awl and hammer; an acrylic-based glue such as PVA.

**Instructions** These directions explain how to make an ungrouted mosaic portrait. Use the image shown

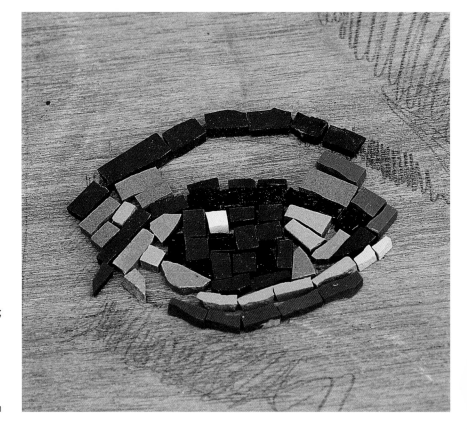

the lightest and darkest hues are positioned to form shading.

• Along with the shading, it is the flow of the tesserae that shapes the facial contours. Inside the row of tesserae around the neck, head, nose and ear, the mosaic pieces are lined up in rows to follow the curves of the face.

• The use of whole square tiles and some smaller pieces, and both shiny and matt black in the hair gives it bulk and depth. The irregular outer edge evokes hair texture.

• The background is built up of mainly full squares in rows to give the design solidity. The addition of some smaller pieces, the variety of shades and the slight unevenness of the rows gives it a touch of movement and energy.

**3** Before transferring the outlines on to the board, try arranging an eye and the mouth to practise cutting tesserae and creating shading. Lay the pieces close together on the board or on your drawing. Use tweezers to place small pieces if necessary. If desired, test other areas. Make any alterations to your design plan before continuing.

**4** Next, transfer the portrait drawing on to the wooden board, or if your drawing skills are up to it, sketch the portrait freehand directly on to the board (OPPOSITE PAGE, TOP).

**5** Starting on the eyes, begin gluing on tesserae, sticking on the eyebrow line and the lines around the eyes first, then filling in the eye centre and lastly the cornea (OPPOSITE PAGE,

BOTTOM). Use a thin plastic straw to dab the glue on each tessera piece before pressing it in place. Cut the tesserae into the required shapes as you need them. (If necessary, odd mistakes can be chipped off with an awl and hammer.) After finishing the eyes, mosaic the mouth (BELOW), nose, and the face and neck outlines, then fill in the face and neck. Work the ears, earrings, hair and dress details next, and the background last.

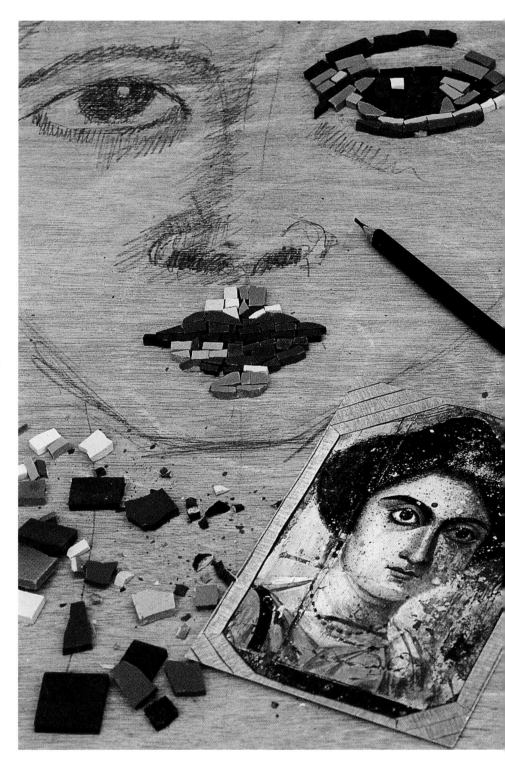

103

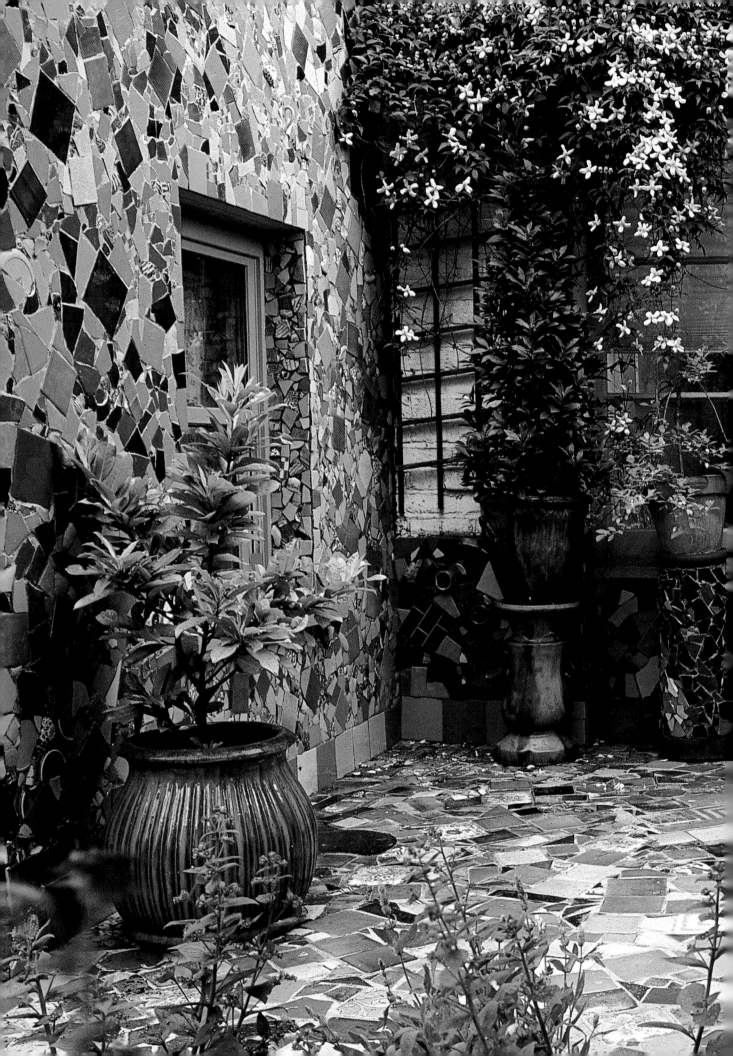

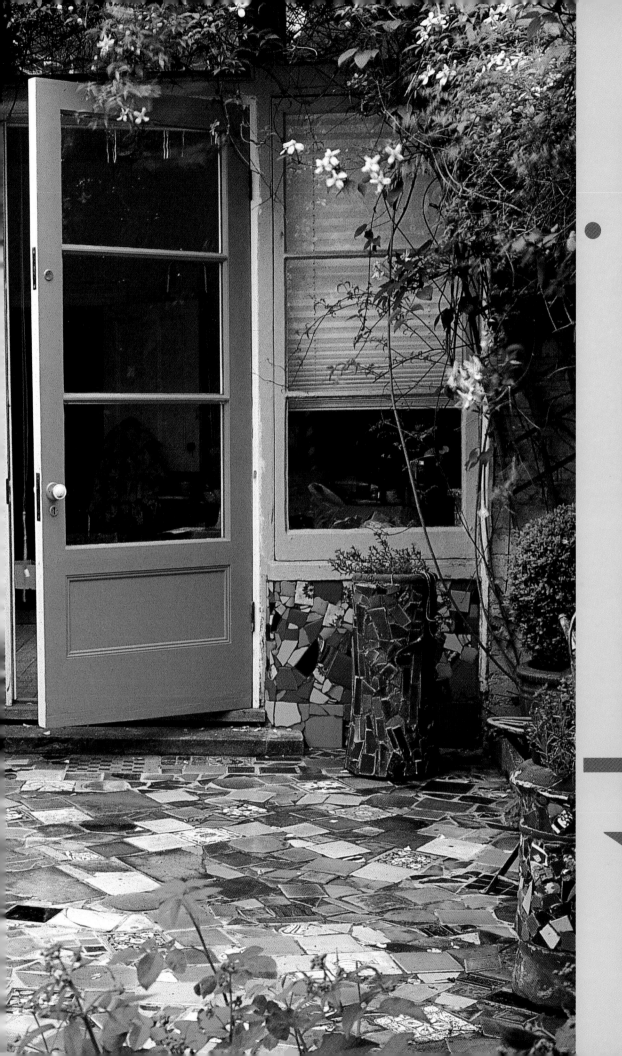

outdoor mosaics

Like the last, this chapter is full of inspiration for you to draw on for your own mosaics. Candace Bahouth's and Kaffe Fassett's designs for outdoor use will give you lots of ideas to play with and will hopefully spark off your enthusiasm for the craft.

When leafing through the following pages, pay particular attention to the wonderful play of colours in each creation and the way the tesserae shards are positioned. Both the flow of mosaic pieces and the carefully thought out juxtaposition of colour introduce energetic movement and complexity into the designs. These delightful original mosaics should be seen as the stepping stones for your own original works.

The guidelines given with most of the mosaic projects, along with the detailed instructions in the Making Mosaics chapter, provide all you need to learn the simple techniques necessary.

The best source of mosaic bases for outdoor use is your local garden shop. Cement urns and boxes, fountains, shrine niches, benches and tables, as well as

RIGHT Kaffe Fassett used an old vegetable print as a guide for this huge, voluptuous cabbage mosaic. He drew the shape on the top of an inexpensive concrete garden table and filled in the design with broken crockery and tiles. To blend in with the design, grey-green grout was used for the cabbage and pink grout for the background.

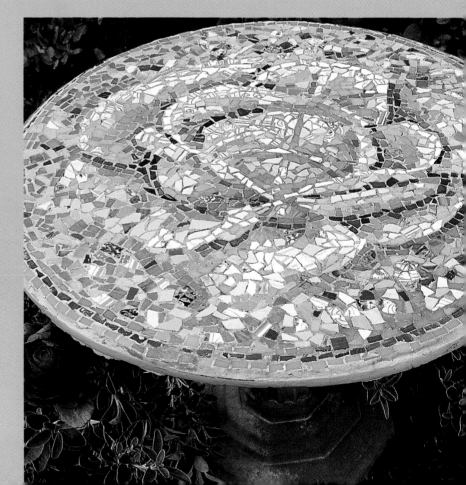

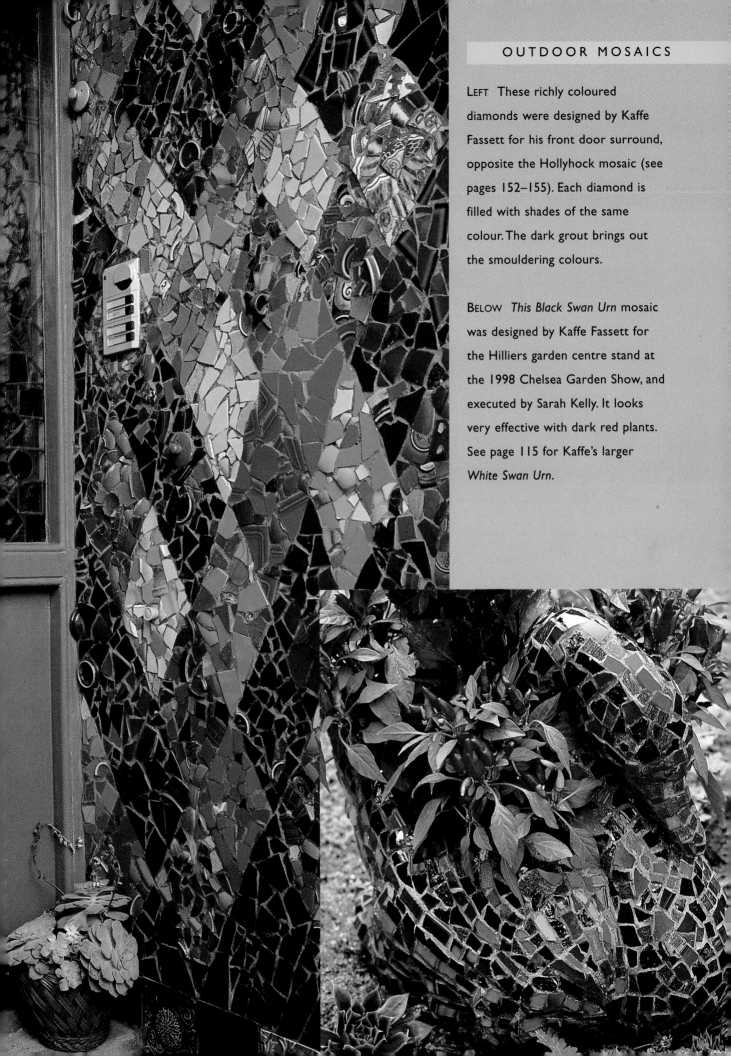

## OUTDOOR MOSAICS

LEFT These richly coloured diamonds were designed by Kaffe Fassett for his front door surround, opposite the Hollyhock mosaic (see pages 152–155). Each diamond is filled with shades of the same colour. The dark grout brings out the smouldering colours.

BELOW *This Black Swan Urn* mosaic was designed by Kaffe Fassett for the Hilliers garden centre stand at the 1998 Chelsea Garden Show, and executed by Sarah Kelly. It looks very effective with dark red plants. See page 115 for Kaffe's larger *White Swan Urn*.

terracotta planters all make excellent foundations for exterior mosaics. For a quick project, you could attempt a small item like Candace's *Blue Shrine* on page 125 or Kaffe's planter covered with giant pieces of broken pottery on page 129. There are also more challenging projects such as mosaic terraces or walls.

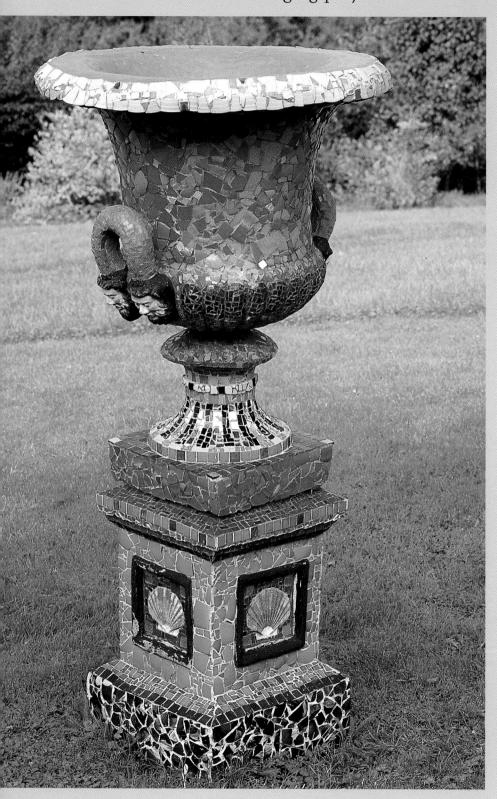

Some of the tesserae materials included in this chapter are broken china and tiles, shells, pebbles, mirror, pearls, pipe stems, gold tesserae and glass mosaic tiles. The types of tesserae to use are suggested for each project, but you should interpret the designs, drawing from your own tesserae collection and your own imagination. Use colours and materials that excite you, and you are sure to enjoy the process of mosaicking!

LEFT The dynamic use of saturated colours dominates Candace Bahouth's large urn. The playful lime green rim and brilliant orange handles give an unexpected twist to this classical shape and make a powerful impact in the landscape.

LEFT Candace Bahouth's sunshine yellow mosaic pillar and ball adds a neo-classical elegance to her border of pinks and lilacs.

ABOVE A jade shrine edged in gold, with candlelight illuminating the mirrored interior, creates a romantic setting for home or garden. (This shrine is a smaller version of Candace Bahouth's *Blue Shrine* on pages 124–127.)

# Garden Wall

The chapel – my studio, my haven – is situated in one of the most pastoral parts of Somerset. An attractive feature of the village we live in is the stone walls bordering the narrow roads and fields. English country walls are a passion of mine. I love their muted colour and their unashamed starkness. And, of course, they are a large mosaic in themselves.

Driving along the Mendip hills looking at the milky grey sky and the dour stone walls seemingly stretching on forever, I thought 'wouldn't a shot of Mediterranean warmth look wonderful here – a bolt of blue.' Some day I'd like to create a large public mosaic on a stone wall in the middle of the countryside, but for now I'll have to restrain myself to our own lichen-covered wall.

Beginning the mosaic at the bottom of the wall, I spread on frostproof cement mortar and began covering the stones with my favourite cobalt-blue shards. The shades reminded me of bluebells, cornflowers and Gaulois packets. At first I sprinkled in some other colours, but decided on a purer palette of blues as I climbed up the wall. Black triangles along the sides formed a distinctive border.

What makes the mosaic unusual is the fact that it covers the capping stones (known as cocks and hens, or lords and ladies) on top. This took a little more effort, but it accentuates the shape of the wall against the green field and the line of

five huge chestnut trees beyond. Watching the chestnuts change with the seasons gives me such pleasure and contentment – from pink and cream candle-shaped blossom to spiky green cases revealing the wondrous mahogany conkers within.

Nature is one of life's most intense emotional experiences, my main inspiration and dwelling place. In this tranquil setting, no matter what the weather – deep with wet or stung with hoar-frost – this slash of blue, this vertical vein of fractured colour, cheers me with its sense of frivolity. And I enjoy the contrast, the notion of embellishing such an austere surface.

RIGHT AND PAGES 112 AND 113 Candace Bahouth mosaicked a streak of Mediterranean blue over the hand-crafted traditional country stone wall in her back garden at her home in Somerset in southwestern England. Her palette consisted of broken crockery predominantly in cobalt blues, with occasional flashes of warmer shades like yellows and greens, plus the intriguing addition of a few pieces of broken mirror. Irregularly shaped black crockery triangles provide a relaxed border along the edge of the mosaic. If you want to attempt a similar treatment, read the instructions for cutting and preparing crockery tesserae on pages 44 and 45. Tips and full instructions for cementing and grouting outdoor mosaics are given on pages 42 and 43, and 46–49.

# White Swan Urn

After the dark palette of the two black swan planters that I mosaicked for the Chelsea Flower Show (see page 105), I was longing to try a pure white swan. A larger scale was also inviting. Broadening one's canvases is always enticing – murals so much more exciting than studio paintings.

My dream was to create a white swan urn that would merge elegantly with a sublime white garden. As I started to work on the swan, Candace arrived with a bag of small gleaming white shells. (Have you noticed how often the very things you need fall into your hands as you start a project?) My assistant Brandon dug into his collection of materials and supplied me with old artificial pearls to add to my palette.

Most mornings I swim on Hampstead Heath where swans confidently glide about, so was able to observe the graceful shape of their beaks, eyes and tail feathers. Though some of the swans I studied had eyes markings that were a faded tone of grey and an almost pink beak, I gave my mosaicked swan quite contrasty black markings and an orange beak. After positioning the eye and beak on the cement swan, I laid the crest of small shells from the beak down the back of the neck, then stuck a cascade of shells down either side of the breast. The artificial pearls were perfect for filling in the gaps between the shells on the swan's head.

The centre front of the swan was filled in with smooth china mosaic, since I knew the planter would be picked up from here and the tail, and would be so heavy that any shells standing proud would sooner or later get dislodged or chipped. Luckily, the broken china contrasts beautifully with the delicate shells – particularly the chunkier pieces cut to look like feathers on the base of the wings near the breast.

After the swan was covered with mosaic, I grouted the broken china areas with a very slightly tinted white grout. Now the grout looks a bit too pale to me. But I am confident that the grout will soon age a deeper colour, especially if the swan is left in the garden to age gracefully.

A white mosaicked chimney pot would provide the ideal pedestal for this stately bird.

RIGHT  Kaffe Fassett's *White Swan Urn*. ABOVE LEFT  The mosaic consists of broken china, small white shells and some artificial pearls.

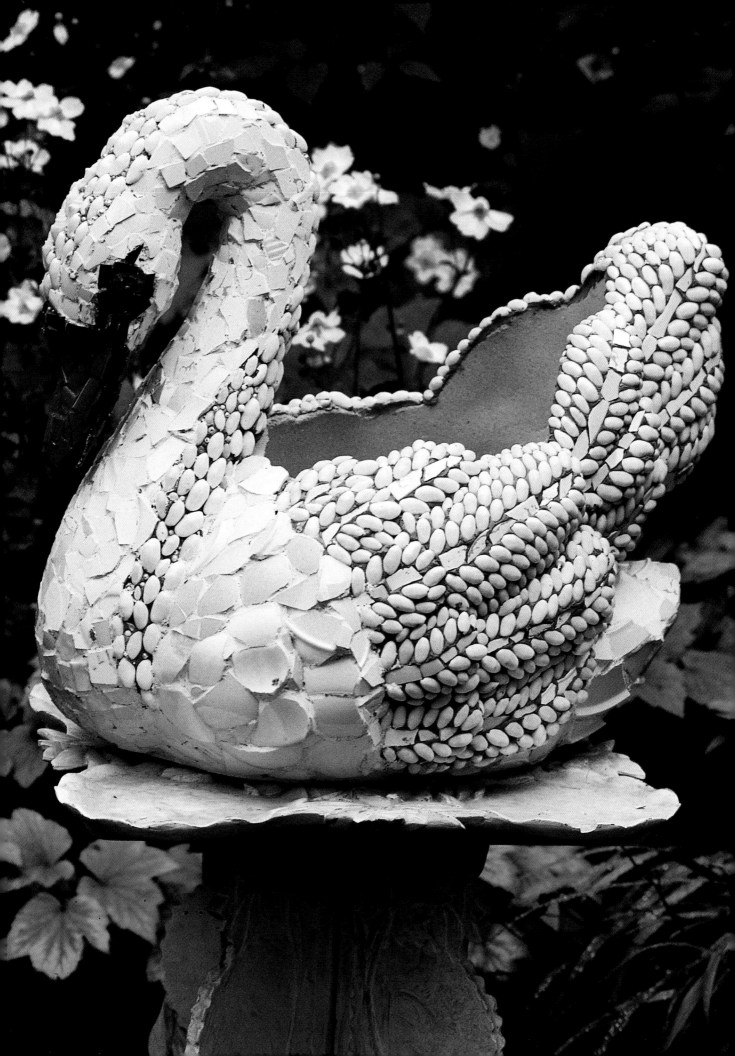

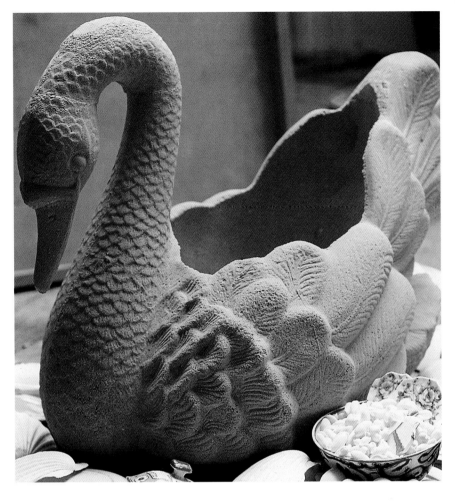

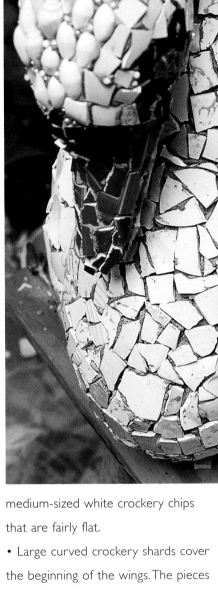

## Mosaicking the swan

**Basic materials and tools** Broken crockery, thin wall tiles, pearls and shells all in white, and for the beak and eye – blue, black and orange crockery chips and vitreous glass mosaic tesserae; concrete swan urn, sealant and paint brush; nippers, cement and grout spreaders, and lint-free cloths; grey cement-based mosaic adhesive and white grout both suitable for exterior use, and acrylics for colouring the grout.

**Instructions** Choose a swan planter that is large enough to accommodate your chosen shells. Prepare the urn for the mosaicking by applying sealant.

1 Study the design features on the planter before proceeding:

• The mosaic follows the contours of the sculpted swan (ABOVE). The beak and eyes are covered with randomly shaped crockery and glass tesserae. The eyes are blue with a small black centre, the beak is orange, and the markings around the eyes and beak are black (ABOVE RIGHT).

• A streak of shells runs from the beak down the back of the neck, splits at the planter opening and runs down either side of the front breast. Pearls fill the gaps between the small shells.

• The rest of the neck and the front breast are covered with small and

medium-sized white crockery chips that are fairly flat.

• Large curved crockery shards cover the beginning of the wings. The pieces used are both concave and convex, and some have curved raised rims from crockery bottoms. Protruding at angles, these chunky tesserae look very feather-like.

• The remaining feather shapes on each wing are covered with neat rows of shells radiating out at an angle

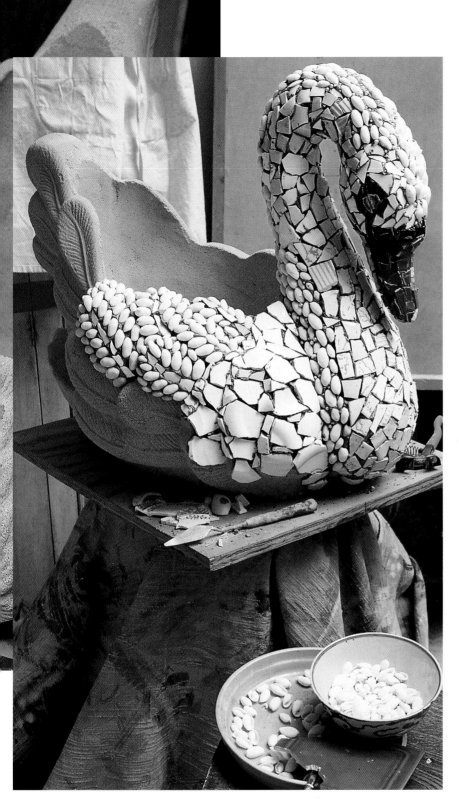

46 and 47, and 50 and 51.) Begin with the mosaic on the beak and eye, then add the crest of shells from the beak down the back of the neck to the opening of the planter and down each side of the breast, sticking the shells as closely together as possible and filling in the gaps with artificial pearls. Next, apply the ceramic chips on the underside of the neck and down the front of the swan. Continue cementing the mosaic backwards filling in first one side then the other.

**4** For grouting the white crockery mosaic, tint the white grout with a pinch of yellow and grey acrylic. For the eye and beak, use a dark grey grout. Grout only the broken crockery areas (see pages 48 and 49).

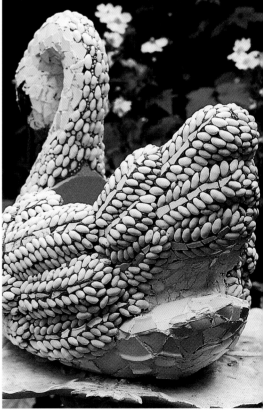

from a centre vein of thin strips of tile (ABOVE AND RIGHT).

• The swan's small tail is covered with large white chips of crockery (RIGHT).

**2** Prepare enough broken crockery tesserae in various sizes and shapes to get started. Cut more chips only as you need them.

**3** Start applying the mosaic, using the spreading technique for the shells, and the spreading or buttering technique for the broken crockery. (See pages

# Tessellated Fountain

Water has provided emotional impact in gardens for centuries – the refreshing sound and the refraction of light giving salvation to the soul and food for the body and mind. The rich significance of fountains is prominent in our earthly Paradise. Fountains are featured strongly in religious symbolism, they represent

the allegorical truth of love and exist even for erotic pleasure.

Enthralled by water themes in gardens, I was pleased when knitwear designer Sarah Burnett and her publisher husband David asked me to create a feature in their pond. They wanted a 'wild' fountain for their idyllic country garden in Dorset.

Applying a patchwork of greens which echoed Sarah's knitting patterns and the surrounding countryside, I began the mosaic inside the shallow bowl of a concrete fountain. Some pretty, lipstick-pink ruffle-edged teacups found at a street market were used on the rim, along with fractured mirror. Reflecting water, sun and the colour in the garden, broken mirror mosaic is always effective outdoors.

Surrounded with warm coloured stones, this blaze of sparkling colour provides a focal point to the garden. The magical properties of refracted light through water drops and the mirror effect of the pond magnify the colours of the herbaceous borders on each side of this enchanted space.

RIGHT  Situated in a country garden in England, Candace Bahouth's *Tessellated Fountain* provides a steadfast radiance in the changing seasons. ABOVE LEFT  Some of the simple vitreous glass tesserae and broken mirror and crockery used by the mosaicist on the fountain.

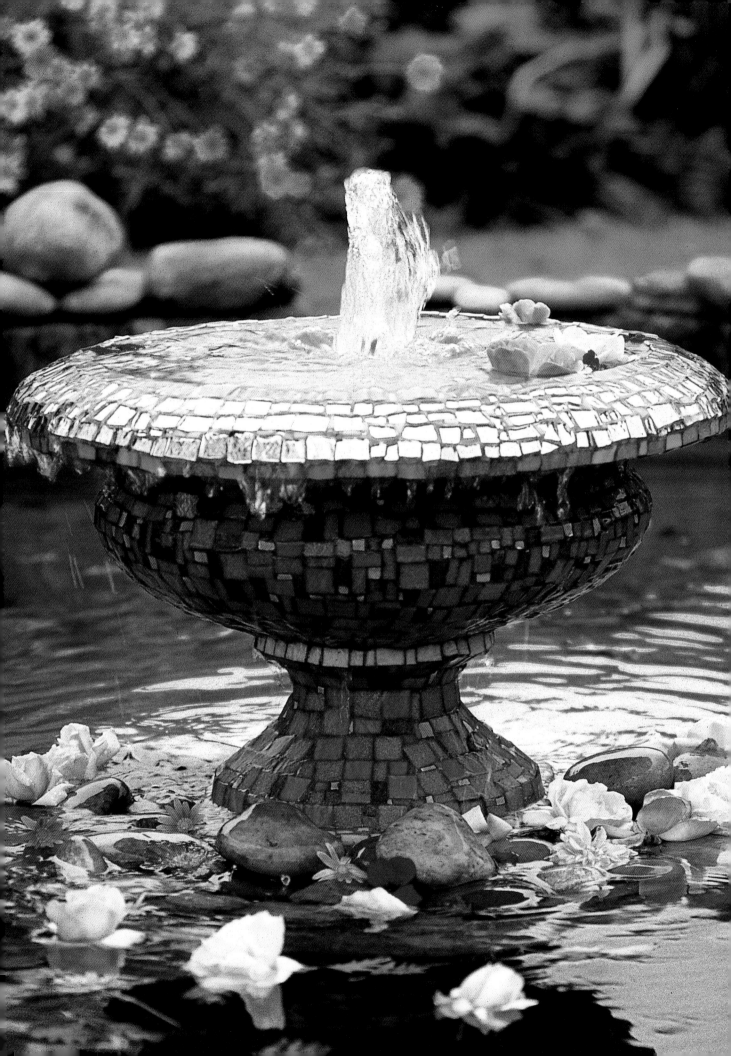

# Mosaicking the fountain

## Basic materials and tools

Vitreous glass mosaic tiles mostly in tones of sky blue and various shades of green (plus a few pieces in lilac), broken china in candy-floss-pink and various shades of green, and broken mirror; concrete urn-shaped fountain, sealant and paint brush; nippers, cement and grout spreaders, and lint-free cloths; frostproof and waterproof cement-based mosaic adhesive and grey grout.

**Instructions** Choose a cement fountain that has fairly smooth surfaces. It doesn't have to be completely smooth, however; low relief can be filled in with the cement adhesive when the mosaic is applied, as was done on the fountain used here (TOP RIGHT). Make sure there is a hole in the bottom of your fountain and plan how the fountain works will be inserted before you start.

Next, prepare the cement fountain by applying sealant to the surfaces. See page 42 for more about preparing mosaic bases prior to cementing.

**1** Study the fountain on the previous page before proceeding:

• Bands of pink, mirror and green ring the broad rim of the fountain. The band closest to the inside of the bowl is mostly made up irregular rectangles of candy-floss-pink china, and has a sprinkling of acid-green vitreous glass slivers. The pink china pieces have been cut from the ruffled band around

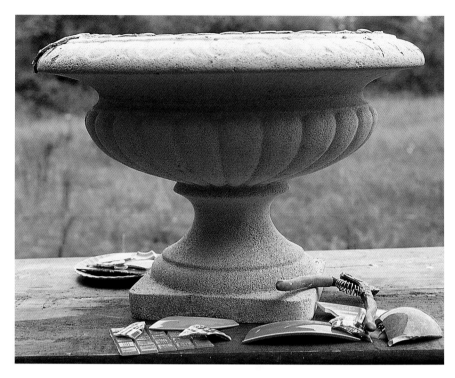

the edge of some china, and the smooth, rounded edges of the pink mosaic pieces have been used to form a smooth, even edge around the fountain rim (RIGHT). The centre band of the rim is made up of irregularly shaped mirror pieces, and the thin outer band is made up of half tiles of vitreous glass in mixed greens.

• A mixture of broken china and odd glass tesserae, cut into irregular rectangles and a few triangles, line the inside of the fountain bowl (OPPOSITE PAGE). The colour theme is predominantly a range of greens that includes jade greens, pine greens and acid greens. A few pieces of lilac glass tile are sprinkled very sparingly through the greens.

• The outside of the fountain bowl is covered with vitreous glass tiles in sky blues. Some of these tesserae are

whole mosaic tiles and others are half and quarter tiles. Small rectangles of pink china are dotted sparingly into this arrangement.

• The lip under the bowl at the top of the urn stem is covered with strips

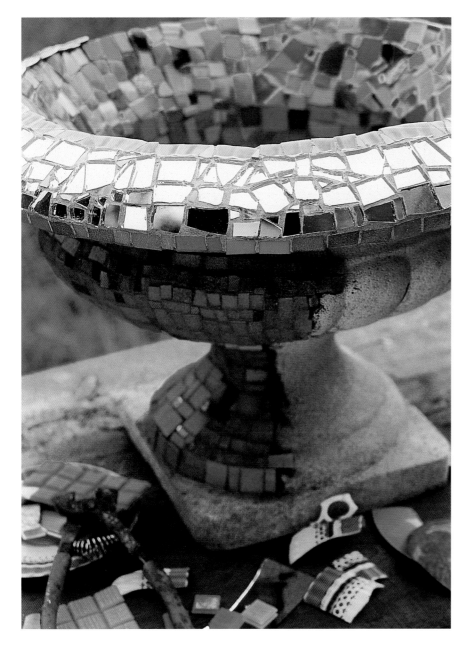

and squares of acid-green vitreous tesserae cut to fit the width of the lip.

• The pedestal is covered with vitreous glass in mixed greens.

• The alignment of the mosaic pieces is very interesting. It does not consist of even rows or even uneven rows, but the arrangement is not a 'crazy' one either, since the pieces are almost all rectangles that are assembled 'upright' (not at angles). The flow of

the tesserae seems best described as a pieced patchwork effect.

• The same grey grout was used on all areas of the mosaic and the gaps between the pieces are quite narrow.

**2** Begin by sorting your tesserae into colour groups for covering the outer bowl, the rim and the inner bowl. This will save time later.

**3** Using the nippers, cut some of the china into irregular rectangles and

squares. Make tesserae that are as flat as possible, dividing curved pieces, such as those from teacups, into smaller pieces to flatten them. Cut some of the vitreous glass into halves and quarters. Cut just enough tesserae to get started. Then try arranging a few bits of the blues for the outer bowl on a flat surface to test the colours and the arrangement. Do the same for the green on the inside of the bowl and for the mirror.

**4** Then start applying the mosaic, spreading the cement over a small area and filling in this area before moving on to the next. Cut more tesserae as you need them. Cement the mosaic over the inside of the bowl first, working from the bottom upwards. Then apply the bands around the rim. (Note that the pink band and the mixed-greens band should overlap the edges of the mosaic on the inside and outside of the bowl.) Next, cement the mosaic on the pedestal and outer bowl, working upwards and leaving a gap along the lip under the bowl. Cover this lip with acid-green vitreous glass strips last so that it overlaps the edges of the blue mosaic. For full cementing instructions and tips, see pages 46 and 47.

**5** Once the cement-based adhesive has set, apply grey grout to the finshed mosaic, including the mirrored sections. See pages 48 and 49 for detailed grouting instructions.

# Mosaic Terrace

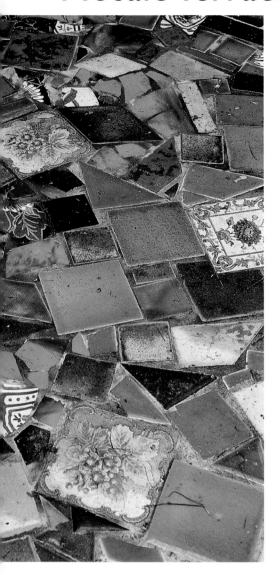

Candace and I both adore the work of Antonio Gaudí, Spain's exuberant architect who took mosaics to a high art on his buildings and parks in Barcelona. Two years ago we decided to revisit the Parc Güell with its serpentine bench smothered in bold arrangements of broken tiles. I was so deeply inspired by the scale and inventive use of colour in these large mosaics that I rushed home determined to cover my terrace with crazy broken tiles and to continue right up the back wall of the house.

ABOVE A detail of Kaffe Fassett's *Mosaic Terrace*. RIGHT The terrace and some of Kaffe's mosaicked plates and planters. The walls are covered with broken crockery and tile. Bright pastels predominate under the window, and green and sky blue above. Some earth browns and flesh tones add a warm note to the wall mosaic. See pages 42–49 for full instructions on how to prepare and mosaic terraces and exterior walls.

First I got plasterers to lay a slab of concrete for the terrace floor, and to render the brick walls next to it as well, so I would be working on a level surface. Then I got started right away. Buttering each tessera individually, I completed the terrace in one day! The next day I went straight into the grouting, but it started pouring with rain. Reluctantly forced to cover the mosaic with plastic, I had to sit the storm out and finish the next day.

The walls took longer as there were quite a few small chips in some sections. Still, they only took two and a half days.

With mosaicked floors you have to be careful to stick to very similar thicknesses of tile and pottery pieces; any drastic discrepancy and you'll be stubbing toes and tripping up visitors. Sometimes I find crockery pieces I really want to include but that are a lot thinner than the others. To get round this problem I build up under the treasured piece with extra cement or lay two thin pieces on top of each other.

On my terrace floor there are a lot of thick studio pots and contemporary tiles mixed in with Victorian tiles for pattern interest. If you love great chunky bits of pottery for terraces, get to know a local garden centre and get broken oriental imports. They have the best colours to my taste.

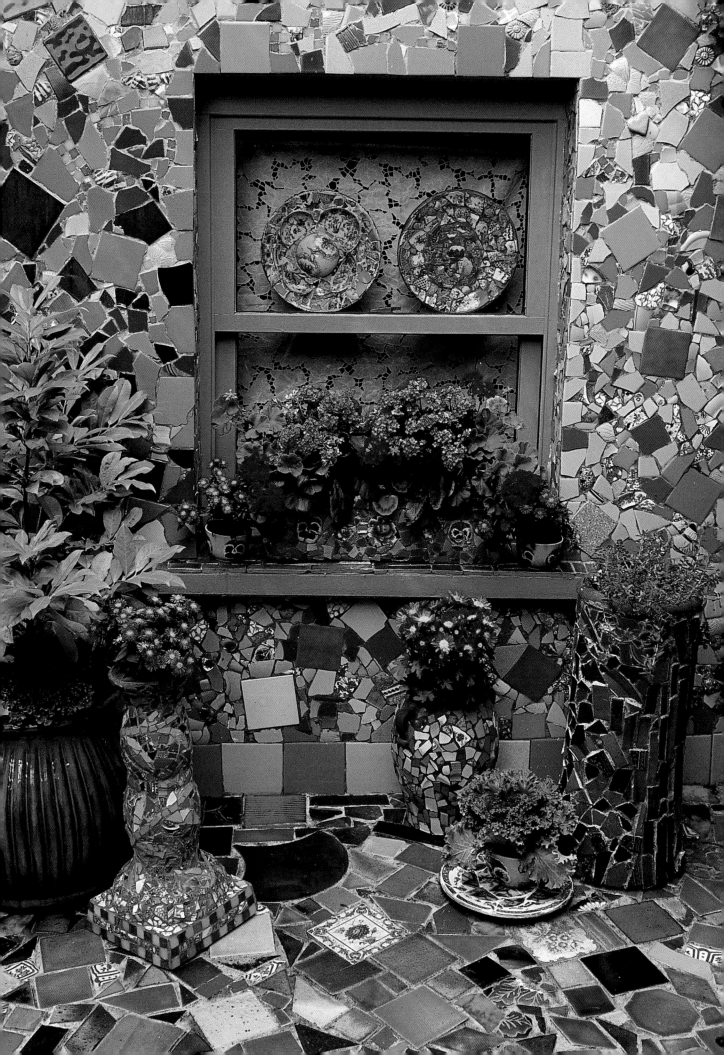

# Blue Shrine

For my retrospective at the American Museum in Bath in 1996, I created four shrines. They were dedicated to my feelings for home and country, for family and friends, for the Sacred, and for Nature primitive and unspoilt, my dwelling place.

We make shrines, almost without knowing we're doing so, when decorating our car dashboards and our desks, or when laying a table with groups of photos, mementoes, stones, shells, feathers, leaves, flowers, cards, candles.

In Greece there seems to be a shrine erected at every curve in the road. These shrines often commemorate a sad loss of life through an accident, but are traditionally small reminders of the presence of a deity, a solace for travellers, a place to stop, rest and pray on the open road.

Looking at niches in Georgian buildings and arched alcoves in England, I was struck by their dimensions and how these ancient proportions seem the perfect shape to contain the memorabilia of a person or event. They inspired my mosaic shrines.

My husband Andrew made various moulds in wood and cast lightweight concrete to create the bases for these pieces. I covered the large one featured here in mirror, gold and a strong ultramarine blue. You really can't go wrong with such a combination, such a direct evocation of romance.

Shrines are like miniature grottoes. A shrine is very simple to mosaic and looks wonderful holding a candle, or equally effective with a bunch of flowers or whatever 'thoughts' you wish to display.

Can you imagine how enchanting a series of them would be if built into an outside wall, or sitting in a bathroom, the ripple of water and candlelight magnified in the fragmented mirror.

RIGHT  Candace Bahouth's *Blue Shrine*. ABOVE LEFT  The mosaic palette used for the shrine – glazed ceramic mosaic tiles, thin glazed wall tiles, gold-leaf glass tesserae and mirror.

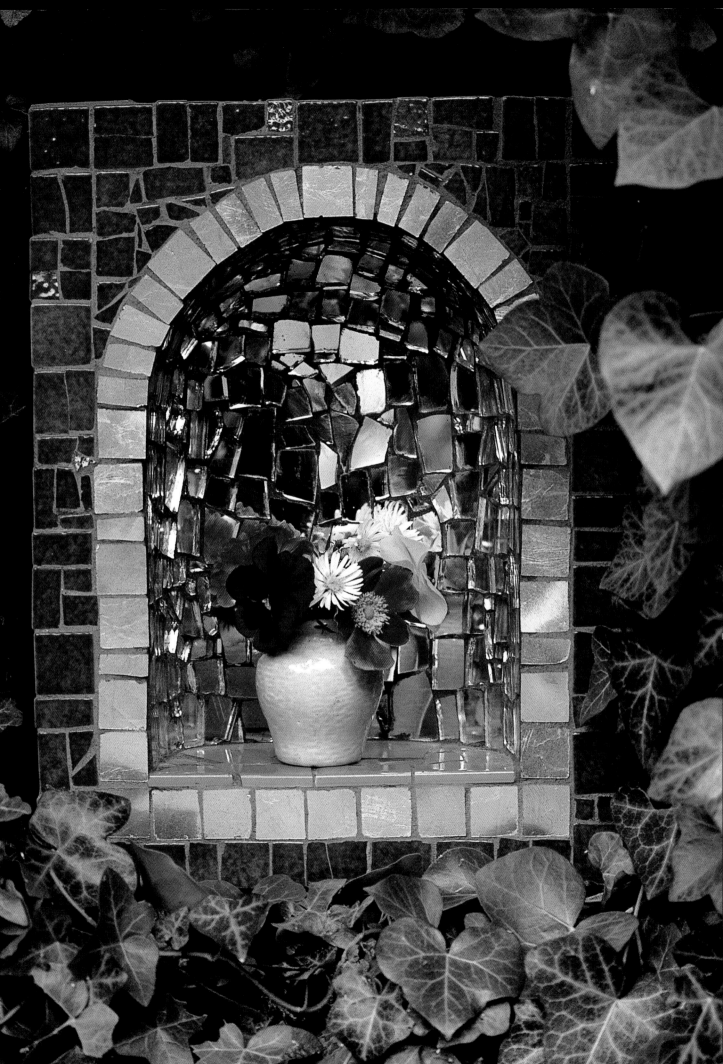

# Mosaicking the shrine

**Basic materials and tools** Gold-leaf glass tesserae, broken mirror, ultramarine blue glazed ceramic mosaic tiles, and ultramarine blue and light blue thin glazed wall tiles; concrete niche (BELOW), sealant and paint brush; nippers, cement and grout spreaders, and lint-free cloths; cement-based mosaic adhesive and grey grout, both suitable for exterior use (frostproof and waterproof).

**Instructions** Before beginning, prepare the cement niche by applying sealant. See pages 42 and 43 for more about preparing mosaic bases.

1 Using the nippers, begin cutting some tesserae to practise your cutting skills. Cut a few of the small blue tiles into halves and a few into quarters. Cut some of the mirror and light blue tile into random shapes.

2 Lay a few pieces of the cut tiles and mirror inside the arched niche to see if the scale of the mosaic chips looks right for the size of your shrine (BELOW). You can use bigger pieces on large shrines, but small shrines will require small pieces, especially for the mirror mosaic, since the shards need to be small enough to fit smoothly around the curved back of the niche.

3 Study the design features on the shrine before proceeding:

• The inside of the arched niche is covered with small, randomly shaped pieces of mirror (OPPOSITE PAGE).

• Randomly shaped pieces of light blue tile cover the floor of the niche.

• A border of whole and half gold-leaf mosaic tiles surround the niche opening. The half tiles were used

mostly around the curved portions of the arch (BELOW RIGHT).

• The front of the shrine has a patchwork mosaic of whole, half and quarter ultramarine blue mosaic tiles. Smaller, randomly shaped pieces were used to fill in areas around the curves.

• For quicker coverage, the sides, top and back of the shrine were covered with randomly-shaped medium- and large-sized pieces of blue wall tile.

• The mosaic pieces are fitted closely together and grey grout fills the very narrow gaps between the tesserae.

**4** Prepare enough mirror chips to get started, cutting random shapes. You can cut the remaining tesserae as you need them.

**5** Start applying the mosaic to the shrine. Spread the cement over a small area each time and fill in this area before moving on to the next. Begin applying the mirror inside the arch. If possible, try to work from the base of the niche upwards so that the mosaic pieces above can rest on those already applied below – this will stop the tesserae from slipping downwards. Where the mirror meets other surfaces, begin covering these adjacent sides as well (to create neat corners, always stick on the tesserae along both surfaces at the same time where two surfaces meet).

Overlap the gold tesserae border over the cut edges of the mirror mosaic. If the edges of the light blue mosaic pieces along the front of the

floor of the niche are smooth and finished, you can overlap them over the tops of the gold tesserae; otherwise overlap the gold tesserae over the cut edges of the floor mosaic as well. Cover the sides, back and top of the shrine with blue wall tile. Leave a gap of about 3mm (⅛in) above the bottom edge of the shrine,

since any tesserae too close to this edge could be damaged. For full cementing instructions and tips, see pages 46 and 47.

**6** Allow the adhesive to set, then apply grey grout to the finished mosaic, including the mirrored section. See pages 48 and 49 for detailed grouting instructions.

# Planter and Pillar

Travelling through Iran, Turkey, Syria and further east in the 1970's I often noticed great columns decorated in bold patterns that gave them a splendid sense of movement. So when Hillier Nurseries asked me to design a garden for their stand at the 1998 Chelsea Flower Show in London my first image was an

avenue of pillars topped with great planters spilling over with exotic plants.

The pillars had to be light enough to be moved once coated in a thick layer of broken crockery mosaic, yet strong enough to hold the plants and not blow over. Hollow terracotta drain pipes seemed the solution, but unable to find the right size I had to have them made to order. The designs for the pillar mosaic included split diamonds, spirals and this bold lattice. Tin trays that slipped into the round hole created the perfect platform for the plant pots.

A set of 1950's Mexican dinner ware purchased at my local car-boot sale provided the ochre tesserae on the pillar. The ochre lattice works well with the deep contrasting jewel tones in the diamonds, as did the black lattice on another of the pillars designed for the flower show (see page 9).

When mosaicking, so many bottoms of cups, saucers and plates usually get tossed aside in favour of the flatter sections that it's a great joy to use up all

those circular ridges on a gutsy dimensional texture.

This round urn is the most successful planter I designed for Hilliers' exhibition stand. It is a homage to the contemporary British potter Rupert Spira. If you have potter friends, sooner or latter you will be able to find a home for their accidents. A couple of gorgeous blood-red bowls exploded in Rupert's kiln giving me the raw material for a very exciting mosaic. To use the big rounded pieces

without cutting or nipping off a centimetre was thrilling. I just stuck the biggest pieces on the urn as they came. The gaps were filled in with smaller shards. The result is a pot both Rupert and I like a lot.

Pieces that were only a reminder of disaster have become a very handsome and serviceable planter.

RIGHT Kaffe Fassett's *Planter and Pillar*. ABOVE LEFT Pieces of the crockery used in the mosaic.

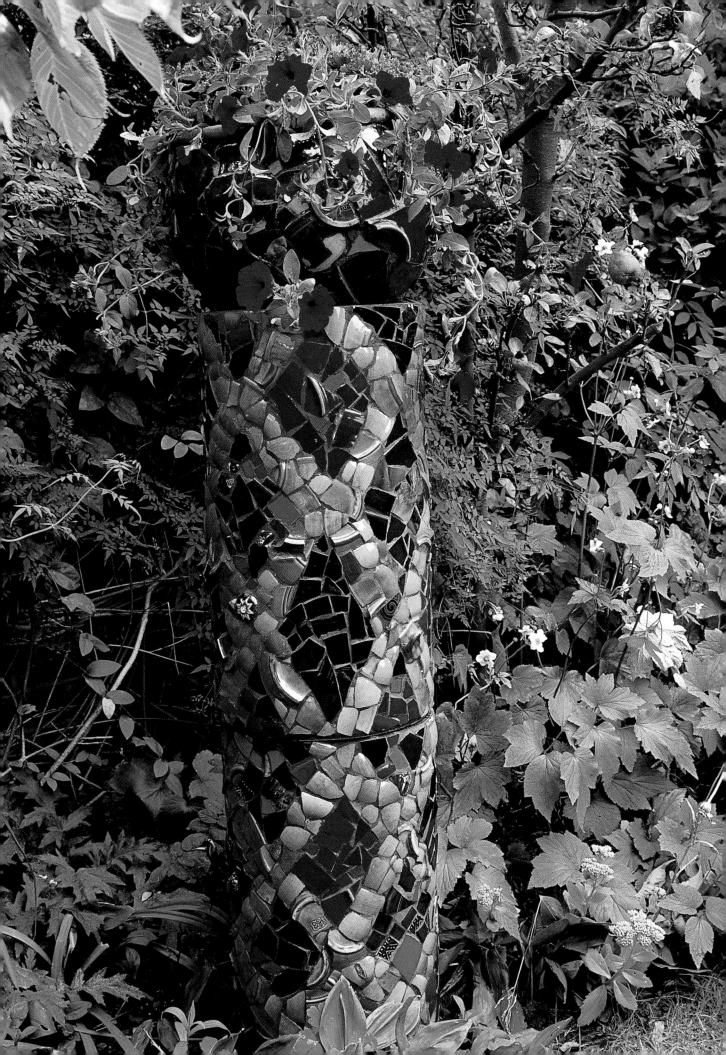

# Mosaicking the planter and pillar

**Basic materials and tools** Broken glazed pottery, tiles and crockery in ochre, black and jewel tones of blues, greens, reds and maroons for the pillar, and in blood reds, with a smattering of blue and green chips for the planter; ceramic drain pipe or old chimney pot (RIGHT), large round terracotta planter, sealant and paint brush; hammer, nippers, cement and grout spreaders, and lint-free cloths; cement-based mosaic adhesive and grey and terracotta coloured grouts, all suitable for exterior use.

**Instructions** Before beginning, prepare the pillar and planter for mosaicking by applying sealant (see page 42).

**I** The mosaic on the pillar is made from fairly large ceramic chips, and the planter is covered with some giant pieces, so leave your collection of crockery, tiles and pottery in fairly large pieces. If they are not already broken, use a hammer to divide the each pot, dish, plate or tile into a few large shards (ABOVE RIGHT). See page 44 for how to use a hammer safely to break crockery.

**2** Divide the broken pottery, crockery and tiles into colour groups for use later. The shades needed for the pillar and planter are listed above.

**3** Study the design features on the pillar and planter before cutting or breaking the tesserae materials into smaller pieces and before beginning the cementing:

• The pillar is wrapped with diagonal bands of ochre that form a bold lattice (RIGHT). Deep contrasting jewel tones fill the diamond shapes.

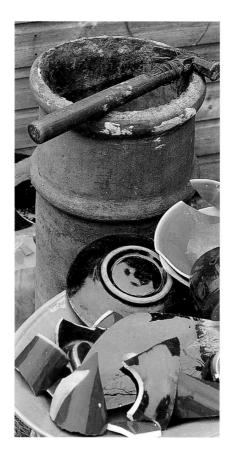

• The shards on the pillar are all fairly large and the mosaic surface is textured rather than smooth. Some of the tesserae are flat, while others are slightly curved, and a few have rounded ridges from pot bases. The odd ceramic handle or lid has been introduced into the mosaic (OPPOSITE PAGE, LEFT).

• The planter is covered with mainly blood red tones and has small scattered flashes of blue and green.

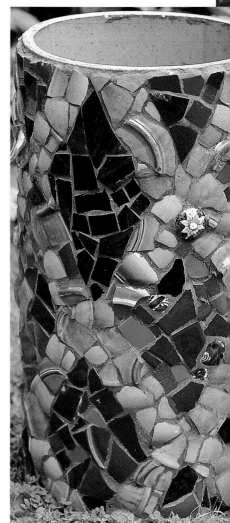

• There are many pieces of broken pottery on the planter that are very large and curved. These pieces fit neatly around the urn (OPPOSITE PAGE, RIGHT). The rest of the mosaic is filled in with medium-sized shards. Like the mosaic on the pillar, the planter mosaic is textured rather than smooth and contains some sculptural chips that feature the ridged bottoms of bowls.

**4** Next, using a pencil or marker, draw the broad lattice on the pillar base as a position guide for filling in the tesserae.

work from the base of the pillar upwards. Ensure that you leave a gap of 3–6mm (⅛–¼in) below the top edge and above the bottom edge, since any tesserae too close to these edges could be damaged. See pages 46 and 47 for full cementing directions and tips. Cement the

mosaic on the planter, again working upwards. Leave a gap at the bottom edge as for the pillar and tuck the shards at the top up snugly against the planter rim.

**5** Once you have drawn the lattice guidelines on the pillar and established the design plan, prepare more tesserae in random shapes, keeping the shards fairly large and using the nippers or a hammer as

required. Prepare only enough tesserae to get started and cut the rest as you need them.

**6** Then start applying the mosaic on the pillar. Cementing the lattice first and filling in the diamonds afterwards,

**7** Use premixed grout shades or colour the grout yourself with acrylics. Apply terracotta coloured grout to the pillar and grey grout to the planter. See pages 48 and 49 for detailed grouting instructions.

**131**

# Egyptian Table

An object given can often be the inspiration to start a piece; its features can also dictate the design. A friend gave me a low cast-iron table that I thought would be practical for outside use. It also turned out to be hideously heavy, requiring weight-lifting exercises! Another friend, who tiles swimming pools, gave me a bucket of off-cuts from one of her jobs, a mixture of cobalt blue, turquoise, several greens and rust, so my colour scheme was decided for me.

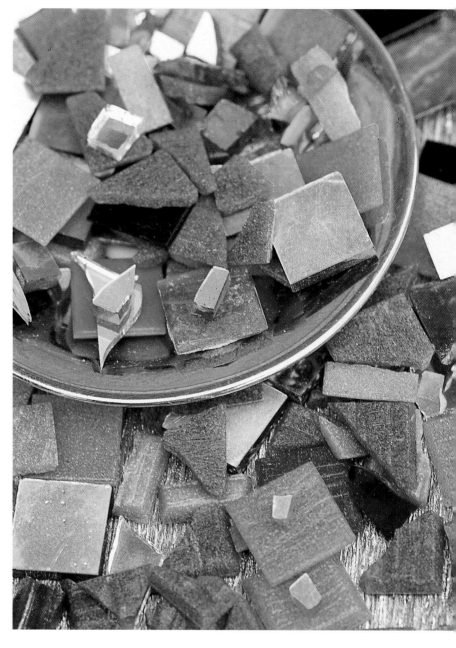

The donated pieces were miniscule, which dictated that I place them very close together. To all these givens, I added the usual – a strong simple border to frame the arrangement.

The table resembled the Egyptian style of furniture with legs placed at the outermost point of each corner, and the colours echoed lapis lazuli, evoking a sense of the richness of that era.

When asked how I choose colours, I can truthfully say that experience has given me an instinct for it. The selection of a dominant colour often begins the process. It is always wise to arrange a test square without cement; this is your play time!

RIGHT  In a garden setting, Candace Bahouth's elegant *Egyptian Table*.
ABOVE  The tesserae and broken mirror used in the table mosaic.

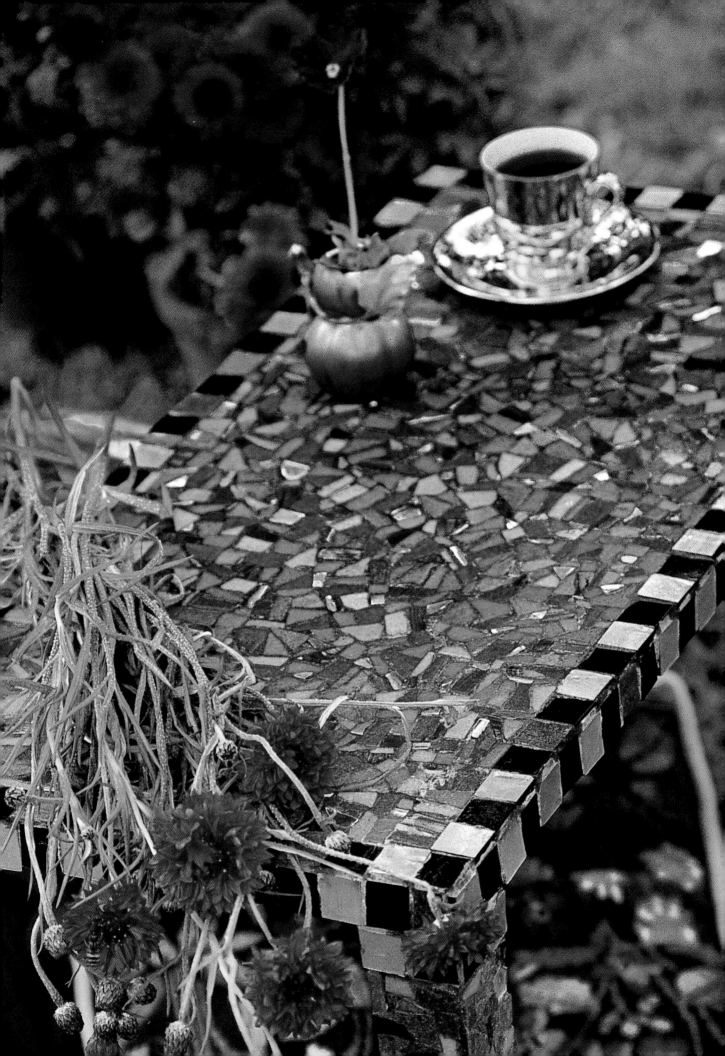

# Mosaicking the table

## Basic materials and tools

Vitreous glass mosaic tesserae in black, turquoise, cobalt blue, sky blue, emerald green and jade, glittery glass tesserae in rust, gold-leaf glass mosaic tesserae, and broken mirror; wooden table, sealant and paint brush; nippers, cement and grout spreaders, and lint-free cloths; cement-based mosaic adhesive and grey grout.

**Instructions**  Choose a small table that has flat-sided legs for your mosaic. A small table can be taken inside during inclement weather, and if it is only outside on sunny days there is no need to make it weatherproof. (If you do want to make a fully weatherproof table, use a metal or concrete table, and frostproof and waterproof cement and grout.)

Before beginning, prepare the wooden table for the mosaicking, scoring and applying sealant. See page 42 for more about preparing mosaic bases prior to cementing.

**1**  Using the nippers, begin cutting some of the vitreous glass tesserae in blues, greens and rusts into small and tiny oddly-shaped pieces. Then cut some of the mirror into tiny pieces. Cut only enough shards to get started and keep them in their colour groups.

**2**  Around the edge of one corner of the wooden table, arrange a bit of the border of black squares alternating with gold squares. Then fill in a small area with the cut tesserae and mirror

(RIGHT). This exercise will give you an initial feel for how easily the odd, random shapes can be fitted together. It will also allow you to test your colour scheme and adjust it if desired.

**3**  Study the basic design features on the table before preparing more tesserae and before beginning the cementing and grouting:

• The main mosaic covering the top of the table and the legs is made up of small and minute randomly shaped pieces of vitreous glass tesserae in blues, greens and rust, and a sprinkling of mirror. The arrangement is random and the pieces are fitted very closely together (OPPOSITE PAGE).

• The border on the table top draws the design together and consists of a single row of alternating black and gold squares, with an occasional blue tile. This border is repeated around the lip of the table and around the top of each leg (RIGHT).

**4**  Once you have established the basic design plan, prepare more tesserae. Then start applying the mosaic. Cement the mosaic on the table top first, working from the edge towards the centre. To create a neat edge, stick on the border along the table lip as you mosaic the edge of the table top. After completing the top, cover the legs. See pages 46 and 47 for full cementing directions.

**5**  Apply grey grout to the finished mosaic following the detailed instructions on pages 48 and 49.

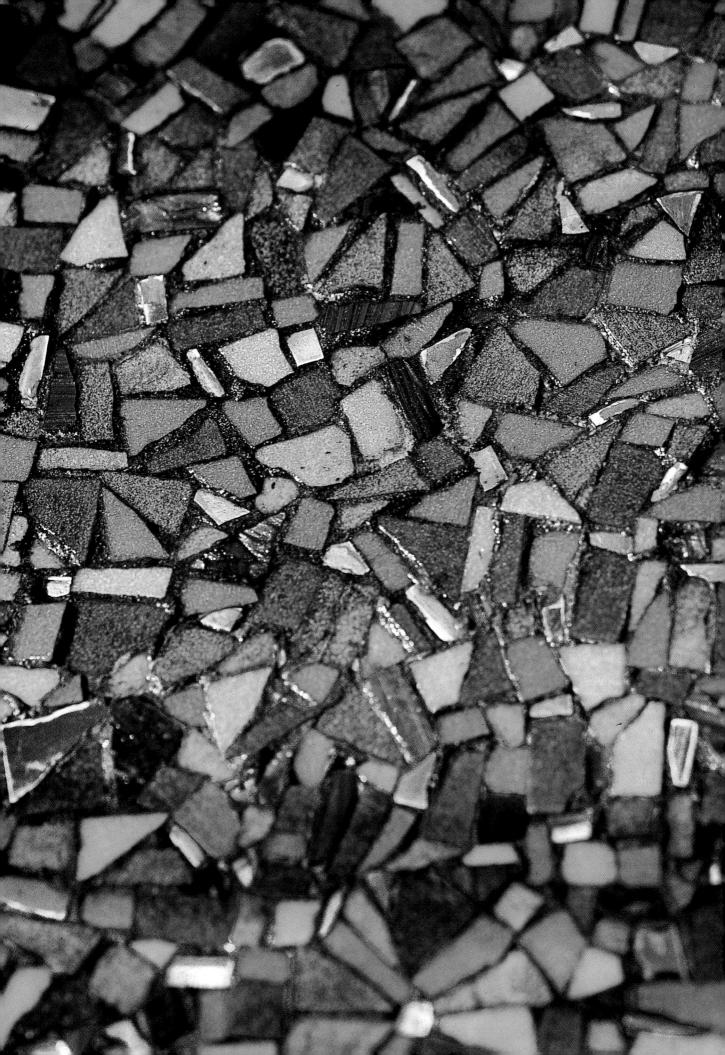

# Blues Flower Box

Often when making my early mosaics, desperate to create a world of colour, I just reached for my brightest, most contrasting tesserae pieces and mixed them all with gay abandon. Starting on this flower box, however, I tried to imagine what colours would enhance garden plants, particularly deep-toned leaves. The answer seemed to be to restrain the palette for maximum effect.

My base was a terracotta trough that you can find at most garden centres. After gathering together broken ceramics in the chosen tones, I covered the sides of the trough with my shards, introducing the bottoms of bowls and cups to enliven the surface.

In the finished mosaic, the blues – turquoise, cobalt, lavender and duck-egg – seem to spark each other wonderfully, and the dark grout (grey with touches of blue and black) makes each hue glow. The turquoises proved to be really effective with new growth, heightening the bright green leaves.

These mosaic shades also harmonize nicely with maroon, purple and lavender blooms and foliage. Notice how the odd shard of a rust or maroon plate slightly warms this cool palette.

Don't be afraid to use other media with your mosaic. When I noticed that the terracotta lip of my flower box looked a bit light, I just slapped a watered down coat of dark acrylic over it. For a more solid opaque surface, you could use artist's acrylic as it comes from the tube, but a soft stain works better here, with the terracotta glowing through.

I designed another version of this flower box using all the pink shards I could scrape together and nipping out pink flowers and pansies from a special hoard of china (see page 123). The flower pieces were stuck on first, then surrounded by my pinks and reds.

You could mosaic a flower box with any palette – maroons with dark rose bits, shades of browns and golds with autumn blooms, or pale green and blues (always a favourite of mine) with highlights of pastel flowers.

RIGHT The bowl and cup bottoms give texture to the mosaic surface of Kaffe Fassett's *Blues Flower Box*. ABOVE A selection of the of the crockery and tiles used for the predominantly blue mosaic palette.

# Mosaicking the flower box

**Basic materials and tools**  Broken crockery and tiles (and a few ceramic and vitreous glass mosaic tesserae) in shades of turquoise, green, cobalt, lavender, navy and sky blue for a predominantly blue colour scheme, with a few odd pieces of rust and maroon to warm the palette; terracotta flower trough (RIGHT), sealant and paint brush; nippers, cement and grout spreaders, and lint-free cloths; cement-based mosaic adhesive and grey grout, both suitable for exterior use (frostproof and waterproof); acrylics for colouring the grout and tinting the terracotta flower trough rim.

**Instructions**  Decide on your colour scheme before beginning the mosaic. If you do not have the colours suggested above for the *Blues Flower Box*, choose colours from your personal collection of broken crockery and tiles.

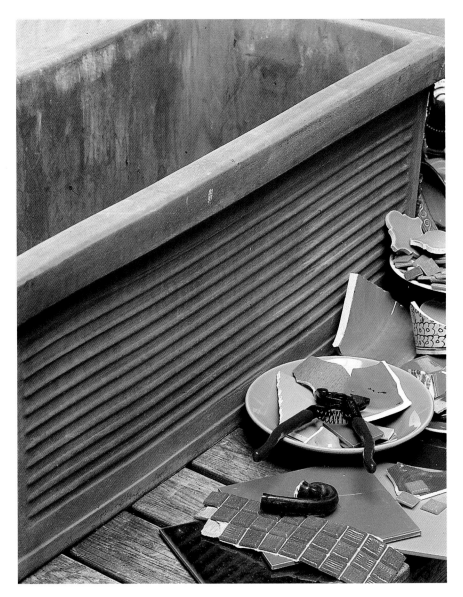

Next, prepare the flower box by applying sealant to the four sides of the trough. See pages 42 and 43 for detailed instructions for how to prepare various types of mosaic bases prior to cementing.

**1**  Using the nippers, begin cutting some of your broken crockery collection into pieces. Make a few medium-sized tesserae that are as flat as possible, dividing curved items, such as those from jugs and bowls, into smaller pieces to flatten them. Be sure to save whole bowl and cup bottoms to use in the mosaic to add texture and low relief. Cut just a few pieces in each of the various shades you have collected.

**2**  To test your colour scheme arrange some of the cut tesserae together on a flat surface. If you are following the colour scheme used on the *Blues Flower Box*, eliminate any colour that doesn't seem to fit the cool palette but be sure you have a few maroons and rusts to soften the otherwise cool design.

**3**  Study the design features on the flower box before preparing more tesserae and before beginning the cementing and grouting:

• The mosaic on the flower trough is made mostly from medium-sized and large pieces of broken crockery and tiles, with some smaller pieces used to fill in the gaps.

• The sculptural bowl and cup bottoms have been sprinkled

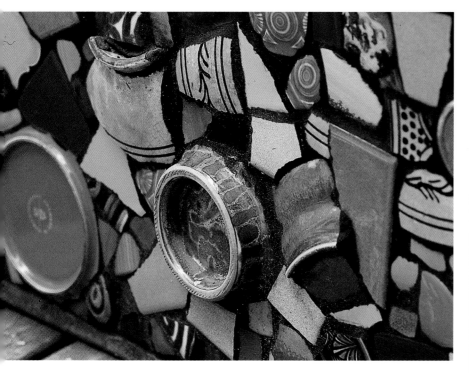

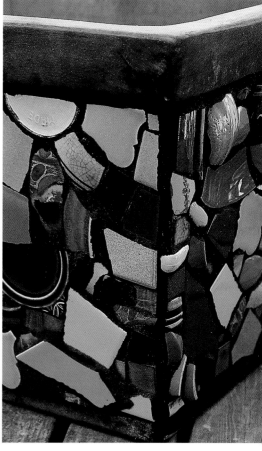

throughout the mosaic to enliven the surface (ABOVE).

• Crockery pieces with patterns have been added to the collection of tesserae to add even more texture to the mosaic.

• The edges of the tesserae along the corners of the trough, under the top rim and along the bottom have been cut as straight as possible for neat perimeters (ABOVE).

**4** Once you have studied the basic design plan, prepare more tesserae chips, cutting random shapes and keeping the shards in their colour groups for easy access during the cementing process. Prepare enough tesserae for at least one side of the flower box. You can cut the remaining tesserae as you need them. Note that although the tesserae might not be the exact shapes you need, they can be trimmed if necessary just before they are cemented in place.

**5** Then start applying the mosaic on the flower trough. Spread the cement on to the terracotta base and stick the tesserae into it; alternatively, butter each piece of ceramic separately if preferred.

If possible, try to work from the base of the flower box upwards – once the adhesive under the first row of chips has set, the tesserae applied above will rest on them, stopping them from slipping downwards. Also, when applying mosaic along the corner of the flower box, cement tesserae along the corner on the adjacent side at the same time so that you can form a neat corner while the cement mortar is still wet.

Do not mosaic the top rim of the trough, and ensure that you leave a gap of at least 6mm (¼in) above the bottom edge. Any tesserae too close to the top and bottom edges of the flower box could be damaged. See pages 46 and 47 for full cementing directions and tips.

**6** Before grouting, colour the grey grout very slightly to achieve the desired shade, adding some black artist's acrylic and a touch of blue. Allow the mosaic adhesive to set before applying the grout. See pages 48 and 49 for detailed instructions on how to colour and apply grout. If desired, tint the upper terracotta rim of the flower box with a dilute solution of bluish-black artist's acrylic using a paint brush.

# Shell-edged Garden Table

Our wobbly garden table was becoming a joke, so my husband Andrew and I decided we needed a more substantial structure to have our summer meals on — something that neither the storms of winter nor the caressing sun of summer could possibly effect. With this in mind, we sunk four clay drainage pipes in the ground for the legs and laid a slab of concrete made to our measurements on

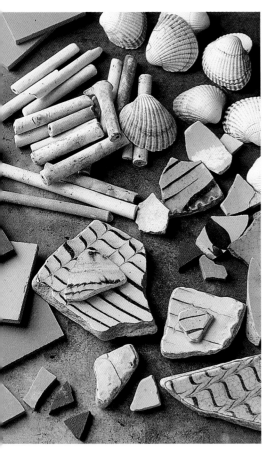

top. It was designed to carry the weight of fourteen dancing elephants all eating chicken vindaloo!

I adore colour in gardens — in the cottage garden in particular. That's why I find added pleasure in seeing mosaic on benches, urns or bird baths. With this garden table I was aiming for a riot of colour in blues and yellows. But by the strangest twist of fate I was given the secret location of a treasured 'dump' of eighteenth-century pottery shards, which revealed hoards of soft custard glazed fragments.

The shards were so subtle in their various shades of creamy yellow, with blue glaze or terracotta detail. My favourite were old brown squiggly ones which reminded me of patterns in nature: the zigzag of a cloud, an animal skin, a shell.

It is incredible how your finished piece can be dictated by the materials at your disposal. The flow really grows from one shard leading to another. In the case of the garden table it led to a complete rethink of colour.

The pale ochre and blue border complements and contains the free-spirited centre of the table. A tonal mixture of pipe stems, shells, pebbles, bits of gold tile and mirror dancing along the vertical edges adds an animated texture to the table — bringing it to life.

When mosaicking a table, bear in mind the need for a flat surface on the top. Try to match the thickness of pieces. You may have to nip curved pieces smaller to lay flat.

RIGHT **The unusual and sophisticated colour scheme on the Candace Bahouth's** *Shell-edged Garden Table* **illustrates the broad scope of mosaic decoration.** ABOVE LEFT **Shells, pipe stems, mirror, pebbles, gold-leaf tesserae, tiles and broken pottery were used to cover the table.**

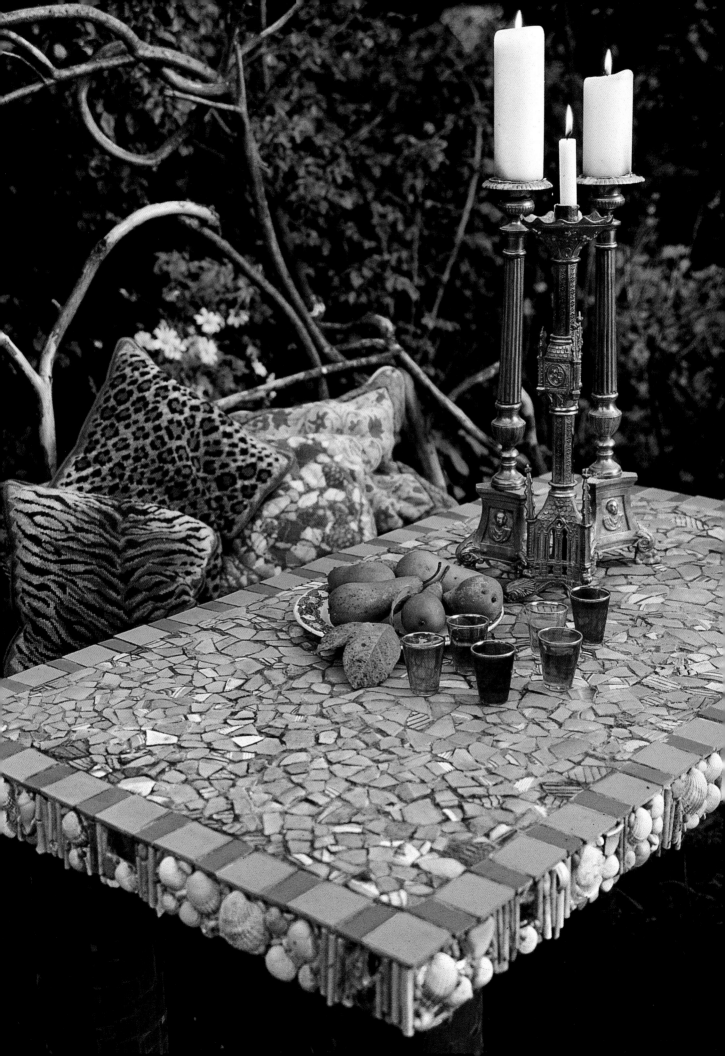

# Mosaicking the table

**Basic materials and tools** Broken crockery predominantly in various shades of creamy yellows and some with blue, brown or white stripes (or other patterns), broken mirror, ceramic pipe stems (see below), some gold-leaf glass tesserae, pebbles, open-mouthed shells, and 5cm (2in) square unglazed ceramic tiles in pigeon blue, pale ochre and terracotta; concrete table, sealant and paint brush; nippers, cement and grout spreaders, and lint-free cloths; white cement-based mosaic adhesive and grey grout, both frostproof and waterproof; acrylics for colouring cement.

**Instructions** The table featured was made by sinking round clay drainpipes into the ground and laying a thick concrete slab on top (BELOW LEFT). You could make your own table in this way or buy a cement table from a garden shop. Ceramic pipe stems supply a very interesting sculptural detail along the lip of the table, but are not, of course, easy to come by. To imitate the effect of the pipe stems, use tiles in similar neutral shades cut into thin strips.

Before beginning, prepare the table for the mosaicking by applying sealant.

**1** Using the nippers, begin cutting the broken crockery into randomly shaped pieces. Make tesserae that are as flat as possible, dividing curved items, such as those from jugs and bowls, into smaller pieces to flatten them. Cut only enough pieces to test the design and keep them in their colour groups. Then cut a few of the blue ceramic tiles in half. (For a flat surface, make sure that the crockery you are using is of similar thicknesses and not much different in thickness from the unglazed ceramic tiles.)

**2** Around the edge of one corner of the table, arrange a bit of the border with whole ochre tiles alternating with half blue ones. Then fill in a small area with the crockery shards. This exercise will give you an initial feel for how easily the random shapes can be fitted together. It also allows you to test the colour scheme and adjust it.

**3** Study the basic design features on the table before proceeding:

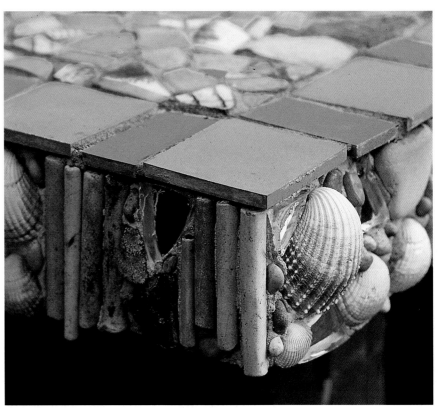

• The border around the top of the table draws the design together. It consists of a single row of alternating whole pale ochre unglazed ceramic tiles and half tiles in pigeon blue (OPPOSITE PAGE, RIGHT).

• The vertical table lip is mosaicked with groups of pipe stems positioned horizontally, groups of pebbles, shells, and occasional bits of crockery, mirror and gold-leaf glass tesserae (BELOW).

• The main mosaic covering the top of the table is made up of randomly shaped pieces of broken crockery, plus a few very small pieces of the blue unglazed ceramic tile from the border. The arrangement is random and the pieces are fitted closely together.

• Pieces of terracotta tile were used to cover the table legs. The pieces are squares and rectangles in different sizes, and they were cut small enough to fit smoothly around the round legs.

Small chips of blue tile are sprinkled sparingly into the terracotta mosaic.

• Grey grout was used on the mosaic on the table top and on the terracotta leg mosaic. The sculptural mosaic along the vertical lip of the table was applied with an ochre-coloured cement; because no grout was used on this section of the table, the coloured cement shows between the pieces (BELOW).

**4** Once you have established the basic design plan, prepare more tesserae for the table top, cutting only enough to get started and keeping the pieces in their colour groups for easy access while mosaicking. Cut some small pieces of mirror and gold-leaf glass tesserae as well. The remaining tesserae can be cut as the mosaicking progresses.

**5** Then start applying the mosaic. Colour the cement for the mosaic on

the vertical lip before beginning that section (see pages 50 and 51 for making mosaics without grout). To create a neat edge around the periphery of the table top, stick on the border along the table lip as you mosaic the border along the edge of the table top; the tile border should extend past the edge of the table and cover the top of the mosaic along the vertical lip. After completing the top, cover the legs. If possible, try to work from the bottom of the legs upwards so that the mosaic pieces above can rest on those already applied below – this will stop the tesserae from slipping downwards. See pages 46 and 47 for full cementing directions.

**6** Apply grey grout to the mosaic on the table top and legs only, carefully avoiding the sculptural mosaic on the lip. See the detailed grouting instructions on pages 48 and 49.

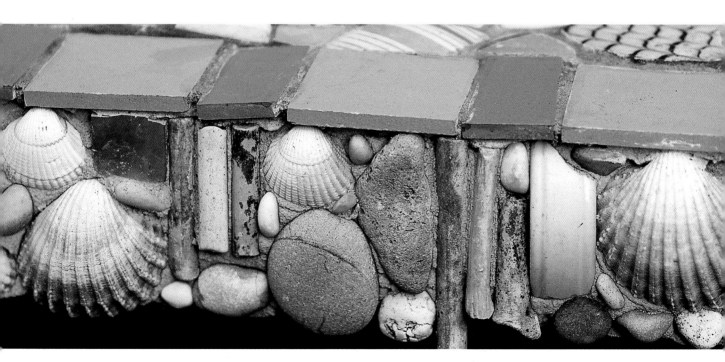

# Theatre Mural

Approaching the Happy Valley School last August, I caught my first glimpse of the site for the mural – a white wall in a white box, with a gentle light green pepper tree softening its corner. I was glad I'd decided to do green trees in my panel, but at the same time feared the mosaic would form a dark, intense

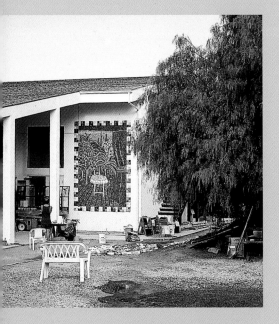

rectangle on the stark white space allotted. The solution seemed to be a mottled chequerboard border that would ease the colours of mosaic into the white spaces blurring the hard edges.

The collection of tesserae started with a pile of reject tiles in shades of green, pink, yellows, whites, browns and blues. My sisters, nieces and close friends gave time and buckets of broken plates in yellows, maroons and blues, bright flower prints, and pale peach for the sky.

A local tile maker donated the gorgeous oranges, crimsons, plums and scarlets for our curtain. From England I had brought shells, some lime green saucers and yellow crockery for the sky. From a garden centre we bought pebbles to add to our collection of tesserae.

Because we would be working very fast wtih cement that would set in a matter of minutes in the dry heat of this California August, I decided to lay out parts of the design on the floor beforehand – not my usual method of working.

The heat was intense during the day – in the 100's – so we would rise at five-thirty and start work at six, just as first light crept up. At eight the sun would hit the mural directly, heating it up suddenly with a glare on the glazed surfaces. By ten we would retreat, unable to make informed decisions until two-thirty or three in the afternoon when the heat and glare had subsided.

We stuck the border tiles on the wall first, then started at the bottom with the pebbled floor at the base of the scene.

From there we moved on to the table, using transferware plates for the table top, fan shells for the border and pointed shells for the fringe and legs. The green grass came next, followed by the trees. The sky colours were worked in horizontal bands across the sky like a water-colour blend.

RIGHT AND ABOVE LEFT  Kaffe Fassett's *Theatre Mural* at the Happy Valley School in Ojai, California. The mural was executed by the designer and a generous team of tirelessly enthusiastic helpers.

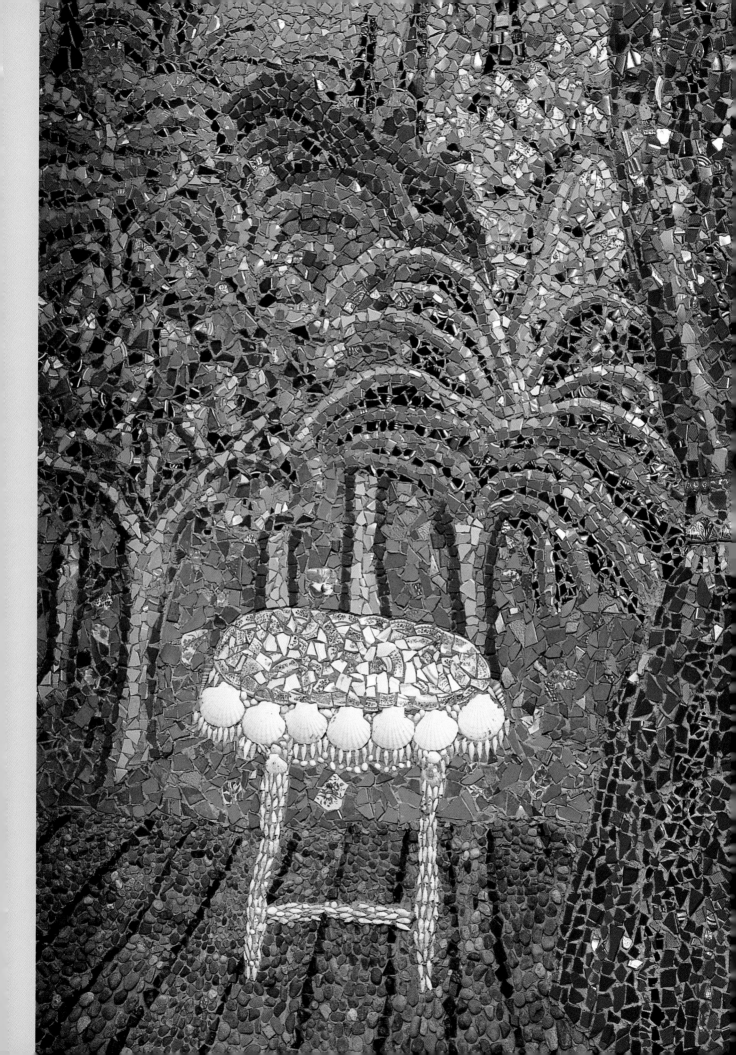

# Mosaicking a mural

**Basic materials and tools** For tesserae you will need: pebbles, shells, broken crockery and tiles in desired shades for your mural design; smooth, cement-rendered wall surface; nippers and cement spreader; cement-based mosaic adhesive suitable for exterior use (frostproof and waterproof).

**Instructions** These directions explain the process of planning and

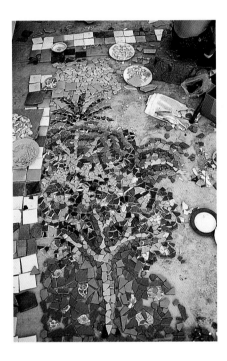

mosaicking an ungrouted mural with relatively large tesserae pieces. You will not necessarily want to use the same images as those in the *Theatre Mural*, but the explanations of how to build up different textures with different types of tesserae and how to mix colours are good guides for any type of subject matter.

Making a mural mosaic by pressing large tesserae into thick cement

mortar – with no grouting – is a very good group project. There are a number of tasks that can be delegated according to the specific skills of the participants. The tasks include planning

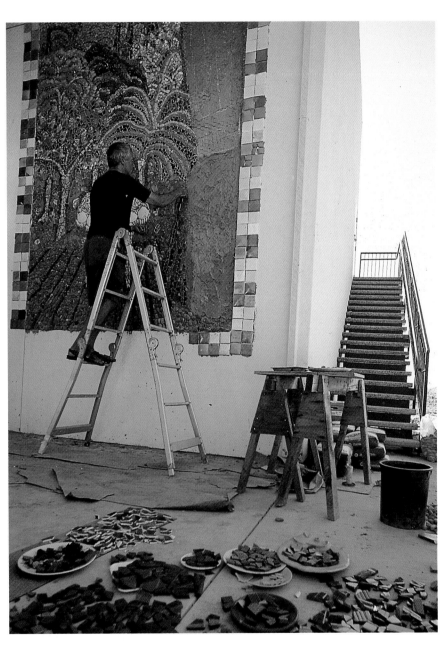

and sketching the design, collecting the tesserae, organizing the tools and equipment, preparing the wall surface, purchasing the suitable cement mortar, breaking up the tiles and

dishes and sorting them into tone groups, mixing batches of cement mortar, and the actual mosaicking.

When making a mural with large tesserae, remember that it is best

viewed at a distance, so will make the most impact on an outside wall.

**1** Begin the mural by planning your design. Be sure to use bold shapes suited to chunky tesserae. A border is

not a must, but it may help to soften the transition from a solid wall colour into the saturated mosaic colours.

**2** Next, make sure that the wall has a smooth cement-rendered surface. See pages 42 and 43 for more about preparing walls for mosaicking.

**3** Draw the design in chalk on a flat surface adjacent to the wall, then cut and lay the tesserae out on the design. This is a good way of checking that the design is working and that there are enough tesserae in the various colours.

Use different types of tesserae for different textures in the design and mix together many shades of each tone for subtle colouring. For instance, on the *Theatre Mural*, the floor boards at the base of the theatre scene are pebbles separated by lines of broken terracotta tiles. The table top is made from transferware plates, fan shells form the border and little pointed shells the fringe and legs. The grass is composed of a selection of many mid-greens and is dotted with little flowers cut from flower-print plates. Yellow and ochre chips form the tree trunks and branches. The leaves each have a light tip, medium-green centre and deeper green base. The sky colours were worked in horizontal bands like a water-colour blend: the sky starts with the deepest peach and orange tones, softening into candy pink, yellow, pale primrose and grey, and ends with

touches of duck-egg blue as it disappears under the red valance. The curtain highlights are crockery and tiles in oranges, bright pinks and yellows, and these shades are

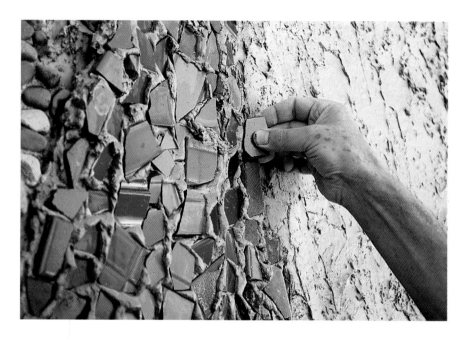

followed by deep oranges, then vertical rows of crimson and maroon, with navy blue for shadows in some areas. The curtain fringe is shades of gold and navy, and the decorated pull-back is a made from a richly patterned Spanish dish.

One difficulty with laying out broken crockery for a mosaic is that each piece shows a white edge – something that disappears once the tesserae are pushed deep into the cement. These flashes of white alter the appearance of the colour and disperse the design, making it very hard to read details like individual leaves. To see more solidity in the forms, stand on a ladder and look

through the lens of a camera; this will make the design come into focus as the white edges recede.

**4** Draw the outline of the design in chalk on the wall, mix the cement and stick on the border first (see pages 50 and 51 for instructions for cementing without grout).

**5** Start filling in the mosaic at the bottom and work upwards. Getting the cement the right thickness takes a little trial and error. The consistency of cake batter (or thick mud) is the best – too loose (yoghurt consistency) and the pieces will slide down the wall; too thick, and it will dry out too fast. Push the tesserae pieces into the cement so that it 'self-grouts' the mosaic. Instead, keeping the glazed chips perfectly flat, position them at slightly different angles so that they will catch the light differently and make the surface shimmer.

# Country Terrace

Just imagine the possibility of using strict geometric shapes as a free-form pattern. The Edwardian encaustic tiles made by Maw and Co, who were highly regarded English tile manufacturers in Brosley, Shropshire, were ideal candidates for this experiment. Thanks to Michael and Hillye Cansdale they were salvaged

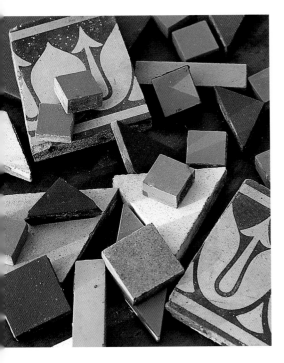

from a hallway and offered to me. I am fortunate to have become known as the glad receiver of any discarded ceramics! Immediately I saw the tiles I thought of embellishing an area at the side of the cottage, a west-facing sun trap. I envisioned a carpet, a flash of blue, outside the French doors, with a border surround and a random cascade of colour within. The tiles sat at the edge of a field covered in brambles and nettles until I finally started the project. Even with the passage of time and open to the elements, the tiles had not suffered at all – though the ants who had settled in were pretty irate!

Since the tiles were very thick, it was impractical to cut them, so the work progressed quickly. First I laid out all the tiles in piles according to shape and colour. I eliminated most of those in black, muddy brown and dirty grey and the hexagon shapes, and concentrated on the intense blue, creamy ochre, white, green and terracotta. I then 'played' with the tiles in a square yard to calculate amounts.

Needing more of certain shapes and colours, I first found small amounts in various locations. Then I located an Italian specialist in Birmingham who had a vast collection of every conceivable design of Victorian and Edwardian floor tiling – including the very same Maw and Co encaustics.

It is imperative to tile on a totally stable and flat surface, so a concrete base was laid for my mosaic. It was eight feet square

and four inches deep. After three days the base was hard enough to work on. I started in a corner to create a diagonal movement, a swing, letting the heavenly blue tiles dominate.

The splash of electric blue has now rejuvenated a rather neglected area of my garden.

RIGHT Candace Bahouth's magical terrace mosaic. ABOVE LEFT A selection of the Edwardian encaustic tiles used for the arrangement.

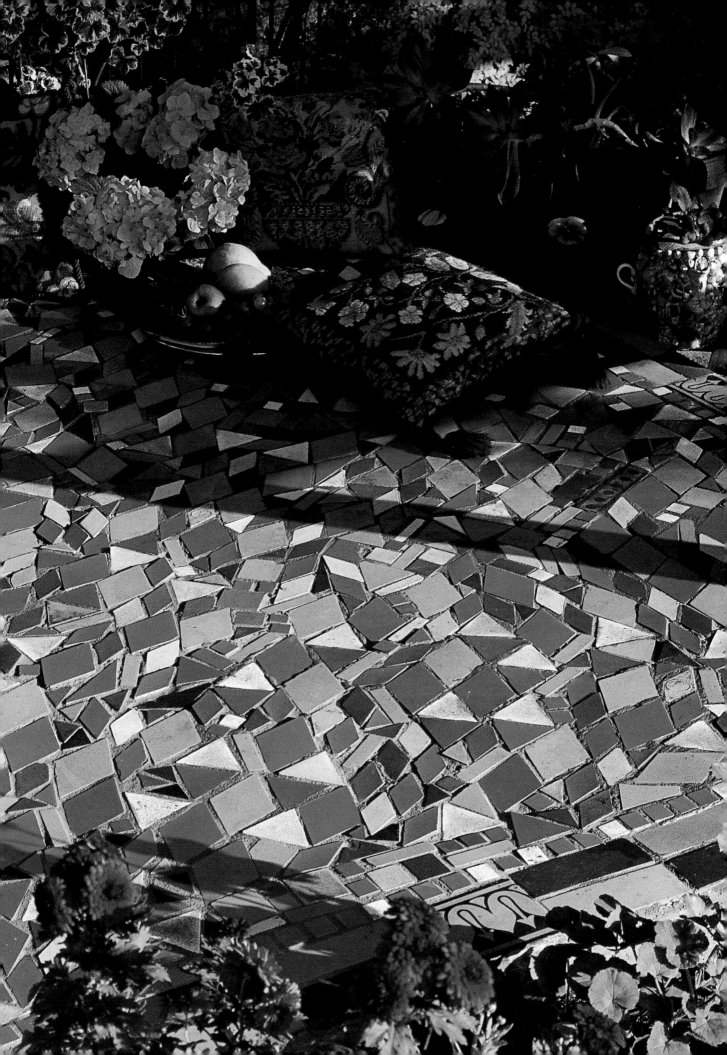

# Mosaicking the terrace

**Basic materials and tools** For the main mosaic, unglazed outdoor floor tiles (those used here are unglazed Edwardian encaustic floor tiles) in various shapes and in sky blue, soft green, custard cream, rust, black and white; for the border, small square unglazed tiles in white and blue, four large square glazed green tiles, and a mixture of large unglazed patterned and unpatterned tiles in brown and custard cream; smooth concrete terrace; tile cutter (optional), cement and grout spreaders, plank of wood to use as a leveller (60cm/24in long piece of three-by-two), and lint-free cloths; cement mortar and grey grout, both suitable for exterior use (frostproof and waterproof).

**Instructions** The movement in this terrace mosaic is enhanced by the use of diamond-shaped and triangular tiles of different sizes. If you cannot find tiles in these shapes, use ordinary terrace tiles instead and cut them into shapes with a tile cutter.

Before beginning, prepare a stable, smooth concrete base for the terrace. Unless you are an expert at this task, it is best to have the concrete terrace laid by a professional. See pages 42 and 43 for more about preparing bases prior to cementing and grouting the mosaic.

**1** Study the design features of the finshed mosaic terrace on the previous page before planning your own mosaic design:

• A row of large patterned and plain unglazed tiles in brown and custard cream form the outer border around the mosaic. A large glazed green tile has been placed in each of the four corners of the outer border (OPPOSITE

PAGE, RIGHT). The inner border consists of a single row of small square unglazed tiles in white and blue.

• The main mosaic is made up of small squares and rectangles, and triangles and diamonds in different sizes. Sky blue tiles are predominant in the mixture, followed by custard cream tiles, then white tiles. A sprinkling of the darker rust, soft green and black tiles in the main mosaic adds depth to the design.

• The tiles in the main mosaic are arranged to create a fluid movement. Because the tiles are not fitted together in a geometric way, the gaps between them are irregular, which increases the fluid effect.

• The grout used to fill in gaps between tesserae throughout the mosaic is the same colour as the cement mortar, which is grey.

**2** Next, decide on the basic design plan for your own mosaic. Arrange a few of your chosen border tiles around the edge, then try filling in a small area of the main mosaic (ABOVE). This exercise will allow you to test how you are going to create the flow of the tiles in the centre. It will also give you a chance to eliminate tile shapes or colours that

are not suitable for the design effect you are aiming at.

**3** Once you have established the basic design plan, you can start applying the mosaic. Remove the tiles you have laid on the terrace. Then mix your cement mortar to the right consistency (see pages 46 and 47 for

level of the mortar if the mosaic dips. Keep the plank clean at all times and test the level regularly.

Continue in this way, spreading the cement mortar over an area, filling it in, then moving on to the next area. Add the border at the same time as the main mosaic.

**4** Although the mortar will seep up between the tiles, the gaps between the tiles will still need some filling and levelling with a grout that matches the mortar. After the cement mortar has set, apply the grout to the finished terrace mosaic following the detailed instructions on pages 48 and 49.

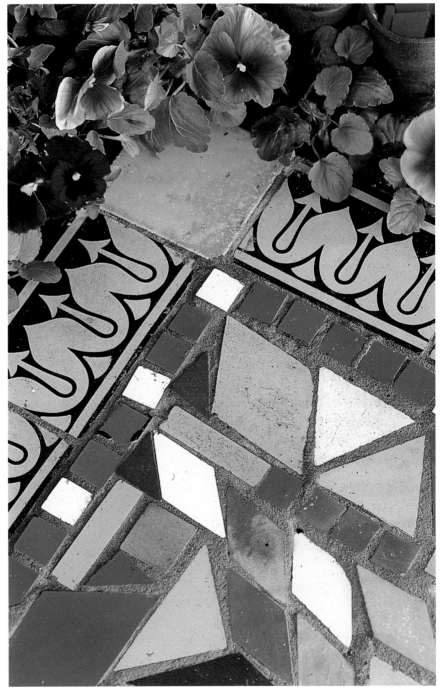

full cementing instructions and tips). Starting in one corner of the terrace in order to create a diagonal movement in the flow of the tiles, spread on the cement mortar over an area not bigger than a square metre (yard). Gradually lay the border tiles then the mixture of main mosaic tiles on the mortar.

As the work progresses check the level of the tiles by sliding the plank of three-by-two over them; adjust the

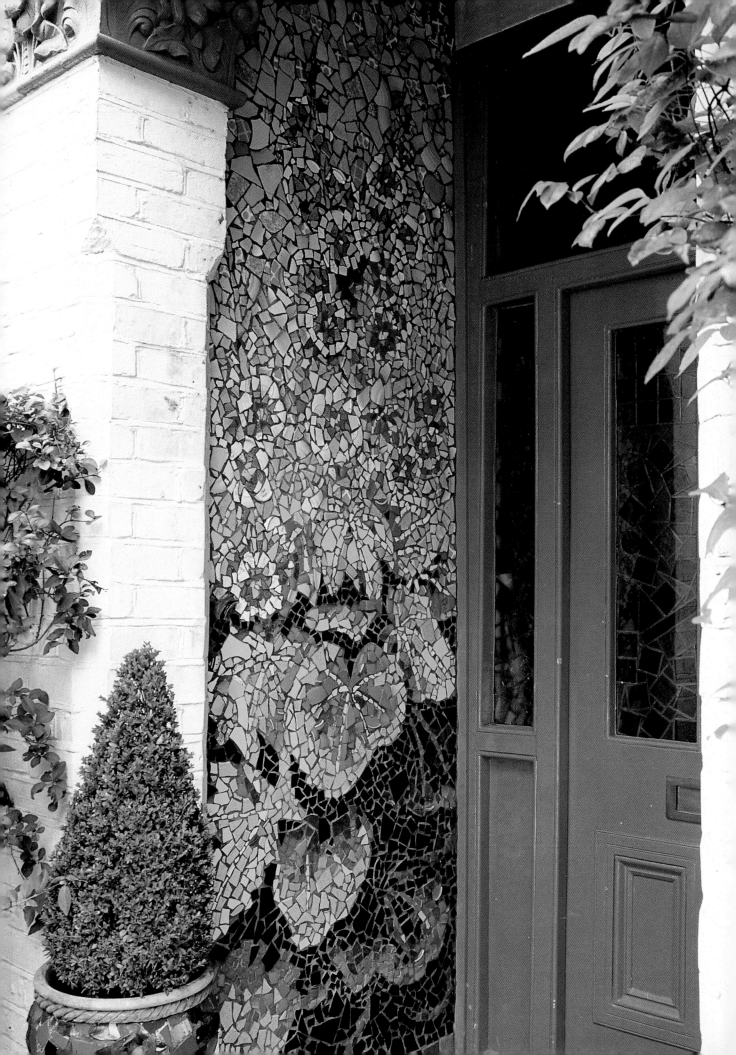

# Hollyhock Door Surround

One of the almost hidden delights of walking British residential streets is catching sight of tiled entranceways to Victorian terraced houses. Often these are very flowery and display a wide range of colours and textures. The entrance of my own house in north London would have had tiles, I'm quite sure, but some tidy soul must have removed them at a time when they went out of fashion. So for the 15 years I've lived here, I've dreamed of restoring them or creating some decoration that would amuse me as I come and go.

Doing this book was the final spur that allowed me to invest the time in my entrance. I scratched around for a tall design that would fit the space and hollyhocks (a jolly plant that spells English cottage garden for me) seemed just the ticket. I started by drawing the flowery scene on the wall with chalk, then gathered trays of tesserae chips in various colours – greens and dark shadow colours for the leaves, peaches, white and yellow for the blossoms, and sundry textures in milky blues for the sky.

When viewed close to, the finished mosaic appears quite an abstract smear of colour, but if you step back into the front garden the large plants come into focus. Varying the scale of the broken tesserae – from large tiles to small fragments – has given vitality and movement to the design. The playful patterns on the crockery in the sky are fun to study and include checks, polka dots, transferware scenes and sponge textures, along with plain shades of blue. I often find the mailman deep in contemplation at my door.

I was going to do a second set of hollyhocks on the other side of the door, but my assistant Brandon had the idea for the more abstract arrangement of richly coloured diamonds (see page 107). It was faster to execute this simple format than the hollyhocks. I drew out very primitive diamonds on the wall and Brandon filled each one in with shades of the same colour (or blue-and-white shards as I had a lot of these). I love the way half saucers look on the geometric diamond shape, also the way the various shades of each colour create such a glow of rich tone. Dark grout is a must to bring out the smouldering colours.

LEFT Kaffe Fassett's *Hollyhock Door Surround* has an English country garden appeal. It contrasts playfully with the *Diamond Surround* on the other side of the door (see page 107). See overleaf for how to mosaic an exterior door surround.

# Mosaicking the door surround

**Basic materials and tools** Broken crockery and thin wall tiles in white, pinks, peaches, oranges, yellows and reds for flowers, blues (including patterned china) for the sky, greens and yellows for leaves, and deep greens for shadows, with light dusty pastels dominating the whole scene for the light airy mood of a leafy garden; smooth cement-rendered wall surface; nippers, cement and grout spreaders, and lint-free cloths; cement-based mosaic adhesive and grey grout, both suitable for exterior use.

**Instructions** Before beginning, score the smooth, cement-rendered wall. See page 43 for more about preparing walls prior to mosaicking.

1 Begin by planning and sketching your design. The hollyhocks used here are just a suggestion of the type of bold leaf and flower shapes that suit a broken crockery mosaic. Be sure to keep the forms large and simple.

2 After sketching your design, either draw it directly on to the wall with chalk or a soft-lead pencil (RIGHT); or draw it on a piece of paper the same size as the wall space, then transfer the outlines on to the wall.

3 To gain an understanding of how to shade and colour a garden scene, study the features on the surround:

• Each leaf has light central veins and is shaded from the outer edge of the leaf towards the centre from light to dark. The leaves at the bottom of the design are darker and get lighter as they approach the flowers. Each leaf has a dark shadow below it which gives the foliage a light and airy look.

• Each flower has a contrasting centre and is shaded like the leaves – from light to darker towards the centre. Some of the flowers are very pale and others slightly darker, and a few are facing away from the viewer, which gives depth to the design.

• A very pale sky pokes through behind the blooms to add to the airy atmosphere. Towards the top of the design, the sky darkens.

• The mosaic pieces are mostly medium-sized, except where small pieces are needed for detail, such as on the flowers or for the leaf veins. Some large chips have been used in the sky and in the deep shadows at the bottom of the scene.

4 It is not necessary to lay out the whole mosaic on a flat surface before cementing it on to the wall. However, it is worthwhile trying to arrange a single leaf and flower to see if the shades you have collected work well together. Lay your life-sized drawing (or a tracing of a leaf and flower you have drawn directly on to the wall) on a flat surface. Using the nippers, cut some randomly shaped pieces of crockery and tiles for a single leaf and flower. Make tesserae that are as flat as possible, dividing curved items into smaller pieces to flatten them. Piece the tesserae together on top of the drawing. On the flower, arrange shards around the outer edge of the flower first, then position a flower centre before filling in the remainder. On the leaf, position the veins first, using thin strips, then arrange pieces around the outer edge before filling in the rest. This exercise will give you an

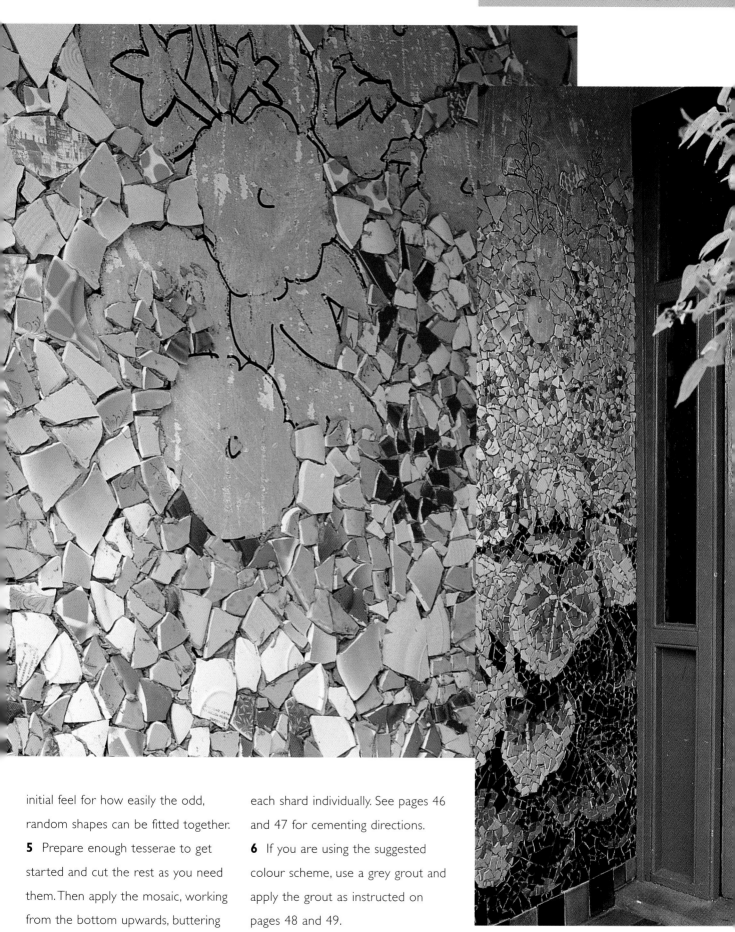

initial feel for how easily the odd, random shapes can be fitted together.

**5** Prepare enough tesserae to get started and cut the rest as you need them. Then apply the mosaic, working from the bottom upwards, buttering each shard individually. See pages 46 and 47 for cementing directions.

**6** If you are using the suggested colour scheme, use a grey grout and apply the grout as instructed on pages 48 and 49.

# Mosaics Glossary

**andamento** – Term used for the 'flow' of mosaic tesserae, which is created by the alignment of the pieces and the gaps between them. See also *Roman mosaics*.

**adhesives** (for mosaics) – Cement-based mortars and acrylic-based glues used to apply tesserae to a base. See *cement-based mortar*, *epoxy resin* and *PVA*.

**bases for mosaic** – The surfaces on to which the tesserae are cemented to create a mosaic. The best mosaic bases are those made from cement or wood. Metal bases require the use of epoxy resin. (See pages 42 and 43 for advice on choosing and preparing a mosaic base.)

**bolster blade** – See *hammer and hardie*.

**buttering** – Applying adhesive to each individual tessera before positioning it on the mosaic base. The more usual technique is to spread the adhesive on to the base rather than the tesserae, but in some instances buttering is preferable.

**Byzantine mosaics** – See *early mosaics* and *gold tesserae*.

**cement** – See *Portland cement* and *cement-based mortar*.

**cement-based mortar** – A compound used in mosaicking as an adhesive; made from a mixture of dry, powdered cement, sand and water, and sometimes other additives, such as lime, and acrylic-based bonding agents. Also called *cement mortar*, or simply *cement* or *mortar*. Mosaic mortar should be mixed to the consistency of thick, smooth, heavy mud. As with grout, it can be coloured if desired, with acrylic paint, special cement colourings or pigments.

**ceramic tesserae** – Small, glazed or unglazed tiles. Unglazed ceramic tesserae made specially for mosaicists are currently available in a range of colours and in two sizes – 2cm (¾in) and 2.5cm (1in) square. They are usually sold glued to paper or nylon mesh, and can be soaked off in warm water. Unlike vitreous glass tesserae, both sides of these tesserae are the same.

**coloured grout** – See *grout*.

**coloured mortar** – See *cement-based mortar*.

**curing** – See *setting*.

**descaling fluid** – Sold for removing build-up of limescale in electric hot-water kettles. This special solution is also sometimes used by mosaicists to clean off spots of cement-based adhesives or grouts stuck to the surface of mosaics. It should only be used diluted and should be tested on a sample mosaic before use. Always follow the manufacturer's safety instructions carefully when using this cleaner and protect your hands and eyes. See also *hydrocholoric acid*.

**direct method** – A mosaic technique in which the tesserae are stuck directly on to the mosaic base with adhesive. The main advantage of this method is that you can see the surface of the mosaic as you are working, unlike with the traditional indirect method (where the tesserae are arranged face down). This is especially important when working with tesserae that are not the same on both sides, like broken china, shells, et cetera. The main disadvantage with this technique is considered to be that it does not produce absolutely flat surfaces – but this can also be seen as an advantage, since the tesserae in an uneven surface can catch the light at different angles and produce interesting reflections and textures. See also *indirect method*.

**early mosaics** – Some of the earliest known mosaics were made by the Sumerians in Mesopotamia in the third millennium BC. These mosaics were composed of long terracotta cone-shaped pegs embedded in mortar on exterior walls and columns; the exposed circular peg heads were painted to form patterns. Other pre-Christian mosaics include Chinese-garden pebble pavements and Turkish pebble floors. Mosaicists of the ancient Greek Empire continued to develop pebble mosaic, introducing greater and greater detail and highlighting the designs with painted pebbles, and thin wire and terracotta outlining. During the Hellenistic period, beginning in the 4th century BC, tesserae cut from natural stones started to appear in mosaics and slowly replaced pebbles. The development of mosaics continued and flowered through the Roman and Byzantine eras with the introduction of new tesserae materials (glass, et cetera) and more and more detailed patterns and pictoral compositions. See also, *Roman mosaics* and *gold tesserae*.

**emblemata** – Panels set into ancient Roman mosaics, usually circular. Emblemata act as a focal or central point in the mosaic design and are often very intricate. It is believed that emblemata were made during the Roman era by master mosaicists using the indirect method, transported to the permanent site when finished, and inserted into a larger mosaic.

**epoxy resin** – A two-part adhesive made up of a resin and a hardener, which have to be mixed together right before use. Epoxy resin is a very strong adhesive and is weather resistant. It is the only adhesive that can be used for applying mosaic to a metallic surface. The disadvantages of using epoxy resin for mosaics are that it expensive, dries quickly and gives off noxious fumes until cured.

**float** – A rectangular, flat-faced implement used to flatten and level cement, and to apply a coat of cement or plaster to a wall. A *notched float*, also called a serrated float or a notched trowel, has grooved edges and is used to spread tile adhesive or cement-based mortar on to a flat surface in preparation for mosaicking or tiling. The flat face is used to spread the adhesive, then the notched edge is wiped across it to create a uniform thickness. The depth and width of the notches determine the thickness of the mortar.

**glass tesserae** – See *gold tesserae*, *smalti* and *vitreous glass tesserae*.

**glues** – See *epoxy resin* and *PVA* for glues for mosaics. See also *cement-based mortar*.

**gold tesserae** – Tesserae first used extensively by the Byzantines in the 5th and 6th centuries, when mosaicists would sometimes set them in the cement at angles to that they would appear to shimmer in the light. Today gold and silver tesserae measuring about 2cm (¾in) square are produced specially for mosaics. The metal leaf is embedded between two layers of glass; the top is a thin layer of clear glass and the bottom is a thicker layer of coloured glass that is green under the gold leaf and blue under the silver.

**grout** – A mortar the consistency of thick mud, used to fill cracks and crevices

between tesserae after a mosaic has been stuck in place. Grout is made in the same way as cement-based adhesives but usually with finer sand. Grout strengthens the mosaic and unifies the design by forming a thin line of colour around the individual pieces. It can be a neutral tone, or brightly coloured to match or contrast with the tesserae. A single colour of grout can be used over the entire mosaic, or various colours to match the changing colours of the tesserae. Grout is produced in powder form or ready-mixed, and is available in a limited number of colours. For other colours, powdered pigment or artist's acrylic can be mixed with white grout.

**grouting** – The process of spreading grout over the mosaic and pushing it into the crevices between the tesserae, after which the excess grout is wiped away and the mosaic surface polished. Some mosaics are not grouted, for instance those composed of smalti, shells or pebbles, or those where the tesserae are pressed deep into the mortar adhesive. See also *squeegee*.

**hammer and hardie** – The traditional mosaicist's tools for cutting tesserae. The mosaicist's hammer has a curved head and two pointed, wedge-shaped carbide-tipped ends. The hardie (also called a *bolster blade*) is a chisel blade with a shaft that is mounted on an anvil. A tessera is placed on the hardie and held between two fingers of the left hand so that it straddles the blade, and is then tapped with the pointed hammer. Although thin mosaic tesserae can be cut with modern nippers, smalti and stone are best cut with the traditional hammer and hardie. See also *masonry hammer*.

**history of mosaics** – See *early mosaics, micromosaics, pitture per l'eternita, Roman mosaics* and *smalti*.

**hydrochloric acid** – A powerful and corrosive chemical, which is sometimes used in diluted form to clean away remaining scum and specks of cement-based mortar on the surface of a mosaic. The acid is diluted in a glass container with 15 times the amount of water, brushed over the mosaic (causing the cement particles to fizz as they dissolve), and immediately washed away with

generous amounts of water. Even diluted, hydrochloric acid should be used with great caution, only out of doors, and preferably under the supervision of an experienced mosaicist. Rubber gloves and safety goggles should be worn at all times when handing hydrochloric acid, and the fumes should not be inhaled. See also *descaling fluid*.

**indirect method** – A traditional mosaic technique, also called the *reverse method*. In this method the mosaic design is drawn in reverse on paper and the tesserae are glued face down to this paper, with the aid of a water-soluble adhesive. The composed mosaic is then tamped, face up, into a bed of mortar. When the cement is dry, the paper is soaked off and the grout is applied in the usual way. (Alternatively, a thin layer of mortar is applied to the back of the paper-faced mosaic, and once dried, the cement-backed mosaic is stuck to its base.) The indirect method has the advantage of producing mosaics with absolutely flat surfaces. To eliminate the main disadvantage of this traditional method – which is that the tesserae are placed face down while the design is composed – a contemporary alternative has been developed. In this modern technique, the tesserae are arranged face up on a piece of low-tack adhesive film. Then, a sheet of paper covered with wallpaper paste (or a high-tack sheet of film) is stuck to the surface of the finished arrangement. Next, the mosaic is flipped over between two sheets of plywood, and the low-tack film carefully removed to produce the traditional 'reversed' design, which is then covered with mortar. See also *direct method*.

**interstices** – Intervening spaces, gaps or crevices between tesserae. Interstices can be of varying widths and are usually filled with grout after the mosaic ashesive has set. In some mosaics, such as those made with smalti, the tesserae are placed so close together that there is no need for grouting.

**keying** – See *scoring*.

**masonry hammer** – A carbide-tipped hammer used in masonry, which is a good substitute for a traditional mosaicist's hammer. See *hammer and hardie*.

**MDF** – Medium-density fibreboard. The

water-repellant variety is a suitable base for mosaic.

**memoryware** – See *pique assiette*.

**micromosaics** – Miniature mosaics made from tiny tesserae and used in the 18th and 19th centuries on jewelry, small boxes, et cetera. The tesserae, called *smalti filati*, are cut from threads of opaque glass and are so fine that there are sometimes 1,400 per square inch.

**mortar** – See *cement-based mortar*.

**mosaic cutters** – See *nippers*.

**mosaicist's hammer** – See *hammer and hardie* and *masonry hammer*.

**mosaic methods** – See *direct method* and *indirect method*.

**mosaic opus** – See *Roman mosaics*.

**nibbling** – The act of cutting tesserae into the desired shapes with nippers.

**notched float or trowel** – See *float*.

**nippers** – A tool used to cut mosaic tesserae. Also called *tile nippers*.

**objets trouvés** – Means literally 'found objects' in French. In mosaics the term is used to cover unusual and often three-dimensional objects used as 'tesserae'. The so-called 'visionary' mosaicists are famous for using unusual *objets trouvés* to build up mosaics, including toys, dolls, whole bottles, spoons, et cetera. See also pages 14–35.

**palette knife** – A knife with a thin, flexible blade of various shapes, used by artists for mixing, scraping or applying paint. This implement is often used by mosaicists for buttering tesserae, applying adhesive to bases, spreading on grout, et cetera, especially when working with fine tesserae.

**pique-assiette** – Means literally 'plate stealer' in French. The term now refers to mosaic work that is predominantly composed of pieces of broken crockery and glass. Also called *memoryware* or *shardware*.

**pitture per l'eternita** – Intricate realistic mosaics made to imitate artists' paintings, started during the Renaissance.

**Portland cement** – A hydraulic (able to harden under water) cement, made by heating a mixture of limestone and clay in a kiln and pulverizing the resulting material. Portland cement is mixed with water, sand and sometimes a latex

**157**

additive to form a mortar used for mosaics. When hard it resembles Portland stone (a type of limestone) in colour. See also *cement-based mortar*.

**pricking out** – A traditional method of transfering the outlines of a mosaic design on to a fresh cement or concrete base. The cement is allowed to cure to a stage when it feels hard but is still not completely set. Then the paper drawing of the mosaic design is fixed in place and the outlines pricked through the paper and into the soft cement with a sharp, pointed implement; the holes are placed about 1–2cm (⅜–¾in) apart. The drawing is removed and the cement allowed to cure before the tesserae are positioned using the direct method.

**PVA** – Polyvinyl acetate, an acrylic-based, thick white liquid adhesive that dries clear. It is sold under various brand names and can be non-water-resistant or water-resistant. Water-resistant PVA is used neat in mosaics as a tesserae adhesive. Diluted with water it can be used to seal mosaic bases, or mixed into cement-based mortars to increase bonding properties.

**reverse method** – See *indirect method*.

**Roman mosaics** – The ancient Romans carried on the mosaic traditions from the Greeks. Good examples of early Roman mosaics made during the second or first centuries BC can be found in Pompeii. The Romans expanded the use of mosaics, using them to cover walls and fountains, as well as floors and pavements, and gradually added more glass and gold tesserae, which had previously been used only sparingly. Roman pictoral mosaics became more and more detailed, and mosaicists developed formal methods for the positioning of the tesserae. In *opus regulatum* the square tesserae are lined up in rows, resulting in a pattern similar to brick work; this type of tesserae arrangement was often used as background filling. *Opus sectile* refers to mosaic where each individual tessera represent one item, such as a whole leaf or a head. *Opus tessellatum* filling is more regular than opus regulatum, since the tesserae are lined up both vertically and horizontally to form an even grid-like pattern. *Opus vermiculatum* describes the outlining of

the contour of a shape with a row of tesserae; when these outlines are echoed outwards by further curving rows to fill an area, the mosaic is called *opus musivum*. See also *smalti*.

**sealants** – Products used in mosaic work to seal mosaic bases and enhance bonding. A common sealant, used on wood or ceramic surfaces is PVA diluted with water.

**setting** – The permanent hardening or firming of mosaic adhesives or grout; also called *curing*. This process is sometimes deliberately slowed down for cement-based mortars (by covering the mosaic to increase the drying time) in order to increase the strength of the adhesion.

**scoring** – Scratching cross-hatched lines into wood or rendered surfaces to provide 'tooth' for the mosaic adhesive. Also called *keying*.

**shardware** – See *pique assiette*.

**slurry** – Thinned down mortar. In mosaic work slurry is sometimes used on cement-rendered surfaces to enhance bonding when cement-based mortar is used as the adhesive. A coating of slurry is brushed on to a dampened wall or floor right before the mortar is trowelled on and the tesserae inserted.

**smalti** (singular *smalto*) – Opaque glass tesserae used as early as the Roman era and still manufactured in Italy today. Smalti is made by mixing molten glass with metallic oxides, pressing the mixture into 1cm (⅜in) thick slabs and splitting the cooled 'pies' into small rectangles approximately 2cm (¾in) by 1cm (⅜in). The broken, rather than pressed, sides are placed uppermost in the mosaic. Grout is not usually used on smalti mosaics because of the small air bubbles in the tesserae that can catch the grout and discolour the pieces. Smalti are very reflective and have an uneven surface. If smaller pieces of smalti are required, there are best cut with a hammer and hardie.

**smalti filati** – See *micromosaics*.

**smalto antico** – An opaque glass tessera that has had extra sand added to it to give it a grainier texture.

**spatula** – An implement with a wide, flexible plastic or rubber blade, used in cooking for scraping the sides of bowls.

A spatula can be used in mosaic work to mix small amounts of mortar and grout, to spread on mortar, and to spread on grout and push it into crevices.

**squeegee** – An instrument with a long, straight rubber edge, used to spread on grout in mosaic work.

**Sumerian mosaics** – See *early mosaics*.

**tamping** – Packing down tightly with a succession of blows or taps; in mosaic work tamping refers to the act of pounding mosaic, which has been glued on to paper or mesh, on to a mortar-covered base to embed the tesserae in the mortar. The prepared mosaic is covered with a board, which is then tapped with a hammer.

**tesselate** – To form tesserae into a mosaic pattern.

**tesselation** – Collection of shapes that fit together to cover a surface without overlapping or leaving gaps; can be regular or irregular.

**tesserae** (singular *tessera*) – Originally used as a generic name for the traditional ceramic, glass or natural stone squares or cubes used to make mosaics, but now generally used for pieces of any material or shape assembled to form mosaics. Contemporary tesserae include shards of crockery, mirror or tiles, shells, pebbles, and all manner of *objets trouvés*, as well as the glass, natural stone, or ceramic squares made specially for mosaic work.

**trowel** – A V-shaped or rectangular metal tool used in mosaic work to mix mortar and spread it on large areas. See also *float*.

**Venetian glass tesserae** – See *vitreous glass tesserae*.

**vitreous glass tesserae** – Small, nonporous glass tiles produced specially for mosaics; also sometimes called *Venetian glass*. The most common vitreous glass tiles measure 2cm (¾in) square by 3mm (⅛in) thick and have bevelled edges and a ridged surface on the underside. The bevelled edges allow the tiles to lie smoothly on gently curved surfaces, and the grooves enhance adhesion. The tiles usually come stuck to a sheet of paper or plastic mesh and are available in range of colours, some with metallic veins. Vitreous glass tesserae are very durable, as well as frostproof and stain resistant.

# Acknowledgments

**Candace Bahouth acknowledges . . .**

A book is constructed somewhat like a mosaic – a group of people gathered together to express an overall vision. Each participant essential to the harmonious whole.

It starts with inspiration, so an ever-loving thank you to Joseph, my son, for sparking off the initial idea of mosaic by bringing and showing me the wonder and beauty of discarded crockery.

For giving direction and encouragement to the whole and agreeing to collaborate on this book, a huge thank you to Kaffe. His prolific, spontaneous, confident energy is always an intoxicating stimulus.

For his 'heart' and organizational skills, a big thank you to Brandon Mably, and also to Jeremy Cooper for his clear logical thought, to my sister Lisa the astrologer, to Jeffrey Chock for email assistance, to Pamela Lady Harlech for her supportive patronage, and to Sarah and David Burnett and Michael and Hillye Cansdale for their generosity.

Thank you to Kim King for loaning the *Mosaic Basket* (so many times) and Annie Scotland for her undaunted effort and structural help well beyond the realms of friendship. To Mike of Romantique in Bath for an unparalleled mosaic service and unforgettable packaging. And I mustn't forget Radio 4 for sanity!

The picture begins to emerge. For framing this book, keeping the endeavour, the structure masterfully together, a heartfelt thank you to Polly Dawes, Debbie Patterson and especially Sally Harding – Sally has worked with me on my other books and her calm serenity brings form and stability to my chaotic approach.

And finally, the stabilizing adhesive that strengthens my life and work, gives me support and vital practical assistance is my darling enthusiastic husband, Andrew – a loving thank you.

**Kaffe Fassett acknowledges . . .**

Though a book like this might take a year to write, many of the seeds were planted back in my childhood; the life-enhancing influence of discovering the work of artists such as Simon Rodia, Facteur Cheval and Raymond Isidore gave me the courage to realize my fantasies. Later, on my travels, I also met some fabulously ambitious mosaicists, like Evi Ferrier – 'I won't stop till I cover all of Australia'. But it was Candace Bahouth with her flair who finally made me actually start mosaics, for which my undying thanks.

The next essential element is the raw material we mosaic makers use. For this I want to thank all car-boot sales, the end of the line tile shops, Sue Avery and Bich Tyler, and especially Rupert Spira for his museum quality broken china.

A huge thank you for the perfect red tiles for the curtain in the mosaicked Theatre Mural goes to Richard T. Keit. Big thanks to all my tireless, cheerful Theatre Mural helpers Nani Steal, Kim Rowe, Michelle Peters, Peggy Coates, Adrian Sweet, Dennis Rice and all at Happy Valley School. For inspired support and encouragement during work on the mural deepest thanks to Holly Fassett and Gayle Ortiz.

Thanks to Elaine M. Goodwin for her mosaic summer school, and to Kirk Dunn, and especially to Sarah Kelly for her months of work on some of the objects in this book.

Thank you to June Henry for introducing me to Andy McIndoe at Hillier Garden Centres, who encouraged and helped create an exciting garden for Chelsea Flower Show 1998. Thanks to Karen Beauchamp for wallpaper, Designers Guild for printing my fabrics so lusciously, Kim King for the loan of the Apple Shelf and Cabbage Table, and Terry Half for extra photography.

And finally, the more I get on in life the more I appreciate the team behind me who allow me to concentrate on my work. Thanks to Richard Womersley, to Anne James for counselling, and to Belinda Mably and Yvonne Edwards for support; to Sally Harding, Polly Dawes and Debbie Patterson for their brilliant work on the book, done with such cheer. Thanks also to Nadine Bazar for picture research.

And lastly to the man who single-handedly runs the show that is my studio, as well as supplying the best ideas, advice and undying support, Brandon Mably.

# Index